Hi, I am the author of the novels *The Two Worlds of the Mind* and *Von Wyck: The Complete Story By Victor Holocaust,* three short story collections, *Conversations At The Party, Perfect Strangers,* and *The Maze,* as well as four collections of lyrics, *Von Wyck Songbook Volume 1: 1986 - 1988,* "*Von Wyck Songbook Volume 2: 1988 - 1991, Von Wyck Songbook Volume 3: 1991 - 1997, Von Wyck Songbook Volume 4: 1998 - 2011.*

I've been reviewing movies off and on for the past few years, primarily on Amazon.com. And mainly films of my favorite filmmaker, Brian De Palma. These are just my opinions, and are not to be taken as fact. Hope you enjoy!

~ Randall Brooks

FILM REVIEWS

By Randall Brooks
(author of " The Two Worlds of the Mind" ,
" Conversations At The Party" ,
And " Perfect Strangers")

RANDOM FILM REVIEWS
BY RANDALL BROOKS
Copyright Randall Brooks 2014

ISBN 978-1500946791

First Printing, August 2014

All rights reserved. No part of this book may be reproduced, stored in a retrieval system or transmitted in any form or by any means without the prior written permission of the publishers and/or author, except by a reviewer who may quote brief passages in a review to be printed in a newspaper, magazine or journal.

Amazon Publishing has allowed this work to remain exactly as the author intended, verbatim, without editorial input.

The Reviews:

1. *The Runaways* (Run Away With The Queens Of Noise…)
2. *Snake Eyes* (De Palma Rolled A Classic Noir Thriller!)
3. *Mission To Mars* (De Palma's Daring Sci-Fi Adventure…)
4. *The Black Dahlia* (De Palma's Film Noir Descent Into Hell…)
5. *Blow Out* (De Palma's Explosive Psychological Conspiracy Thriller Will Blow You Away!)
6. *Dressed To Kill* (De Palma Invites You To The Latest Fashion…In Murder!)
7. *Carrie* (De Palma's Deranged Prom Date!)
8. *Gothika* (Not Alone…In Thinking *Gothika* Is Godawful!)
9. *The Exorcism of Emily Rose* (I Need An Exorcism To Erase This From My Mind…)
10. *Body Double* (De Palma's Erotic Driller Thriller…)
11. *Phantom of the Paradise* (De Palma's Rock N Roll Phantasy…)
12. *V For Vendetta* (When Things Explode, They Go 'Kapow'!)
13. *The Departed* (Scorcese Strikes Back!)
14. *Femme Fatale* (De Palma's Dream Within A Dream…)
15. *Sisters* (De Palma's Psychotic 'Sister Act'…)
16. *Mission: Impossible* (De Palma Does Psychological Espionage…)
17. *Halloween* (Rob Zombie, Hoover Dealer!)
18. *The Funhouse* (Tobe Hooper's Ride Of Terror…)

19. *Friday The 13th* (Jason's Nightmare...To be 'Re-Imagined'...)
20. *Greetings* (De Palma's Satiric Salutations...)
21. *Hi, Mom!* (De Palma's 'Hello, Vietnam, I Don't Give A Damn!')
22. *Murder A La Mod* (De Palma's DyNamic DeMented DeRanged DeBut...)
23. *Obsession* (A De Palma Classic Mystery, Suspense, Noir!)
24. *Raising Cain* (De Palma's Deceptive, Deranged, Demented Personality Disorder...)
25. *The Fury* (De Palma's Psychological, Telepathic, Paranormal, Mystery Thriller...)
26. *The Bonfire of the Vanities* (De Palma's Smoldering Satire...)
27. *Wise Guys* (De Palma's Madcap Mob Movie...)
28. *Saw* (Mind Rot @ Its Most Blatant!)
29. *Hostel Part II* (Yet Another Gory Snuff Film...)
30. *Psycho* (It Was Psychotic To Remake *Psycho!*)
31. *The Usual Suspects* (Film Noir At Its unUsual Best!)
32. *L.A. Confidential* (Confidentially...Not Noir!)
33. *The Queen of the Damned* (This Vampire Tale Rocks!)
34. *Evil Remains* (Creepy Psychological Slasher Horror At Its Finest!)
35. *Nights In Rodanthe* (Oh, Those Summer Nights...)
36. *Sunset Boulevard* ('Sunset Boo-la-vard'...)
37. *Redacted* (De Palma's Anti-War Masterpiece...)
38. *Rambo III* (Brain Cells Died When This Came Out!)
39. *Double Impact* (Dynamic Double Van Damme...)

40. *The Rage: Carrie 2* (Calling A Film *Carrie* Without Carrie Is, Well…Scary!)
41. *The Number 23* (Modern Day Gothic Film Noir…)
42. *Orphan* (Little Orphan Esther…)
43. *Rose Red* (Horrible Piece of Excrement…)
44. *Million Dollar Baby* (Clint's Million Dollar Mess…)
45. *The Shining* (*The Simpsons*' "The Shinning" Was Better Than Stephen King's *The Shining*!)
46. *The Dunwich Horror* (Lovecraft Dun Right…)
47. *Extremely Loud & Incredibly Close* (Amazingly Close To Home…)
48. *Death Proof* (Quentin's Quintessential Classic Homage To Drive-In Grindhouse!)
49. *Passion* (De Palma Puts Passion Back Into Filmmaking!)
50. *Carrie* (*Carrie* Ruined For A New Generation…)

-Bonus:

52. *Under The Dome* - **Season One** (Garbage In…Garbage Out…)
53. *Under The Dome* - **Season Two** (King's Great Novel Bastardized For Television…)
54. *Under The Dome* - **Season Three** (Dumbed Down Trash Claiming To Be Based On A Stephen King Novel)
54. *Glee* - **Season Four** (Feels Like A Weak Sequel…)
55. *Glee* - **Season Five** (No Longer Gleeful)
56. *Glee* - **Season Six** (*Glee* Is Officially Dead!)
57. *The Dukes of Hazzard:* **Complete 5th Season** (General Lee Jumps The Shark…)

-Plus:

Listmania List #1: Stanley Kubrick: King Of Cinema
Listmania List #2: Brian De Palma: DePalma - Dynamic Independent Director

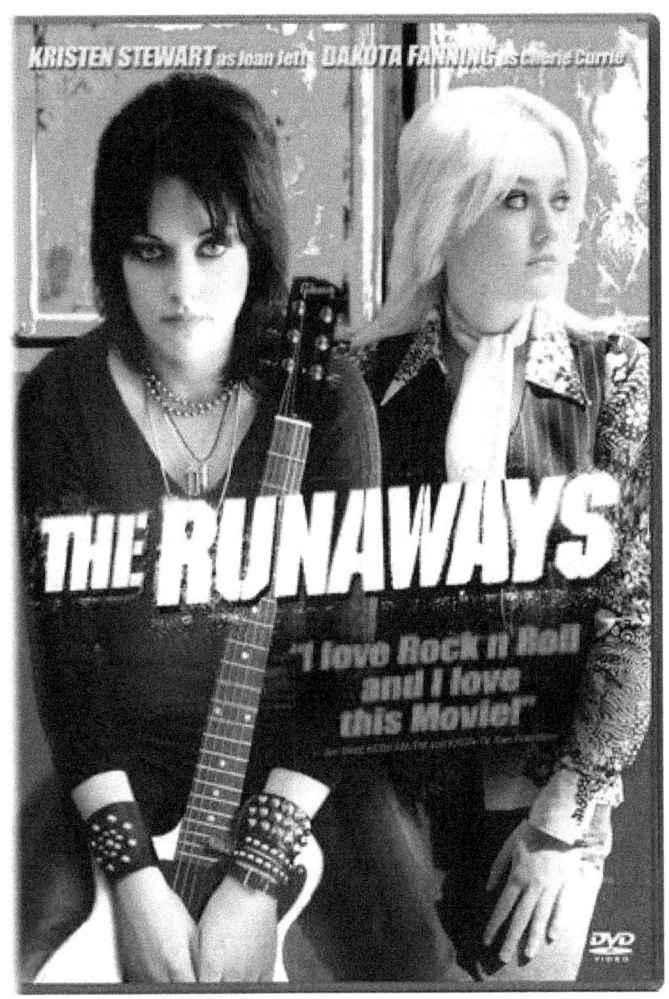

Run Away With The Queens Of Noise...
This review is from: *The Runaways* (DVD)

I must say that this is a great movie! It is the bomb, the ch-ch-ch-ch-cherry bomb of rock movies! Based on the novel *Neon Angel: The Life Of A Runaway* by Cherie Curie, director Floria Sigismondi crafts a very unique and refreshing look into the 70's, rock and roll, and the lives of some very talented females that changed the way the public viewed women in rock, when they were just teenagers.

Dakota Fanning is superb in this! Dakota is a force to be reckoned with, a very uniquely talented actress! She breathes life into the film and gives a topnotch vibrant performance. And as for Kristin Stewart, I've not seen her in anything else that I know of (I flat out refuse to see any of the *Twilight* films!), but I can say that she shined like a diamond in this! She wasn't just 'playing' Joan Jett, it was like she *was* Joan Jett! And Michael Shannon's portrayal of manager Kim Fowley was spot on! You would almost think Shannon was Fowley's bastard son.

However, I was a bit perplexed that there wasn't more attention on the rest of the band, mainly on Lita Ford. I am a fan of the Runaways, and I must say, had you forgotten that Lita was in the band, this movie doesn't really help remind you. I was especially upset at the end when the credits started, and Joan Jett, Cherie Curie, and even Kim Fowley's future careers were mentioned, but not a word about how Lita went on to a very successful solo career. And there was hardly any mention at all of drummer Sandy West.

I have sense watched the awesome documentary *Edgeplay: The Story Of The Runaways*, and am even more flustered with this film. For one, after seeing the real Cherie Curie, I think the actress playing Marie Curie would have been a lot more of a suitable fit than Dakota Fanning! Don't get me wrong, I love Dakota, and think she did a marvelous job in this, but look for some footage of the real Cherie and see what I mean. I also have a huge problem with the film ignoring Jackie Fox and Vickie Blue, the real life bass players for the band, and substituting them with the fictional "Robin". What the fuck?! But, I still enjoy it for what it was, a good "rock -n- roll" movie. But, as a bio of the Runaways, I think it could have been better.

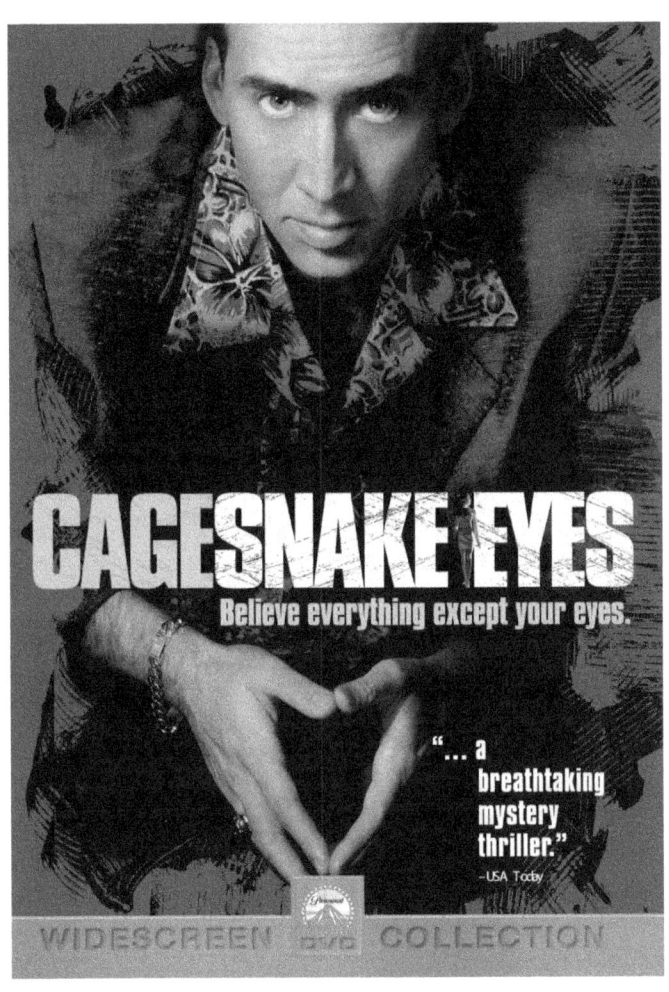

De Palma Rolled A Classic Noir Thriller!
This review is from: *Snake Eyes* (DVD)

Personally I think *Snake Eyes* is a very superior film! Sorry to see that most people just don't "get" De Palma. He doesn't make films for the Academy worshipping crowds. He makes actual works of art. De Palma doesn't make movies for critics either. Oh, sure, De Palma is 'flawed', but so are most, if not all, true artists. But, his 'flaws' mostly only show when he is working for major studio "Hollywood" films. But even then he is so far superior to anything general generic Hollywood can dish out, in my opinion.

De Palma is one of the last of a rare dying breed of filmmaker, in the same vein, style, and category of the likes of Godard, Felini, Antonioni, Lelouch, Kubrick, Hitchcock, Welles, Wilder, Bergman, and such. To truly "get" him and appreciate him, one must realize that his films go far beyond mere "storytelling" in the conventional sense, not making the typical plot-driven drivel, but visual feasts, that stun the senses, and tells stories visually, with his camera movement and style. And, *Snake Eyes* is one of those type of films, where the 'story' is in the camera movements, not necessarily the script.

Keeping in check with so many common themes that have run consistently throughout De Palma's career (the trouble with the double, betrayal, conspiracy, etc), De Palma wastes no time taking viewers inside his noirish conspiracy thriller set in Atlantic City during a hurricane. His opening shot flows for over 15 minutes, uninterrupted,

introducing every character you need to know in that short time frame. He interweaves between TV point of view to the actual casino in record breaking time, and in breathtaking fashion.

Between the very first shot of the politician and his entourage, including two powerful characters in the film played by Gary Sinise as Kevin Dunne, a political figure played by John Heard, Nicolas Cage as Rick Santoro (perfectly cast as an over-the-top cop on the make), a sleazy news reporter (played by Kevin Dunn), a bookie that owes Santoro a dept (played by Louis Guzman), the boxer Lincoln Tyler (played by Stan Shaw), his promoter, and everybody else involved in the 'conspiracy', as well as everything you need to know about the story, whether seen or heard, are all shown to the viewer in that short time span.

And, De Palma employs so many terrific camera angles and devices and tricks, that the film should be kept in a film school vault and studied every year for the next couple of decades.

From a mysterious redheaded woman to a blonde who is revealed to be a brunette with a wig on (played by Carla Gugino), from following a bloody hundred dollar bill to a ruby red ring, De Palma sets us on the coarse, working from a great script by David Koep (who scripted *Mission: Impossible* and *Carlito's Way*), putting things right before your very eyes, and/or in your ears, just to have you questioning everything and everyone you see on screen.

And, the dark humor and irony is delicious! Especially when Rick receives a phone call from a show girl, saying she's his lucky number seven right as the assassination takes place.

The slogan "Believe everything except your eyes" was a perfect tag line for this 1998 classic psychological mystery, noirish conspiracy thriller from the Master of Suspense. Because, after the film is over, and you know the way the plot turned out, then go back and view it again, you see that De Palma shows everything you need to see in the first 15 minutes of the film, and it's all right in front of your very eyes!

And, be sure to watch this film all the way until you see the words "The End" pop up to know just how sinister this story really is. Hint: A ruby red ring in stone.?.?.
And, when De Palma returns his camera back outside the arena, and the storm is raging, thus is the build up to a very awesome climatic scene in what is already established as a *very* noirish story/film.

Brian De Palma really hit a solid homerun for his fans with this classic, exposing just how evil, ugly, and sinister the world of Atlantic City really is.
And, the song at the end of the film By Mercedes Brooks, called "Sin City" is awesome, and the lyrics recap the story of the film.

Definitely the best film Nicolas Cage has *ever* been lucky enough to be cast in, and his best performance by far! Awesome! I would rate it a *lot* higher than just 5 stars if possible.

18

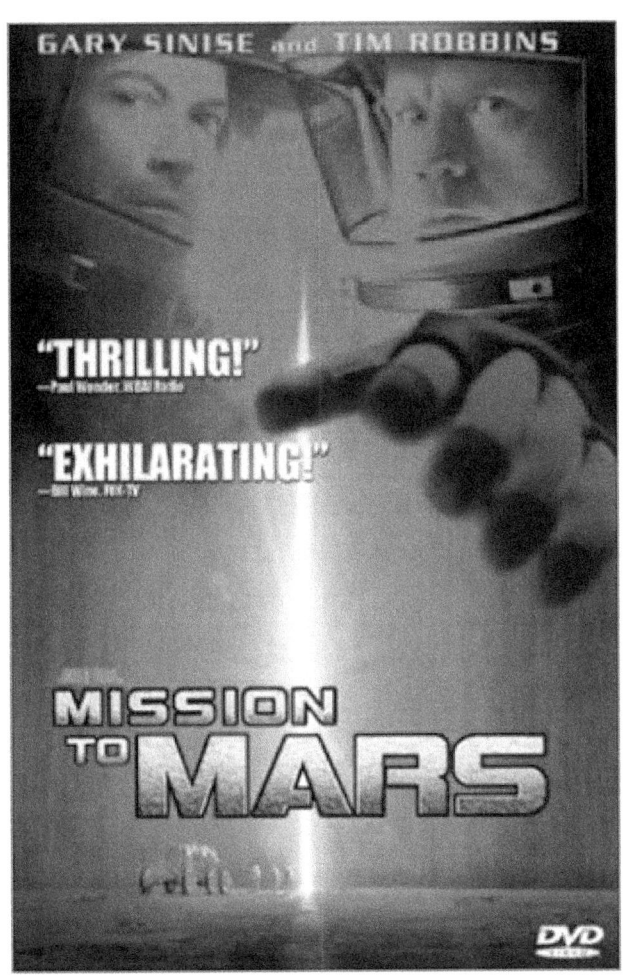

De Palma's Daring Sci-Fi Adventure...
This review is from *Mission To Mars* (DVD)

I have always being stupefied by why this movie was so hated. Was it because it wasn't an *Independence Day* clone, or a *Men In Black* type of trash?!?! I don't mean to offend anyone that likes those type films, but this film just isn't that type of movie. This is a more intelligent, cerebral film as far as I'm concerned.

Ok, this is a Brian De Palma film, let's establish that right off the bat. To appreciate (read "get") De Palma, one must be exposed to and appreciate films by filmmakers ranging from Michelangelo to Fellini, from Kubrick to Hitchcock, from Coppola to Welles, from Hawks to Capra, from Donen to Lelouch, from Scorcese to Godard, from Wilder to Lynch. Filmmakers who pioneered the art of visual storytelling, relying on great, strong, awe-inspiring, jaw dropping visuals coupled with good solid acting and a very enticing Human story; and not have to be "talked to death" with dialogue overflowing in *every* scene. You have to, as a viewer, read facial expressions, eye movement, guess what's being said, guess what's going on, question where you may be in the movie as far as plot, keeping you almost in a state of utter confusion only to wrap everything together at film's end in a way that will have you feeling like the rug has just been pulled out from under you because it's done in such utter climatic fashion.

This film starts with a De Palma trademark crane tracking shot that goes on for the entire length of

credits, starting with a rocket ship launch that reveals itself to be only a bottle rocket as the film opens showing us that all is not what it appears to be from the start, and a back yard barbeque and all the characters that we'll need to know in this ten minute take. Then the shots of Mars, and the way scenes are done via telescreen depicting communication between the astronauts on Mars and the Space Station. The CGI effects in this film are amazing! Finally a great movie that uses CGI to serve the story instead of the other way around. The Martian Storm Funnel scene alone is worth viewing the film over and over for.

The stunning way De Palma shows us a 'vortex' scene in so many different ways, or creating a 'vortex' mood in so many scenes. Ranging from the M&M's Phil (played brilliantly by Jerry O'Connell) has displayed as his ideal perfect woman to another scene where the M&M's are spilled and floating in a DNA form, to the scene where the micrometeoroids hit the ship, and the Dr. Pepper and the leaking fuel are showing us the same DNA vortex. Or scenes showing the spaceship done in a whirling fashion. And I won't spoil the ending by saying that it is nothing short of an awesome vortex climax that will leave you breathless.

This is a De Palma film that I was expecting to go in a different direction than it took when I first saw it when it first hit video. As a matter of fact, I let myself be led to believe that the film was building toward something sinister, like Tobe Hooper's *Invaders From Mars*, or Philip Kaufman's *Invasion Of The Body Snatchers*, between what was

happening on screen visually along with composer Ennio Morricone's awesome score. So, when the four main characters meet the Martian alien, I initially hated this movie as it continued on from there until the final minute or two. Then, the final minute or two Paul Hirsch's edited flashback scene pops up from out of nowhere and I was stunned; and the other part of the ending all worked for me. I immediately watched it again as soon as I could, and I've loved it even more every time I've viewed it, which is very often. I feel that the scene with Maggie at the end is one of the most powerful, emotional things I've seen in a film in a long time.

And something that I believe that any married man would relate to. Especially one who has maybe lost his wife, and would give practically anything to have her back again. That to me was what this film was about, one man's voyage "Home", a journey (or odyssey, if you will) to the residence within the heart, where we may find eternal bliss. I thought Paul Hirsch's editing has never been better, especially on a De Palma film, than in that final scene! And, then when I went back and watched the film again, I loved every second of it, even some of the scenes I initially thought were a bit "hokey" because I realized the hokey dialogue in some scenes is really essential, because sometimes that is how we as people talk. But that is what I like in this, that the screenplay is kind of "weak", the actual "story" is told visually by De Palma's deft camera. When you realize the whole story revolves around Maggie and about going "Home", you may even realize why the Martian Spirit is crying a single tear when She appears (it's not just because She sensed

the pain of their journey, and their pain of losing a friend along the way. She is also crying a tear for all Humanity).

As for filmmaking techniques that I hinted at before, now that I've mentioned Maggie (*so perfectly played by Kim Delaney*), a character that's not only seen but one time in the film (well, twice counting the flashback at the end), yet a character that is definitely no small character; as there never seem to be any of those in any of De Palma's films - even the *smallest* of roles are also most times some of the most key roles- is shown to us in a movie within a movie within a movie, and to me this movie is worth owning just for scenes like that alone, let alone all the other *numerous* scenes that are just awe-inspiring to any film student today.

Yes, there's maybe some non-perfect dialogue, and/or dialogue in a scene that didn't need it, but overall this is a solid masterpiece of sci-fi! I would easily rank this on the same level as Kubrick's *2001: A Space Odyssey*, Ridley Scott's *Blade Runner*, Spielberg's *Close Encounters Of The Third Kind*, George Lucas' first 3 *Star Wars* films, or *Contact*. No gory *Men In Black* type aliens, thank god. This is a lot more "cerebral" than those. And, I am sure that is why it was so heavily panned when it came out, because it wasn't one of those type films, which were over-saturating the market back then. This is a simple story about a lonely widower that only wants to go "Home", even if it means leaving the world you're in now to get there, this is an awesome version of any "Odyssey" story ever told! Highly recommended!

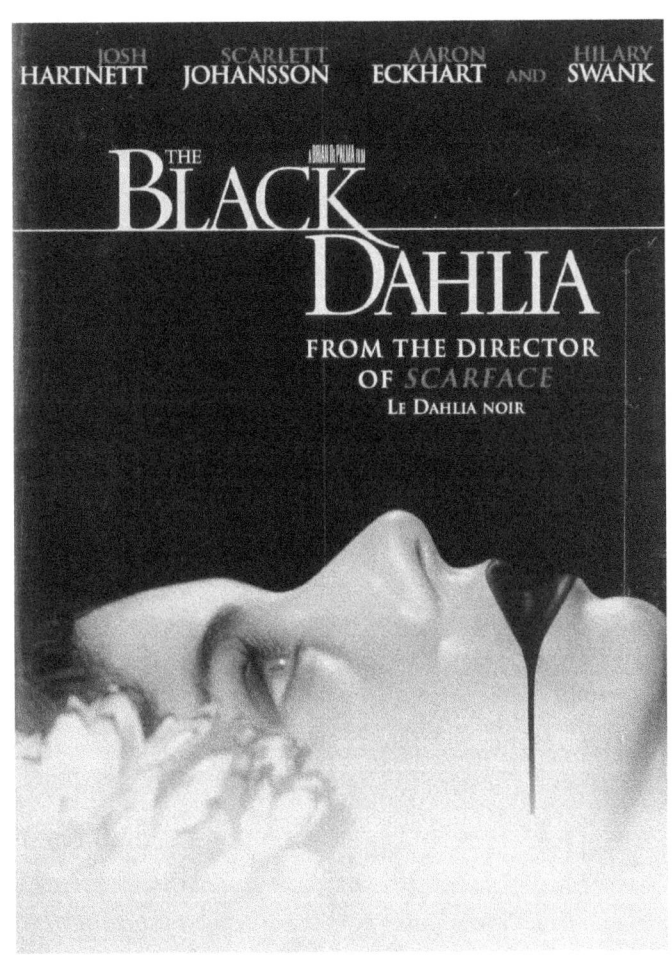

De Palma's Film Noir Descent Into Hell...
This review is from: *The Black Dahlia* (DVD)

I cannot believe all of the negative reviews on this film. And I have no idea why people would rather see the generic *Hollywoodland* and give it such praise, liken to throwing roses at it, but they are heaving meat cleavers at this ingenious intellectual intelligent psychological mystery thriller. And, both films are fictional stories set in the 40's and 50's about factual accounts.

People want to complain about how bad the dialogue is in *The Black Dahlia*, not realizing how *realistic* it is for the time period, but they hail *Hollywoodland* as a masterpiece of cinema, when its dialogue *is* atrocious, and so fake for the period it's supposed to be representing. Such a generic film! But, that's, unfortunately, what people want in this day and age of fast food, video game living. They don't want to have to think, my God, that would just be too hard on them, especially when they can laugh at the latest Adam Sandler vehicle wasting every brain cell they have, but not having to question what they are seeing. To me, that's very scary, for I believe people should question *everything* they see, be it a film, a TV show, or (especially) the news.

Brian De Palma doesn't make films for critics or idiots, so that's why so many people are attacking him, because they're *idiots*!! Don't get me wrong, I believe that everyone is entitled to their own opinion, but some of the reasons I've read for not liking this film are just retarded (no offense)!

Saying that it hardly deals with the Dahlia, saying the acting and/or dialogue is atrocious, and calling De Palma a hack?!?

This is not supposed to be a true account of the black dahlia, but a *fictional* one! And, it's not 40, but only 20 minutes into the film that the body of the Dahlia is discovered. And, as for the reason of doing it the way it was done, showing it as a back drop, was showing that there was *always* something corrupt and/or evil lurking in the background, and/or underneath the surface. (That last part is for a reviewer that complained that there was even an 'earthquake' sequence. Hello! There are earthquakes in L.A. everyday!) Plus, the earthquake was used to distract from Blanchard seeing Madeline Linscott's name inside the matchbook Bucky had tossed him, a scene that proves crucial in a later flash back. And, as for the dialogue, well, this is how people talked in the 40's; especially in the movies.

Every frame of this film is dripped in such beautiful film noir, that it makes the viewer feel as if they are in the 40's, or at least watching a film from that era. And, the reason for the 'over-the-top' acting, as it's been written, is for the same reason, to capture what is was really like in L.A. in the 1940's.

And, of coarse, there's the complaint about Aaron Eckhart overacting...well, didn't anyone hear that he was hyped up on Benzedrine (the character, not the actor), which would have that effect? And, it's *all* about the dahlia once her body is discovered, unlike some idiotic reviews would have you believe, just not in the way that falls under 'conventional'. It's

about how the 2 cops become obsessed with the dahlia and solving the case, putting other cases aside, like Raymond "Junior" Nash, a child molester and murderer, and Bobby Dewitt (whose initials are cut into Kay's back, B.D. -maybe a visual reference to Brian De Palma?) a lowlife bank robber and pimp that Blanchard had put away, but will soon be getting released, and Blanchard can't risk Dewitt being on the loose.

In the meantime, Bucky becomes obsessed with Madeline Linscott, a dahlia-type wanna be, femme fatale. (One of the many great lines in the movie come from her: "Oh, what's your name?" she asks Bucky. "Bucky," he replies. "Bucky? I'll try to remember," she responds in a terrific salute to Hepburn and Bacall. It's all in the facial expression as she speaks, full of sarcasm.)

Everyone in this film is dynamite, whether it be in some of the lead roles by Josh Hartnett, Aaron Eckhart, Scarlett Johansson, Hillary Swank, or Mia Kirschner; or some of the minor roles played by Kevin Dunn, Gregg Henry, and (last but NOT least) the always great William Finley. And as for the criticism of Fiona Shaw, well, shame on you all, for she brings down the house with her brilliant performance of Ramona Linscott!! Her performance is equal to that of Bette Davis in *Whatever Happened To Baby Jane?*. Kudos to you Fiona for that awesome homage!

Then there's the brilliant way the 'screen test' films are shot and incorporated into the film to serve as both character and plot development is reason

enough to praise this film *and* De Palma! And, it was too cool that Brian dubbed his own voice as the director of the 'screen test' films! (Where is a Pauline Kael in this day and age, because we really need one?!) This is a solid homerun for De Palma, and an obvious 'postcard' to all of his fans. This is an explosive descent into Hell, as described by the director, not some 'lightweight' *L.A. Confidential.*

And, the gore is very minimal (surprising since it's such a sinister story), unlike an idiotic gross-out episode of *CSI*, or some gorefest like *Saw* or *Hostel*, which is probably what a lot of viewers were expecting. And, as for the mystery within a mystery within a mystery, kudos to you Brian for pulling off such a difficult, exciting project. This is the kind of movie that only true fans of good psychological, suspense, mystery thrillers can enjoy; people who like to think as they're watching the film, enjoy being challenged by all the twists and turns, and not have to have everything spelled out for them, like some low-rate episode of *Murder, She Wrote.* (You know, dumbed down and spelled out in a simplistic A, B, C's kind of way.) If you want to see a film that is mesmerizing in every scene, and something that you'll want to view multiple times, then *The Black Dahlia* is for you.

A great, stylish, sinister movie that will haunt you for sometime after each viewing. De Palma employs such great techniques as dual/split optics, split screen, split diameter, as well as other great techniques that most filmmakers today either don't know how to use, or are just flat out too lazy to use.

It's really scary to me that people enjoy some video game looking CGI stuffed piece of crap over *any* film by De Palma and/or Kubrick and/or any other director that knows how to make stunning visual art, relying on just good ole fashioned acting and a good story to tell the tale, coupled with knowing how to make great use of the lost art of visual storytelling, which this film has plenty of in abundance.

For all you other people who need a "popcorn" candy style film that simplifies and/or dumbs down everything in the plot just to please the masses, then pass on this one, but leave the reviews up to people who enjoy the art of filmmaking, and appreciate a great film with a great story when they see one. And quit picking on De Palma for giving us such films to treasure!

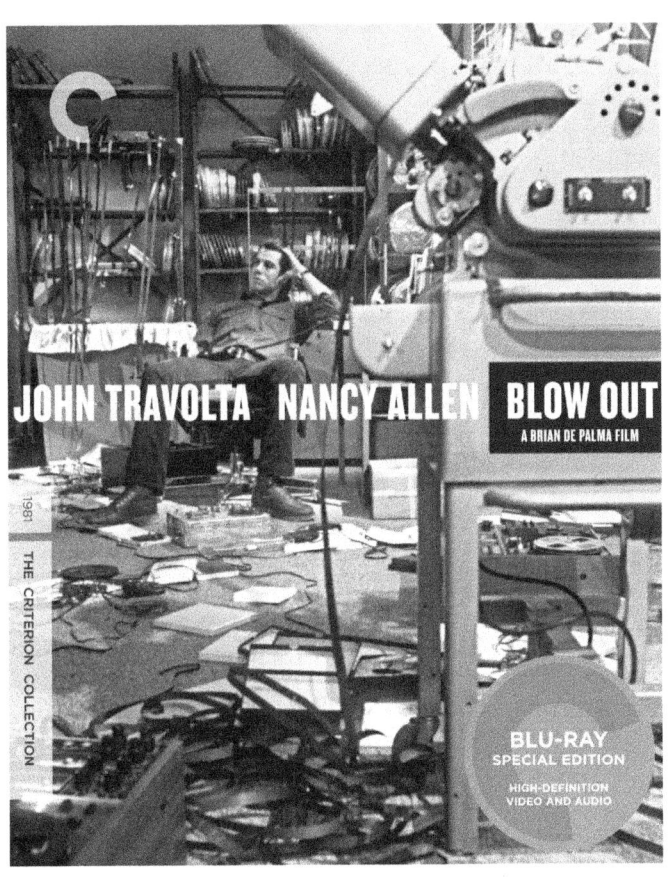

De Palma's Explosive Psychological Conspiracy Thriller Will Blow You Away! This review is from: *Blow Out* (Criterion Collection) (DVD)

Just like in 1980, when Brian De Palma, Master Of The Macabre, invited you to see the latest showing in fashion...in murder with *Dressed To Kill*, in 1981 he invited you to listen to the sound of murder, conspiracy, paranoia, mistaken identity, a psychotic serial killer, and political corruption...in *Blow Out*, written and directed by De Palma, and produced by George Litto.

Starting the film out with a B-grade slasher flick, brilliantly satirizing the heavily trafficked god-awful sleazy marketing of a school bus full of gonzo slasher films, De Palma establishes from the outset that all is not as it appears to be (plus, he shows just how easy he could just as well do a cheap-ass slasher flick if he so chose, but would rather expose them for the low-brow form of film that they are).

De Palma makes great use of *many* of his brilliant techniques in this, ranging from split screen, split diopter, to spinning and whirling, crane tracking shots, to slow motion, making everything work to his advantage.

The story is quite a mix of *Blow Up* (but, where in *Blow Up*, Antonioni's themes were how things lost meaning and/or relevance once out of context, De Palma shows just how important each and every little piece of a puzzle is important, whether in/out of context or not), *The Conversation* (where as

Coppola had a character 'think' he heard the sound of a murder, De Palma lets you know his character *did* hear the sound of a murder), *Vertigo* (the hero has an incident from the past that is 'crippling' to him now, plus the whole 'saving the lady' theme), and the real life Chappaquiddick Incident (but, here we are shown that it *was* a cover up!). Showing (and exposing) just how corrupt and manipulating the film industry, the media, and politics are, this film will leave you utterly breathless, and cold, and in utter bewilderment to see how a Human life can be condensed to nothing more than a mere scream in a low budget horror film.

De Palma discovered/rediscovered a *lot* of talent during his tenure as director, and is continuing to do so. The list reads like a novel of who's who. He's been a diving board for a lot of careers!

Ironically, De Palma started Travolta's film career with *Carrie*, and 'killed' his career with this film, which features his best performance ever.

As for Nancy Allen's character, Sally, I'll admit that I didn't 'get' her, and/or really enjoy her in this until just a few years ago; and, when I did, I have loved her performance ever since, maybe over anything else she's ever done. It's her simply playing a Jersey girl, like Marissa Tomei, Debi Mazar, et al.

She's supposed to come across a bit ditzy and 'disconnected' on the surface, but underneath, she is highly intelligent, has a heart of gold, and is tough as nails when push comes to shove; and is a very 'inconvenient woman', as in she is in the way and

needs to be 'erased'. One of my fav scenes is with her and Jack, and she asks if he wants her to fix something to eat, like some Corn Flakes.?.? Now, just how 'air-headed' is *that*??? But, then she can turn right around and confront the sleazy Manny like she did!

As a fan of Nancy Allen's, I recommend people check out all four De Palma films she's in (*Carrie, Home Movies, Dressed To Kill, Blow Out*), as well as *Strange Invaders, Poltergeist III*, and all 3 *Robocop* films. I *love* Nancy, in my opinion, the *true* 'scream queen' of horror!

To be honest, the more I've watched this over the years, it's the plot at the end that kind of bothers me...Why doesn't Jack just go with her instead of wiring her and waiting behind???

Don't compare De Palma with other De Palma, but with the film(s) that get released at the same period as his, and/or competing with his. I say that because I love every film the man has made, each one in a different unique way, for, in my opinion, I have yet to see one that just didn't floor me, and/or impress the hell out of me.

This is considered by many to be De Palma's finest hour. Fortunately, a lot of important people have discovered this masterpiece over the years, but it is a shame that it didn't get the right amount of acclaim upon its initial release.

And as for the Criterion release: The transfer is magnificent! And the bonus interviews are definitely worthwhile viewing, and the inclusion of De Palma's early film *Murder A La Mod* (even though I already have that on a separate DVD) makes this a *must have* for that film alone!

HIGHLY recommended!!

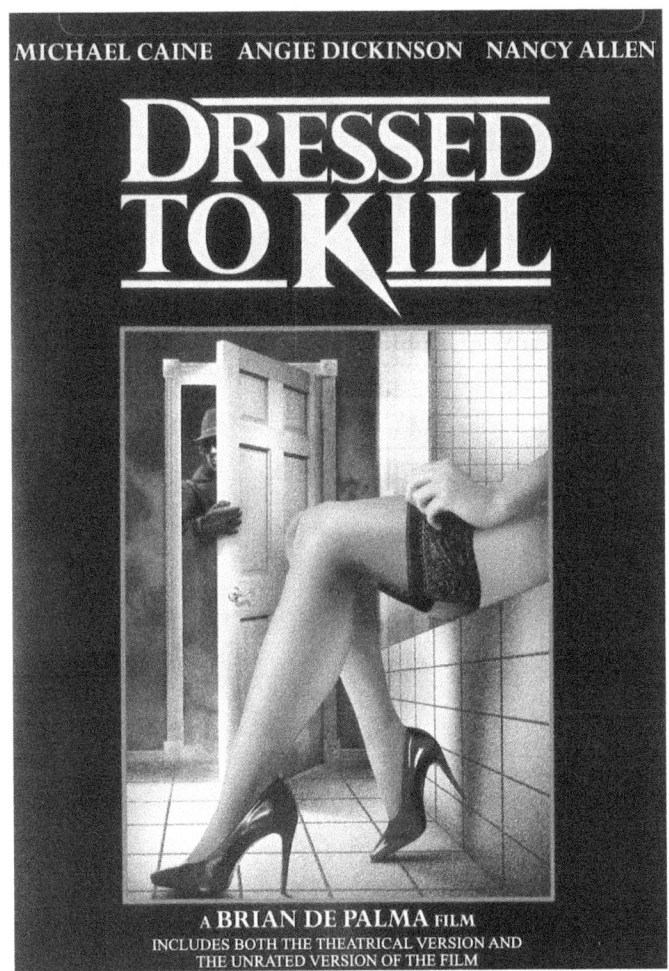

De Palma Invites You To The Latest Fashion...In Murder!
This review is from *Dressed To Kill* (DVD)

1980 was a very good year for some groundbreaking films in different genres that completely reshaped and redefined the genre they represented, ranging from Stanley Kubrick's haunting psychological ghost story horror film *The Shining* to Brian De Palma's erotic psychological mystery thriller *Dressed To Kill*.

Written and directed by De Palma, this chiller did for elevators what Hitchcock's *Psycho* did for showers two generations before it, and still has people squeamish of elevators; and for good reason. This is a darkly satiric film about voyeurism, paranoia, erotica, sexual perversion, sexual deviancy, sexual identity, psychological fear, sexual escapades, and murder, which tells a story of a sexually frustrated housewife who is only trying to find sexual satisfaction and has a one night stand, then gets sliced the fuck up in an elevator by a transsexual with a sexual identity crisis, starring Angie Dickinson, Nancy Allen, Michael Caine, and Dennis Franz.

The film starts with, not one, but two back-to-back erotic sex scenes, the first as the film opens and Kate Miller (Dickinson) is in the shower, soaping herself in a very erotic way as her husband is shaving right outside the shower curtain, when a strange man appears and proceeds to rape her from behind, only for her to awaken in bed while having sex with her husband. De Palma bookends the film

with dream sequences, beginning the film with Angie Dickinson, and the last one with Nancy Allen's character Liz Blake, in the shower, and they're both very erotic yet suspenseful scenes in one sense or another.

Produced by De Palma's friend, George Litto, who had produced *Obsession*, and *Blow Out* after this one, this is an excursion into psychological erotic madness that is as grotesque, gory, twisted, perverted, demented, deranged, horrifying, spellbinding, sensual, elegant, thrilling, bloody, and scary as anything anyone that likes this genre of film would ever want in a film. De Palma uses pretty much all of his trademark techniques here, split-screen, split dioptor, great tracking shots, crane shots, etc, to tell an awesome story that excels in some of the best scenes of visual storytelling ever committed to film.

This is the film that got women's groups calling De Palma 'misogynistic', saying he was too violent towards women in his films all because he filmed one woman (maybe two?) getting murdered in a very classy manner, yet there were all of these cheesy slasher flicks having women running around as naked as the day they were born, making them act like airhead bimbos, getting cut all up like spaghetti, but that seemed to be OK; but they wanted to pick on De Palma for this classic masterpiece??? Huh? Really?

This was also the first film that De Palma had to duke it out with the MPAA over ratings (they wanted to give it an X), so he cut it into an R-rated

version (which I, personally prefer), but the DVD features both, the R and the Unrated (X) versions of the film. And, this is loaded with a lot of great special bonus features!
HIGHLY recommended!

PS: A bit of film trivia: De Palma used a 'body double' for Angie Dickinson's nude shower scene, which in turn inspired his 1984 classic *Body Double*, which was his cinematic 'answer' to critics who wanted to bash him, reproaching his decision for using a body double in this film.

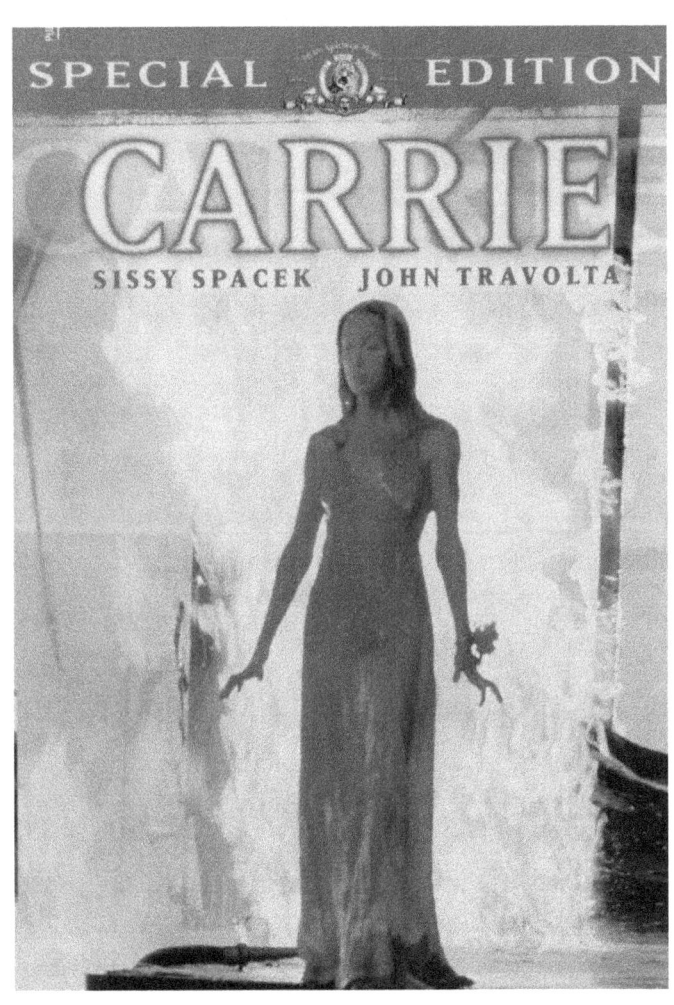

De Palma's Deranged Prom Date!
This review is from: *Carrie* (Special Edition) (DVD)

Brian De Palma is my favorite director because he is one of the rare filmmakers still making films like they are supposed to be made, and not like these god awful bad CGI infested video game looking pieces of garbage coming out lately. Seriously, what the hell is happening to cinema today?! It is very rare that a movie actually looks like a film anymore! It's amazing how a movie made in 1976 can look just as great, if not better, today than it did when it came out, and that is the case with "Carrie".

Right on the heels of *Obsession* (1975), De Palma directed the film adaptation of Stephen King's first novel, *Carrie* (1976), the story of the girl with telekinetic powers who is the underdog in her high school, and has a very horrific date to the prom that goes horribly awry. Produced by Paul Monash and scripted by Lawrence D. Cohen. Working on a very modest (meaning low) budget, De Palma created a satiric scary masterpiece!

Yes, "satiric", because it is really a satire with lots of dark humor permeating throughout it.

Well, to begin with, it's neat, knowing how De Palma works, loving to tell stories in complicated ways, using flashbacks, weaving back and forth, and nonlinear fashion, that he would choose to use a very straight forward approach with this film, when the source novel itself was written in a back and forth, nonlinear fashion, with lots of flashbacks.

The film opens with an awesome crane tracking shot showing high school girls outside playing volleyball, and the camera slowly moving in on one particular girl.

Starring Sissy Spacek (in an Oscar nominated role), Piper Laurie (who De Palma got to come out of retirement for this role, and she was nominated for an Oscar, too, for her performance in this), Nancy Allen, John Travolta (in his first film), Amy Irving, P.J. Soles, Edie McClure, William Katt, Priscilla Pointer (Amy Irving's real-life mom) and Betty Buckley, the cast reads like a "Who's-who" of now established Hollywood big name stars, most of which made their debuts in this film.

De Palma's pacing during the long drawn out prom set piece is awesome! The way he puts Tommy and Carrie in a spinning cycle dancing to symbolize the exuberance of how Carrie is feeling will leave you breathless (with an awesome score by Pino Donaggio throughout the entire film), and his use of split screen during Carrie's revenge sequence is utterly amazing! The prom sequence has gone down in movie history as one of the greatest scenes ever in horror film and/or drama (and/or satire), for this film is all three genres. And this film contains scenes that rival anything ever done in horror!!

But in my opinion, the best part of the film is the scene at the end of the film in which Sue Snell wakes up from a nightmare all frantic and screaming, with her mom consoling her, and Sue is continuously screaming as the camera starts backing away, up toward the ceiling, as mother tries to

console daughter, in another great crane tracking shot, completely reversing itself from the opening shot at the beginning of the film, the backward crane shot mirroring the opening crane shot.

One of the (if not the) best psychological, telekinetic, sinister, horrifying, satiric tragedies ever filmed.

HIGHLY recommended!

Not Alone…In Thinking *Gothika* Is Godawful!
This review is from: *Gothika*
(Widescreen Edition) (Snap Case) (DVD)

I just watched this movie again after not seeing it since I bought it used a few years ago. Talk about one hell of a mess! I was cringing through this, and for all the wrong reasons. And after about an hour into it, I lost count of how many times it started over-using deux es machina, throwing everything but the kitchen sink at the screen hoping something would stick, and nothing does! Wow, what a waste of film, and a waste of my time!

Director Mathieu Kassovitz does an amiable job of creating atmosphere early on, but it is quickly all wasted by an atrocious screenplay by Sebastian Gutierrez. Plus, I wasn't that impressed with Halle Berry's "generic" acting either. Yes, she's good, but not as great as a lot of people want to let on. On the other hand, poor Penelope Cruz, who is a great actress, is completely wasted here! I kept saying to myself that it would be a better film if it were more about her, but to my heavy disappointment, she is only in a few little scenes; matter of fact, you can count them on one hand. What a shame!

And while I've never been a huge fan of Robert Downey Jr., he does some good acting in some things, and even does a good job here, but it is all in vain, for his talents are also wasted here as well; as are the talents of John Carroll Lynch, and practically everybody else that is in this.

You know a movie is bad when at the one hour mark, the lead character screams out at the ghost, "What do you want from me?!", and you start laughing and thinking "I just want this movie to *end*!" The word "convoluted" doesn't even begin to describe this film! It might have been better if they had stuck to either making a straight-forward ghost story, or a straight-forward psychological mystery thriller, but this film tries (too hard) to make all of the above, and fails miserably. It started out as a three, to four, star movie, but I quickly started reducing stars as it went along, and by the end it was barely even worth rating one star.
I recommend skipping this one!

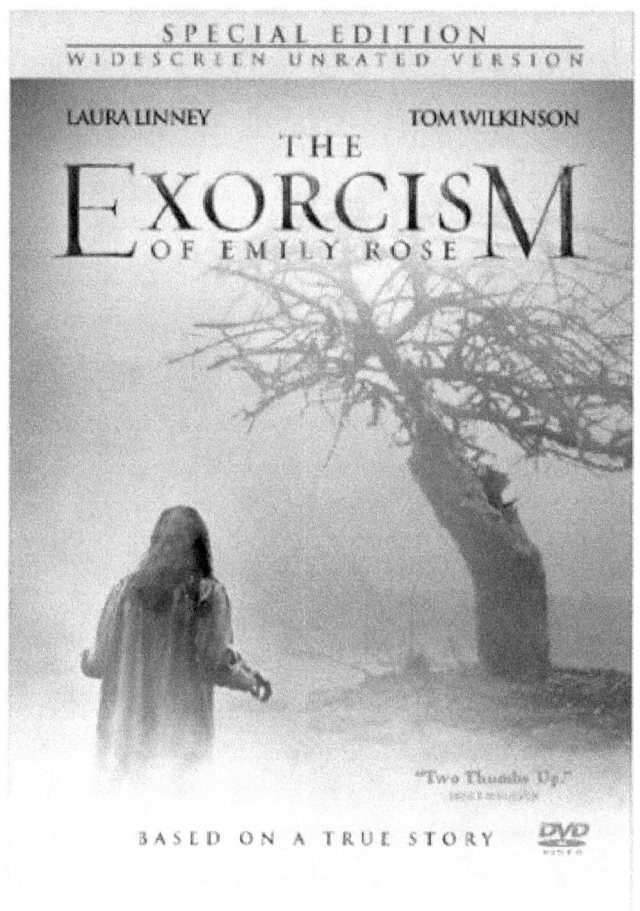

I Need An Exorcism To Erase This From My Mind...
This review is from:
The Exorcism of Emily Rose (DVD)

The first time I saw this about five or six years ago, I really liked it a lot (I think I was high?). However, upon recently viewing it again about a few months ago, I noticed all of its flaws. The performance by Laura Linney is pathetic! She's so much better in a similar role (as an attorney) in *Primal Fear*. And, the courtroom scenes played out like a TV movie, a Lifetime movie at that. And the dialogue was a joke! Laura Linney's character was reduced to simply saying "I object" every other second, with no *real* legal argument behind it, and the Judge would always agree with her.?.!

It was so painful for anyone even remotely interested in legal thrillers to have to watch. There was not enough 'exorcism' footage shown to excite anyone, and the greatest scene in the film (in the barn) was way too brief. There were way too many loose ends left dangling, and things like the 3:00 A.M. phenomenon were never explained. Plus, it's never made clear as to whether Emily was really possessed or just an over imaginative anorexic teen whose religious fervor drove her to believe she was possessed. Oh, and the whole "Mother Mary" shit at the end was just crap! Even if she was possessed, she might have had visions of Christ or the Devil, but not the dead Mary! Only Catholics (if you're Catholic, I mean no offense) believe that Mary was a Holy Figure, so that's another reason that scene was *so* wrong for this film.

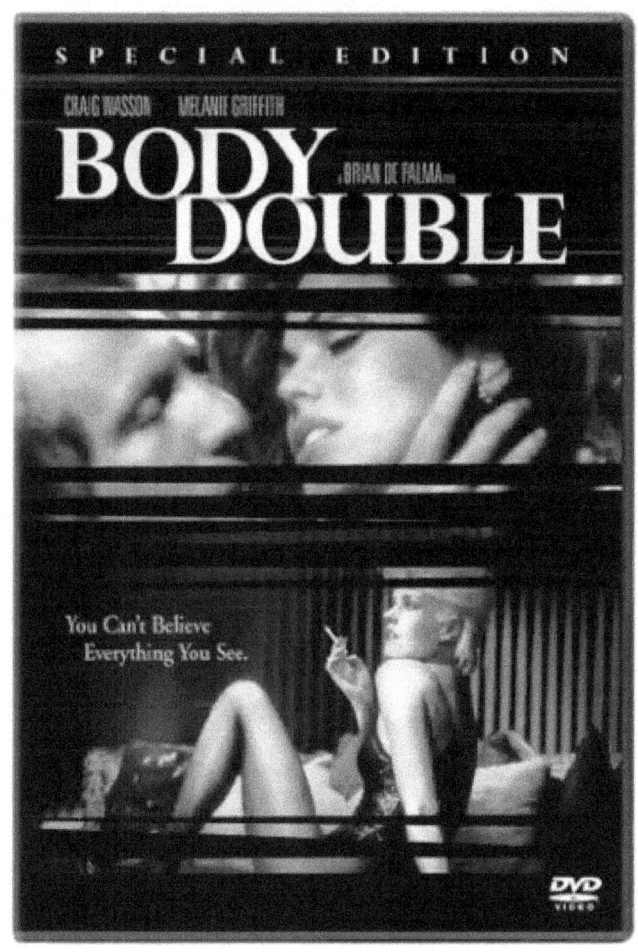

De Palma's Erotic Driller Thriller...
This review is from: *Body Double* (DVD)

As for De Palma, I need to review the entire catalog of his whenever I get the chance, for he helped me realize I see the world the way he does at a very young age when *Carrie* came out. And, by the time I saw this one, I was 'De Palma-crazed'. I love a lot of other filmmakers (especially Hitchcock and Kubrick), but Brian does that special 'something' that appeals to the manic depression in all of us. Plus, I love how he revels in enjoying other people's pleasures, perversions, fears, and desires.

With his unique visual style, and his ability to grab you from the very beginning, make Brian De Palma films 'dangerous yet seductive worlds', and I am glad to say that De Palma once again did not disappoint, and that he successfully delivered a very broad range of emotions that he takes viewers on in this film.

I saw this when it came out, and I still remember it blowing the top of my head off! I have loved this film even more every time I view it (which is *very* often) over the years. I almost knew from the beginning where the story would take me but it did not stop me from enjoying the film and admiring De Palma's ability to trick me by making me see what he only wanted me to see, yet never hiding the whole picture.

What a gruesome, poignant, satirical, often hilarious, and always remarkable movie it is. It is certainly De Palma's loving homage to his favorite

Hitchcock, and not just to one but several of his movies. It is a sharp satire on Hollywood, of course, but first of all, it is the story told masterfully by the Master of Suspense, making daring use of his unique and fascinating visual style. It is a great sordid-noir film and is quite creepy at times, as well darkly hilarious, for it is a satire as well as a thriller. Be sure to watch for the scene that is a running parody of bad porno film trailers, and the 'glowing' reviews from critics! Hilarious and brilliant!

While filming *Dressed To Kill* in 1979, Brian De Palma was first inspired to make this film. The notorious shower scene with Angie Dickinson (in full a la-nude), a 'body double' was brought in to stand in whenever it was showing Angie Dickinson from the neck down, nude. Great way to immediately throw you off balance as a viewer, symbolizing right away, don't trust what you are watching, for like a magician, at some point in this story he's going to surprise you by making you believe you saw one thing but not another, while showing the viewer what they are seeing the entire time right before your very eyes! Vavoom!

Of coarse this has rings and tones of *Rear Window* and *Vertigo* all through it (as well as a few other great Hitchcock thrillers, like *Shadow Of A Doubt, Dial M For Murder*, and *Marnie*, which the latter featured Melanie Griffith's mom, Tippi Hedren), what better films to pay homage to?!

It also has flourishes of the French, Italian, and European filmmakers that have inspired De Palma throughout as well. It has the perfect combination a

psychological erotic thriller is supposed to have, all the right ingredients, from erotic fervor to dark sinister terror, from insane biting satire to leaving you breathless in despair. It's a Brian De Palma Showing...An event to celebrate....A classic work of film art.

Anyways, he shelved the idea, working and writing on it between his next two classics, *Blow Out* (1981) and *Scarface* (1983).

So, in 1984, Brian De Palma returned to the genre that only he does best: The erotic/psychological/suspense/mystery/thriller/satire . He fleshed out (no pun intended) a story only he could tell (he was initially just going to produce it, but thank god he decided to direct it as well!).

He throws the viewer off guard right away by starting the film making viewers believe they are about to see a good late night B-grade vampire flick, then immediately shows that it's only a movie starring the main character of De Palma's film. Then, as the title of the film comes on screen, with an awesome desert background that is suddenly pulled away, revealing that it (the background) is just a matte painting for some movie backdrop. Right away, like The Magician, De Palma is revealing to not trust what you are about to see for the next two hours, even though it will be done right before your very eyes. The tagline was perfect for this film: "Don't believe everything you see".

Jake Scully, our main character (played to perfection by Craig Wasson) is a claustrophobic,

soon-to-be-out-of-work actor, who goes home after a bad day's shoot just to find his girlfriend in bed with someone else! And, if wonders never cease, the apartment is hers, so he goes packing.

From staying with a friend, a local bartender, then moving through treacherous auditions (when he already "is working now, and that's what matters, isn't it?"), to have the skies depart when he befriends a chap between acting auditions and acting class, which plays out like Acting 101, with a 'psychiatric' acting teacher whose methods just may or may not be helpful or harmful, which one???!

A very crucial scene there where Jake is told "You must act!", De Palma's way or reminding his audience that they must 'live', not just be a couch potato watching life go by, participate, act! And, then things get even better for Jake (this is his lucky day, let me tell you, ha-ha!), his new friend (played by the great Gregg Henry) is called away for an acting gig out of town, so he needs Jake to housesit the house he's subletting. Using a real house in L.A., it is beautifully built, shaped like a spaceship, and very high in the air, with windows all around it, brilliantly filmed. Awesome!

Then Jake is told and shown that his next door neighbor likes to do an erotic dance every night in front of her window, in full view of Jake and the handy telescope that is set in that sole position, aimed right at her house. And, Jake, being a person of very low self esteem, and just feeling he's back in the 'world', even though it's not a world to brag about. He *is* living in L.A.'s dirty underbelly, getting

only bit parts in low-rate, B-grade (possibly direct to video?) obscure films, but he lets his esteem and obsession for a better life get in the way, seeking solace by watching the lady next door do a very sexy striptease for two nights in a row, and even while she's sleeping (he knows when you're awake, ha-ha) he still likes to peep in on her, thus noticing at some point that someone else is also watching her.

So, in a fanatic, obsessive/compulsive way, he starts to follow Gloria Revelle (played by the beautiful/talented Deborah Shelton), the lady that lives in the house across from his. It is here that De Palma really shines with his technique of 'pure cinema', 'visual storytelling', making use of extremely long takes, and long scenes, with no dialogue, lasting for over 20 minutes.

There then is a seduction that is extremely wondrous and breathtaking. Yes, there is such a thing as love at first sight! Gloria and Jake are similar in several ways. Both are claustrophobic, but in completely separate terms of the word. Both live in a world of fear, dread, depression, despair, loneliness, in a seedy world of decadence, the beautifully filmed L.A. A very sinister, corrupt city if there ever was one, especially in the movie business, and/or the life of 'The Idle Rich'.

Jake then is plunged in to a world of hapless terror while he witnesses a murder, but is 'paralyzed', and can't 'act' to save the victim. He tries, lord knows he tries!

A brief appearance by the great Guy Boyd as a very 'noirish', been-there-seen-that-world-weary-wise-guy detective, who really drills (again, no pun intended) Scully like the victim got drilled to death.

Cut to Jake in a spinning bed, watching late night porno ads, and a very particular one catches his eye, *Holly Does Hollywood*. He calls, gets an audition for the next *Holly* flick, reads for the director, gets the job.?.?. What is Jake so suddenly obsessed with now? *Who* is Jake suddenly obsessed with now? Porno actress Holly Body (played by Melanie Griffith in her *best* role *ever*), a naive (?), blue-eyed, bleach blonde, brain dead bimbo (?); or is she a very intelligent, extremely beautiful, rough and tough (?) femme fatale that Jake shouldn't be getting involved with???!

One of Craig's best scenes as Jake are during this period, especially in the porn flick, when he walks into the bathroom, saying "Ok" with such a stilted slur, *just* like real porno. *Very bad* dialogue! Or, dialogue done *very badly*!

Frankie Goes To Hollywood deliver a tour-de-force performance in this crucial point of the film (as great as The Yardbirds in Antonioni's *Blow Up*!) remaining as fresh today as it did then.

Eventually the mystery is solved, super dog kills the bad man, and we have The End! But, not so easy as all that. This is a very deep, disturbing, hypnotic, visceral, cerebral look inside the Human mind, and the wicked world of Hollywood. The sleazy-ness of it all. And, the blood and gore behind the scenes.

And, Jake must learn to (literally) 'act'.

The way De Palma catches 'claustrophobia' visually is utterly breathtaking, and *so* realistic. The journey into Jake's mind is a cinema sweep of pure genius! And, all over a body double.

This is a film that will play you like a fool, but treat like its best friend at the same time. De Palma, of coarse, had to take on the MPAA in defense of the rating of this film. Plus, he originally wanted to cast a real life porno actress as Holly Body, but the studios shot him down on that one, but in his favor really, because this was the role Melanie Griffith was born to play! He first fought them over ratings in 1980 over *Dressed To Kill*, then in 1983 over *Scarface*, winning all three times. This is also the film which helped concrete him as 'misogynistic', something he got labeled by extremist women's groups when he made *Dressed To Kill* (something that baffles me even to this day, because here were all these sleazy low-rate B-grade horror films that De Palma was mocking with the book-ends of this film, nude females running around like brain dead bimbo's, but everybody loved those, but De Palma films a woman nude with style and class, or a woman murdered -count ONE woman- and he gets attacked for being too violent toward women in his films.?.?.?.) Do what????!

This is a very classy, stylish, almost noirish, psychological, sinister look into the whole seedy Hollywood world, warts and all, from the glitz to the 'sluts'. And, he did it with guts! True masterpiece from the Master of Horror that remains

as timeless as when it was released. Highly recommended!

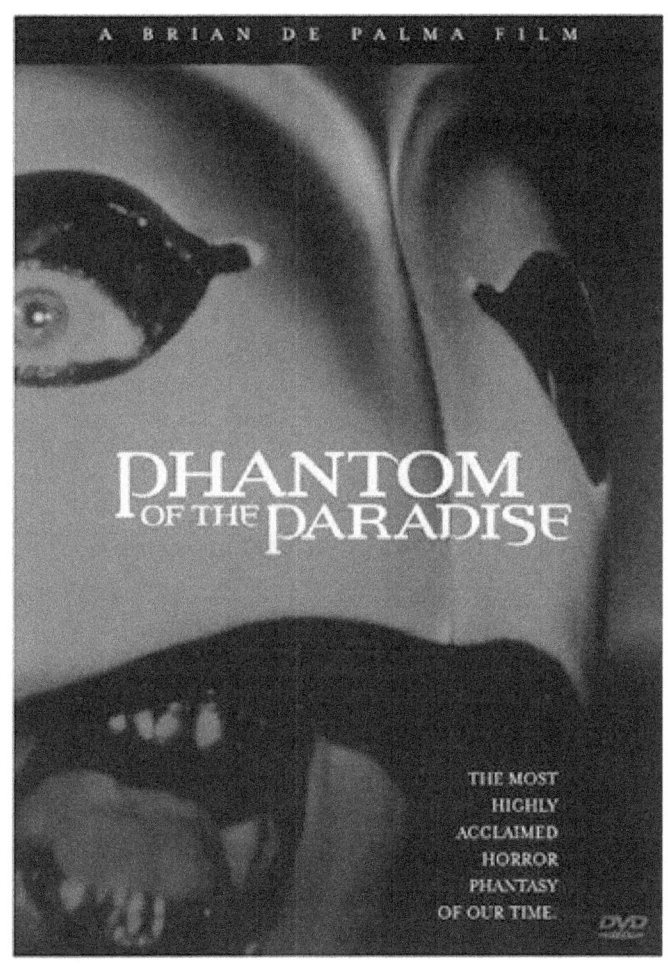

De Palma's Rock N Roll Phantasy...
This review is from: *Phantom of the Paradise* (DVD)

I first saw this about 20 years ago, and had it recorded on VHS, and I about wore the tape out. I, luckily, found it on DVD about 12 years ago, and I love to just let it play over and over as I work around the house, for its soundtrack (and the dialogue) make for one of the best 'albums' I've ever heard. I could watch it over and over as well.

Great rock music, radical range of emotions (one minute you'll be laughing your ass off, the next wiping away tears, saying 'Oh, no, I'm not crying, that's sweat from my brow'), to being terrified, back to laughing, et al...meanwhile, rocking the entire time! And, it is not a musical, just has a lot of musical performances in it by a lot of different fictional artists. And, De Palma's techniques in this are just jaw-dropping awe-inspiring!

In 1974, after the release of *Sisters*, De Palma wrote and directed his second 'mainstream' film, produced by Edward R. Pressman (the producer of *Sisters*), with songs written by Paul Williams, making this one of the greatest collaborations in film musical history. But, this isn't a musical in the generic conventional sense of the word. Nor is it just a satire, nor just horror, nor just parody, but all of the above. Good psychological sinister fun!

Fusing *Phantom Of The Opera* with "Faust" and *The Picture Of Dorian Gray,* music of the period, and countless other great horror film references, De

Palma created a classic masterpiece of cinema that not only is still considered a classic today, but is celebrated every year at 'Phantompalooza' (where the film is performed live, and usually featuring a few of the cast members from the film), to it now (unfortunately) being in line for a remake for a newer generation (Yeah, make a new one for Baby Cakes, because he didn't understand the original).

Starring William Finley (*Murder A La Mod, Sisters, The Fury, The Black Dahlia*), Paul Williams, George Memmoli, Gerrit Graham (*Greetings Hi, Mom!,* and *Home Movies*), and introducing Jessica Harper (who went on to star in cult classics like *Suspiria* and *Shock Treatment*), De Palma tells a story so sad, so funny, so horrific, so tragic, so demented, so deranged, so twisted, and so awesome like only he can.

The film is about a young unknown songwriter/composer named Winslow Leach (Finley), who just composed a rock cantata of "Faust" (about a guy selling his soul to the Devil in turn to be famous - for those that don't know the story of "Faust"). The cantata gets stolen by Swan (Williams), a big name rock producer and owner of the rock club The Paradise Theater. When Winslow tries to retrieve his stolen masterpiece, he is greeted by Swan's thug body guards, mainly Philbin (Memmoli). During this period, Winslow meets Phoenix (Harper), and falls in love with her.

Swan sets Winslow up, he is sent to Sing-Sing prison (yes, Sing-Sing! Oh, the irony! Ha-ha), has his teeth removed because of a dental experiment

financed by Swan, then escapes, breaks into the record company and tries to destroy the new version of his cantata recorded by Swan's 'band', The Beach Bums, an obvious Beach Boys parody band (the film started with them as The Juicy Fruits, a Sha Na Na parody act, and they end up as The Undeads, an obvious Alice Cooper/KISS/glam rock parody), then gets disfigured by a record press, and drops out of sight, reported dead.

Then, like the Phantom of the Opera, Winslow, wearing a black cape and mask, starts 'haunting' The Paradise Theater, hoping to get Swan to get Phoenix to sing his songs instead of The Juicy Fruits.

Swan gets Winslow to sign a contract (here's the *great* irony of Winslow writing a cantata about "Faust"!), and then tricks him by getting The Juicy Fruits, now called The Undeads, with a new 'front' man named Beef (Graham).

Well, from this point on, there are numerous twists and turns, and moments of humor, horror, and tragedy. This film is filled with longing, broken hearts (and body parts), romance, and a "Psycho" shower scene parody to rival Hitchcock's classic. This is a film that should have had the 'midnight madness' celebrations like *Rocky Horror Picture Show*, for it is just as great, if not better. And it was a year ahead of *Rocky Horror*!

The different elements of music fused with the different elements of film make for such a glorious ride that you won't want it to end. It's one of the most highly acclaimed horror/satire/musical

'phantasies' ever, and rightly so! A spectacular celebration of music, film, and music and film as art. And, it also does a great job parodying the whole 'more famous in Death' aspect of the music/entertainment industry.

It also skewers remakes, rehashing, 'borrowing', plagiarizing, and flat out about anything else. The whole way a particular set piece is designed (Swan's desk) to look like a large golden record, and when Swan is 'auditioning' singers from that desk, in a 'smorgasboard' kind of way is just too priceless! The musical performance sequences are so awesome and awe-inspiring that, between this and the dance sequence in *Carrie*, De Palma was offered both, *Grease* and *Saturday Night Fever* to direct, but very wisely turned them down (those were great films, just not his style). This is!

I highly recommend this film to anyone, whether they are fans of De Palma or not, for it is an awesome experience! If you liked *Rocky Horror Picture Show*, you'll love this. Jessica Harper will blow you away with her vocal chops, singing like an angel, well, *just* like a young Karen Carpenter. This is a film for anyone and/or everyone who loves 70's music, and wants to experience the nostalgia of it, from 'beach-rock' to glam-rock', and everything in between. Paul Williams wrote possibly the best songs he's ever composed for this little ditty of cinema.

PS: A bit of film trivia...Sissy Spacek served as Set Decorator, her husband Jack Fisk did Set Design (and worked with De Palma again on *Carrie*), and look for a very brief cameo by William Katt in the audience during Beef's performance with The Undeads.

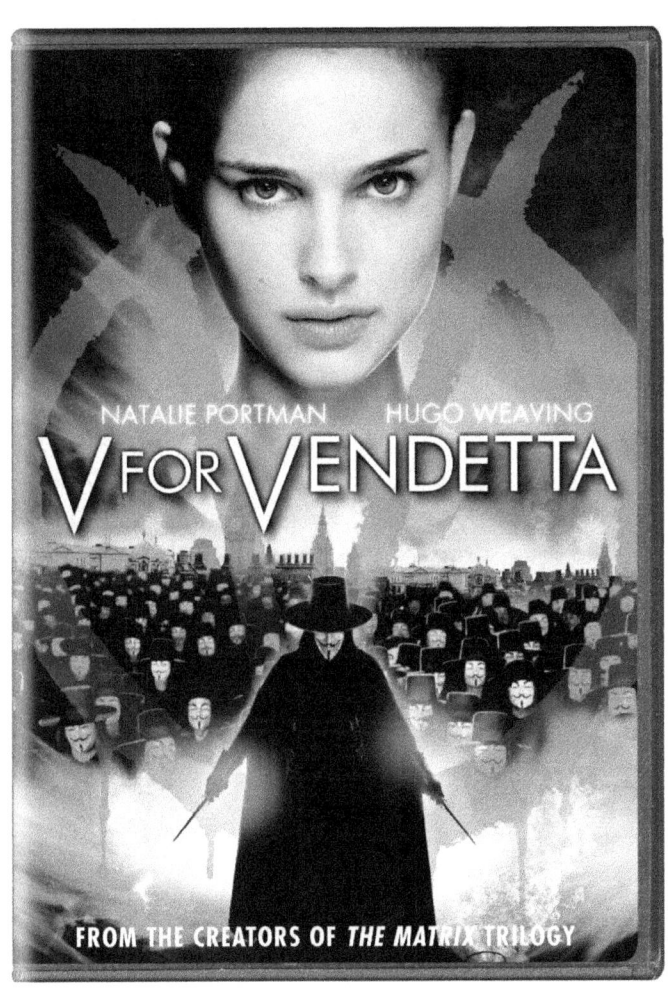

When Things Explode, They Go 'Kapow'!
This review is from: *V For Vendetta* (DVD)

This is without a doubt a modern day masterpiece! And, I really love how it just rips the whole fear fueled by the media/fascist government/terrorism by our own government wide open. It is a great film that deals with the freedoms of speech, thought, and religion being stripped away from us in a fascist community, allowing a government to rule over the people instead of the people ruling the government, as it was intended when the government for the people, by the people was created.

This is the second best film of 2006 (2nd only to De Palma's *The Black Dahlia*). The political statements about "terrorism" and how it can be induced by the very same government that's supposed to protect us is something that mirrors our own society today. Our freedoms are being stripped one by one. This film is about a fascist government that installs fear in its people by acts of terrorism, blaming such acts on 'enemy' foreigners, when the acts were committed by the very same government that's supposed to be protecting the people from such terrorist acts; like our own country!

I highly recommend this film, especially to anyone who knows the *real* reality of our fascist state. It will bring out the 'commie' in most people who oppose our fascist politicians and the ongoing senseless war. This is without a doubt a masterpiece, entertaining and bravely 'open' about our current state of political stance in our 'free' world. And, especially pharmaceutical companies

keeping people drugged (think Hydrocodone, Oxycodone, Oxycotin, something that's ripping across America like wildfire; and, it's legal!) so they will believe all the lies and continue to live in fear really hits close to home. No matter what someone's political party is, be it Democrat, Republican, or Independent, this is a film that's *very* important for *everyone* to see!

People need to wake up before this happens to us! Think about it, racism, homophobia, and anti-independent thought is becoming the norm, and listening to fools and the general masses is something that's promoted as the way to follow.

In a great reference to *Phantom of the Opera*, *1984*, *Logan's Run*, *Brave New World*, *Blade Runner*, *They Live*, *Invasion of the Body Snatchers*, *Metropolis*, and Michael Moore's documentary *Fahrenheit 9/11*, the Wachowski brothers deliver their best film since *Bound*.

We live in a country where at the age of 18, a person is considered an adult, and can vote, and can be called into a stupid war to defend their country, a war that was started by our very own government to serve their own agendas. We started quickly declining into a fascist state when our former president was in charge, leading us with his ignorance, cockiness, and overwhelming stupidity. We as a nation need to wake up and bond together and say "Stop!" before it's too late. And, it's definitely time to stop all of the hate crimes!

This is an important and entertaining movie that

you'll want to view over and over. It's political and romantic, and very intelligent. Oh, and, the British humor thrown in midway through via a television show is pure genius! Very well written, brilliantly directed, and intensely acted by a topnotch cast! It is definitely one you will want to own so you can view it over and over, like a favorite album.

Scorcese Strikes Back!
This review is from: *The Departed*
(Widescreen Edition) (DVD)

When the TV ads for this film first popped up, I was telling friends that this was the first Scorcese film in *years* that I was actually excited about seeing, and it was the same time as a De Palma film as well. But, since Brian and his film (*The Black Dahlia*) took such a beating for god knows what reasons unknown to any intelligent person, I took a 'political' stance and trashed Scorcese and his film, because I have felt for the past 12 years that Martin Scorcese is the most over-hyped, over-praised, overrated director in the industry; with people throwing roses at his films, while in the meantime they hate my favorite director Brian De Palma, and want to heave meat cleavers at his classic films. But I do love *The Departed* a lot more than I ever thought that I would.

Yes, Martin Scorcese is the most overrated, overly hyped, highly praised director living today. And, for what? Well, I'll tell you: It's for his latest film, *The Departed*! He did once make some really great films, like *Mean Streets*, *Alice Doesn't Live Here Anymore*, *Taxi Driver*, *The Color of Money*, *Raging Bull*, *The Last Waltz*, and *Goodfellas*. But, that's been over 15 years ago. *Casino* was pretty good, but it was just an attempt at remaking *Goodfellas*. And, films like *Gangs of New York*, *Bringing Out the Dead*, and *The Aviator* just didn't strike my fancy. His remake of *Cape Fear* was good, but nowhere near as great as he used to be.

But, lo and behold, Marty has remade another film, *Infernal Affairs*, and made himself a new classic that he deserved every accolade thrown his way for. He definitely deserved the Best Director award at the Academy Awards for this. For all of you people who praise Scorcese like he's God, well, I have to say you're right on this one. This is an extremely deep and profound and intense fast paced masterpiece of modern cinema that will leave you utterly breathless in practically every scene. And, it is rich with irony! Especially the plot of having, not one, but two moles, each one on a different side than the other.

Scorcese is on fire here, making quick cuts left and right, entering scenes through a circle point of view, cutting back and forth between scenes and characters, past and present, and using an extremely terrific soundtrack to boost the film along like a freight train to Hell. This kicks people like Tarantino back into kindergarten!! This is possibly the best crime thriller genre film that I've seen in years.

Brilliant storytelling at its best! I just didn't like that a certain character got killed in the end that should have lived, but that's not going to taint my judgement of this great film. Everybody in the film is perfect for their roles, and their performances all shine through. This isn't near as gory as a lot of people make it out to be. It is violent, but no more so than any of Coppolla's *Godfather* films, and even less so than Scorcese's own *Goodfellas*. Marty really out did himself with this one. Highly recommended!

De Palma's Dream Within A Dream...
This review is from: *Femme Fatale* (DVD)

I have had people ask me if maybe my reviews are tainted by my love for De Palma. I mean, even the best directors in the world don't knock out 5-star material every go around. Brian does! That's why I love him so much. Matter of fact, some of his films, like this one, are more of a 10 star rating, but he always at least gets a 5 star. But, it's all a matter of opinion. But, I've never been let down by him in over 30 years of viewing films. That's why he's my favorite. He's one of the *best*!

De Palma is *the* director that made me see films in a completely different way when I was a teenager. His films are a reflection of how I view life at times. With De Palma, one can never go wrong by watching his films! He loves to make films that challenge his viewers, and that his fans will love. He loathes most (if not all) critics, so he doesn't make films for them, but for his audience -his fans. He makes films with a certain style sometimes (like *Raising Cain*) borrowing not only from Hitchcock and/or his other great (French/Italian) inspirational filmmakers, like Antonioni, Godard, Fellini, Lelouch, but also borrowing from himself *on purpose* just to piss critics off.

De Palma has a style all his own, no doubt, especially when he writes and directs a film; and this one has that in spades. It's flourished with brilliance and stunning beauty throughout the entire film. Superb in every aspect of the word, this is a surreal experience one has to see to believe, and

then see again.

Rebecca Romijn-Stamos gives a top-notch 'Grace Kelly' performance as Laure, a bad girl, rotten to the heart, who is involved in a jewelry heist at Cannes, then an identity switch and personal intrigue. She is also Lily, a woman who has lost her husband and child in an accident, and is suicidal with grief. Also in the film is Gregg Henry, who has worked with De Palma in *Scarface*, *Body Double*, and recently in *The Black Dahlia*; and Peter Coyote as a Politico who Laure/Lily seduces and manipulates into marriage. Antonio Banderas shines as Nicholas Bardos, a photographer, a 'photog', 'paparazi scum', who takes a crucial photograph, maybe just one photo too many.?.?. He gets swept up in a world of mystery and intrigue that takes him on a journey like a labyrinth maze, full of mystery.

Watch for him during a great scene with him and Laure/Lily in a hotel room, where he convincingly tells her the outcome of her character and the film; but only if you can really grasp what's going on. Plus, there are scads of hilarity in that scene, and scattered throughout the entire film. 'Smart guys' like him, well, we all know what happens to them.?.?.?...

Very exotic and erotic, hypnotizing and spellbinding, romantic and twisted, this is a film that lays all of its clues right in front of you the entire time, making it all the more fun to watch over and over. The scenes with water, even an Evian bottle, are especially fun and brilliant hidden gems. Don't let yourself ever get comfortable, for every

time you think you know where you are in this, De Palma spins you around like a carousel, and puts you in a whole new perspective. Awesome. Very satiric as well.

This is a brilliant masterpiece from a brilliant master filmmaker. Classic in every right, a great throw back to awesome cinema like the films of Hitchcock, Wilder, Welles. Godard, Antonioni, Polanski, and especially Lynch. And a throwback to De Palma's early erotic/political/psychological thrillers like *Dressed To Kill*, *Body Double*, *Blow Out*, and *Raising Cain*. The film opens with a clip from *Double Indemnity* playing as Laure lays watching silently, showing from the outset that you are not only about to see a noirish story, nor just a film about a 'bad girl', but also an out-and-out celebration of the art/craft of filmmaking itself.

David Lynch was going to play himself in the opening of the film as the director screening his film at Cannes, but he fell ill and had to back out, so De Palma got another top name director to do it.

Like a dream within a dream within a dream, so toxic and compelling this is. Ask yourself: Would you change your destiny if you could see the future and had the chance? It's really that simple a plot when it all breaks down.
The end result has split audiences down the middle, but for all you film buffs out there that love resolutions that satisfy the appetite, well, look no further. Get it? Well, read it again...

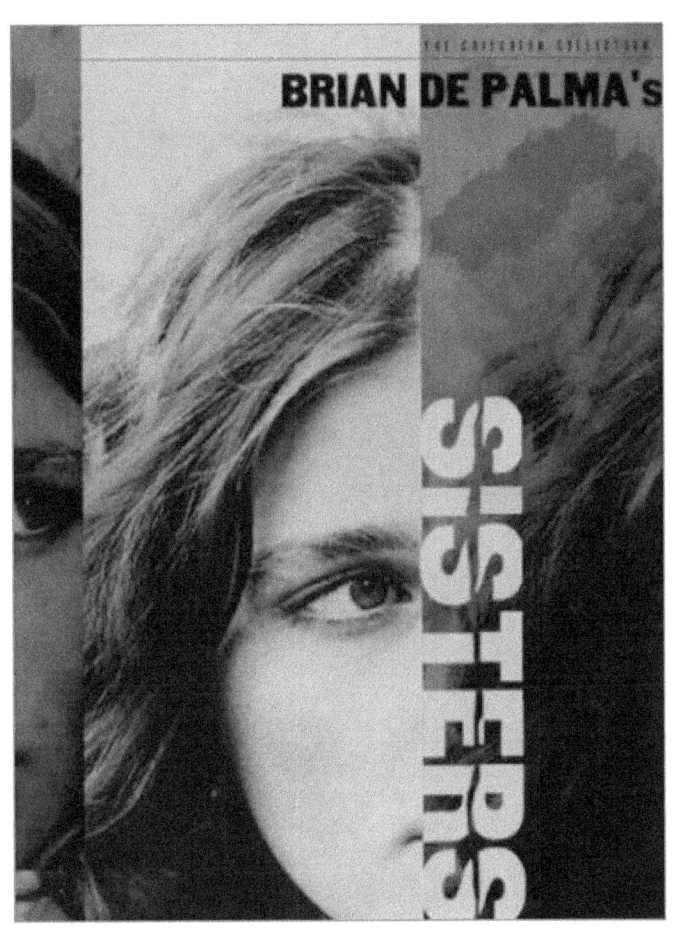

De Palma's Psychotic 'Sister Act'...
This review is from: *Sisters*
(Criterion Collection (DVD)

I am proud to say I own every film De Palma has ever made, and I feel that each one is extremely entertaining in its own way, making it a *very* worthwhile investment. Spending an entire afternoon viewing De Palma films sounds like a wonderful way to spend a day, and I know because I have done that a few times over the years. His films only get better with time, and/or with each subsequent viewing.

I can still remember when I first saw this over 24 years ago, and the impact it had on me; and, it is just as fresh today as it was then (the film *and* the impact). I love all De Palma's films, but my favorites of his are the one's he wrote and directed, like this one.

In 1973, after spending the last few years making great independent films like *Murder A La Mod*, *The Wedding Party*, *Greetings*, and *Hi, Mom!*, Brian De Palma was put on the map as the new Master Of Suspense with his first 'mainstream' film, *Sisters*, a very demented, deranged, twisted, psychological horror film that rivals even the best of today's top thrillers. He uses themes that would continue throughout his career in this film: The doppleganger, split personalities, multiple personality disorder(s), mistaken identity, voyeurism, and horrifying psychological madness, and murder and mayhem. And sinister satire!

The film stars Margot Kidder in her *best* performance ever. Kidder will literally blow your mind, for she gives the performance of a lifetime achievement award in this. Her French accent was something else!! And, her performance as, not one, not two, but three radically different characters was phenomenal! Too bad she's more remembered for the *Superman* movies than she is this. She was hot!! De Palma has always got top performances out of his actors, but Margot did deserve the Prize! I still think that it was her that he based one of John Lithgow's 'personalities' on in his 1992 classic *Raising Cain*. (There was a 'Margo', which in all honesty, was the scene stealing persona, so much so that De Palma ended the film with 'her'. Carter, Cain, and Josh were all secondary to Margo in terms of screen persona, and 'character'.)

Lisle Wilson, as a "modern-day Janet Leigh" (De Palma wanted to cast someone with 'star power' like Sidney Poitier that the audience would just literally be utterly stunned when he gets murdered half way through the film, like Janet Leigh in *Psycho*. However, Lisle Wilson is a really great actor, and I think that he was a terrific choice for the role.). De Palma regulars William Finley , Jennifer Salt, and Charles Durning, as well as Bernard Hughes, Dolph Sweet, and Mary Davenport (Jennifer Salt's real-life mother) round out the excellent cast in this exuberant masterpiece that will stun the senses!

Rich in irony, and deeply entrenched in dark humor (watch for an early scene where Danielle Breton wins a set of steak knives on a game show she is on,

and Lisle Wilson's character wins a dinner for two at an African restaurant -establishing stereotypes and irony in one set piece), this is a film that ends in a psychological, sinister, demented, deranged, almost psychedelic, hypnotic, kaleidoscopic, bloody climax that will leave you utterly stunned, breathless, and scared witless! And, the final twist at the end, where a particular character is watching a particular item through binoculars until the cows (literally) come home is awesome and utterly hilarious, but also very bone chilling all the same.

This is a very great mixture of genres, mainly horror and satire, and something that will stick in the recesses of your mind and stay there for days and days to come, and haunt you on a very deep scale. As other reviewers have stated, this isn't De Palma's first film, but in many ways, it is the first 'Brian De Palma film'. Easily in the same league as *Psycho*, *Halloween*, *Suspiria*, *Rosemary's Baby*, *Repulsion*, and referencing such greats as *Rope*, *Rear Window*, *Psycho*, and *The Cabinet Of Dr. Caligari*, this is a very timeless classic masterpiece that will rival anything in its genre that you've ever seen! And, why Margot Kidder didn't have every award there is thrown at her for her performance is a crime, for she is show stopping in this.

The awesome score was done by the great Bernard Herrmann, who De Palma got to come out of retirement to do, and who went on to score De Palma's *Obsession*. And, De Palma originally wanted to get bigger name stars for the roles of Grace and Philip: He wanted to get Marlo Thomas to play Grace, and Sidney Poitier to play Philip, but

due to budget constraints, and/or other reasons, that never came to fruition, which in my opinion is a good thing, because what may have appeared as a good idea on paper, I don't think would have worked as well on screen. Jennifer Salt (who had been in De Palma's *The Wedding Party* and *Hi, Mom!*) was born for this role, and Lisle Wilson gave a very topnotch performance as the 'male Janet Leigh'.

This is a terrific mind fuck (please pardon language) psychological twisted journey into the mind that will just blow your head off!

De Palma Does Psychological Espionage... This review is from: *Mission: Impossible* (DVD)

My mission here, dare I accept it, is to explain the very simple plot of this film (way too many people have declared and/or criticized the plot being too convoluted) because a *lot* of people (for God knows what reason) just didn't understand it. Yes, believe it or not, a lot of critics (professional and online) have cited the *very* simple plot of this film too complicated and/or convoluted. I have even heard it referred to as "Mission Plot: Impenetrable".

So many critics wanted to declare the plot of this film incomprehensible. I just watched some old clips from "Siskel & Ebert At The Movies" a couple of months ago, and I saw their review of this, and honestly I was torn between laughter and terror. Laughter at how ignoramus they sounded saying that the plot was so complicated and convoluted and hard to follow; and terrified for the very same reasons, because I sensed that it was as if they were trying to use power of suggestion on people, convincing them ahead of time that they will not understand this film. (Trust me, critics get paid to do such things!) I had no problem understanding the brilliant plot of this film! Matter of fact, that was one of the main reasons I loved it so much (other than De Palma's awesome style and techniques). This is worthwhile, intelligent entertainment, though not for the cerebrally challenged. No offense!

Like *The Untouchables* (another film from a classic TV show that De Palma made for Paramount), producers Tom Cruise and Paula Wagner hired Brian De Palma to direct this espionage-action-summer popcorn fest for Paramount, and once he did, it became a 'Brian De Palma film', filled with lots of psychological profiles, deceptive characters, and a whole host of other mind blowing craftsmanship that only he can deliver. Working from a script by Robert Townshend (*Chinatown*) and David Koep (who worked with De Palma on *Carlito's Way* and *Snake Eyes*), De Palma delivered a tour-de-force of psychological, action, and espionage that is just as mind blowing today as it was when it was released to great acclaim 28 years ago. Yes, still a classic, if not more so, after all these years!

De Palma's trademark touches are throughout the entire film, swirling camera work, altered camera angles, split screen, split diopter, et al. I haven't seen a film in this genre of such magnitude in a long time! And, even though Cruise was a producer of the film, he and De Palma butted heads over budget (Cruise was concerned about going over, and De Palma said "Fuck it, who cares!"), and it's obvious Paramount knew who to listen to about that matter (plus, everyone knows what an egotistical, arrogant little prick Cruise is anyways), letting De Palma make the film *his* and not Cruise's. De Palma paces it in such a way that every climatic scene just builds and builds until he (literally) blows you out of your seat at the end.

The film opens with a typical De Palma 'bait and switch' scene (where you see one thing, but it turns out to be something entirely different than what you expected it to be), where we are introduced to the first team of spy agents, led by Ethan Hunt (Tom Cruise). They return to base headquarters, and their boss Mr. Phelps (Jon Voight in a superb performance) returns from vacation and sends them on a new mission on a mole hunt to recover a stolen NOC list, a list of spies' names that matches another disc with their code names, and this list of names cannot get out in the open. Emilio Estevez turns in a wonderful un-credited performance as Jack, one of the team members (he did it just for the opportunity to work with De Palma) who is first to meet with a sinister fate when this mission goes horribly and horrifyingly wrong. The rest of the team is killed, Mr. Phelps is shot, so Ethan is the lone survivor, making him the lead suspect as the mole. He is then disavowed as an agent.

Enter Kittridge (Henry Czerny), the head of the whole operation, who is now on the trail of Ethan with (almost) a vengeance, so Ethan goes into hiding. That's when Ethan discovers the trail of 'JOB' and Max, and proceeds by internet to meet with Max (Vanessa Redgrave in one of her best roles ever). Claire (Emmanuelle Beart), one of the previous team members -and Mr. Phelps' wife (and thought dead)- finds Ethan and lets him know that she is alive after all, leading Ethan to be suspicious of her, even as they rebuild a new team of spies (Ving Rhames -who worked with De Palma in *Casualties Of War*- and Jean Reno) from a list of other disavowed agents.

Then, out of the blue Mr. Phelps returns in a pivotal scene that De Palma plays for all it's worth, with Jim (Phelps) telling Ethan his version of the failed mission, him getting shot, and how he survived, all the while Ethan is having flashbacks of how it *really* happened (very reminiscent of Hitchcock's classics *Stagefright* which opened with a 'false flashback', and *I Confess*, which featured pivotal flashbacks that revealed more than what was being told), letting the viewer in on who *really* set up Ethan's team for the assassination.

Ethan and team break into Langley in one of the most memorable exhilarating, breathtaking scenes in cinema history to steal the real NOC list so it can be delivered to Max in return for Job. This leads to one of the most awesome set pieces in espionage/action movie history, setting the most climatic scene of all on a train moving at high speed. Ethan saves the NOC list from getting into the open, exposes Job for who he really is, and he and his team are re-avowed back into the spy business. See, simple plot!

De Palma employs a very old technique: Tell a simple story in a very complicated way, something that Hitchcock, Kubrick, Antonioni, Bergman, Fellini, Lynch, and any other great director does to make a great film. And, this is a great film! Forget the sequels (if they could be called such) even exist, for this is the *only* 'Mission' that exists other than the TV show it is based on. This film has such a cool psychological angle as well as one of espionage. "Mission: Impossible" puts a solid stamp into this genre in my opinion.

Oh yeah, a final twist: "How about a cinema of Aruba, Mr. Hunt???". Now this message is gonna self destruct...

Rob Zombie, Hoover Dealer!
This review is from: *Halloween* (DVD)

Rob Zombie may as well be in the business of selling vacuum cleaners, for he has given a whole new meaning to the word 'suck'! I've never seen any of Zombie's trash, er, I mean films (if they could be called such), but I have heard from a *lot* of people (friends/family/critics/strangers) that *House of 1,000 Corpses* was horrendous, a poor man's *Texas Chainsaw Massacre*, awful, dreadful, *not* scary, etc., etc. I had forgotten (like a *lot* of people) that he had made a 2nd 'film', *The Devil's Rejects*. How he was allowed to even make a 3rd, especially a remake of *Halloween* is *so* beyond me!! When I 1first saw a trailer for it I thought it was yet another awful sequel, but *no*, it's a remake...*Ugh*! This is garbage. Yes, garbage! This is a vile piece of celluloid. It's a useless remake of a film that did *not* need a remake! Zombie took something and revamped it when it was something that didn't need to be touched.

Calling it a 're-imagined version' doesn't change the fact that it is still a *remake* (and "remake" is just another name for "theft"!) , and a totally unnecessary, unneeded, dreadful, awful, atrocious, sacrilege at that.

And, for the people posting on here "Who cares about the original? It was boring and slow, and it took *so* long to develop characters, which was a waste of time, because you're just getting to know characters that are gonna get killed anyways?", well, you all scare me more than this crap ever could! Where is your moral compass? Your moral center?

Your moral core? In other words, your Human side? Just how dehumanized (not to mention how lowbrow) society has become is so frightening. Plus, you all miss the entire point of a horror movie, showing your ignorance to the mechanisms that make a scary movie successful; a rule of thumb that goes all the way back to the silent days of cinema: You *must* get to know the characters so you can feel for them, then therefore be scared when they start getting murdered.

It seems as though the mass viewing public doesn't feel the need for 'plot' these days, they just want the latest trend in being 'shocked' instead of being scared, and unfortunately they aren't educated enough to know the difference; or, they have become too dehumanized to even care. Just because Zombie loves horror does not mean he can make a good horror film.

What made *Halloween* so great: Pacing, and realistic situations, and realistic characters doing realistic things, and *very* creepy atmosphere and music. Plus, it is a very dark psychological film at heart. The way Michael Myers kills off Laurie Strode's friends, making sure she has no one to run to when he goes for her. And, none of them were running around a lake out in a deserted forest in the middle of the night like stupid airhheads screaming "Here I am Mr. Murderer, come kill me!" like they were in the senseless *Friday the 13th* movies, which were just clones of Carpenter's classic film. No, they were all doing very realistic things suburban teenagers (of that era) do: Smoke a bit of pot, go to school, baby sit, etc

Rob Zombie has raped, pillaged, stolen, ruined, and destroyed everything that was great about this horror masterpiece (yes, masterpiece!) by tinkering around with something that didn't need fixing. He needs to be committed to the 'house of 1,000 corpses' and tortured by 'the devil's rejects' for this sacrilege! Poor Debra Hill is doing flips in her grave, for this is the second John Carpenter/Debra Hill film to be remade counting *The Fog*. R.I.P. Debra! Carpenter's *Halloween* is considered a classic, and ranked among the likes of Hitchcock's *Psycho* for a reason: It is a solid masterpiece of psychological horror, *not* just another slasher/horror film. It didn't need sequels, and sure as heck didn't need to be remade.

If it had been a frame by frame/shot for shot remake, I might have given it a fairer shake, but to try and give 'history' to Mike Myers, and making his family look like white trash from "The Jerry Springer Show", well, he should have called it something else, because it is NOT *Halloween*! I just don't find it necessary to have a 'backstory' on Michael Myers, well, other than the one that was put into *Halloween II*, revealing that Laurie Strode was his younger sister. That was the only thing I like about *Halloween II*, and wished there were some way to edit it into the original film.

I would urge anyone that wants to see what all the fuss is about to seek out the John Carpenter/Debra Hill classic, and see the film that has terrified audiences for over 30 years to this day, the last 15 minutes so intense, it could induce heart attacks;

and forget this dog turd even exists! I mean, really, who's gonna be talking about Rob Zombie's *Halloween* in a few years from now??? Except to say "Avoid it like a rabid dog!" People won't even remember it long enough to say that in another couple of years. It will fade away and rot like a rotten tomato, so it begs to question: *Why* did Zombie waste his time remaking a classic when he could have at least tried to make something original (even though his 'original' films are just as forgettable as well)? This ranks in the same lowbrow category as Gus Van Sant's atrocious remake of *Psycho*.

Sorry, but I'm trying *not* to think about anything in this film anymore. I'm trying *real* hard to forget it even exists, which really isn't that hard to do. Either way, good or bad, I do wish the remake cycle would come to a grinding halt! As for Zombie, well, I don't know what else to say, for I feel like he's a waste of breath (no offense), and his 'remake' is sucking trees out of the ground! Avoid!!

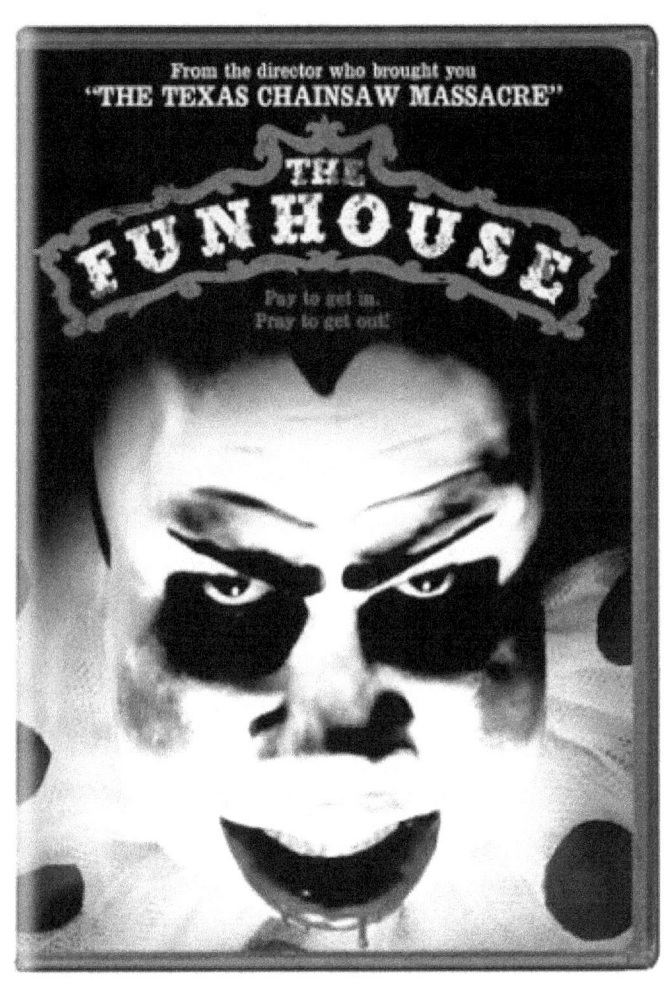

Tobe Hooper's Ride Of Terror...
This review is from: *The Funhouse* (DVD)

Tobe Hooper's *The Funhouse* is a pure delight in horror and a real treat for any fan of the genre. And a *lot* of people have never heard of this little gem from Tobe Hooper. It's really sad because they don't make scary films like this anymore. Even though it had been about 20 years since I had last seen it on VHS, as soon as I saw the DVD (in anamorphic 2:35 widescreen), I (literally) had 'flashbacks' to the days when I used to, not only watch a bunch of slasher/horror genre films, but the good ole days of going to the fair. Hooper's way of capturing that experience on film is pure magic. I love how he captured the feeling of a good old country fair, right down to the realistic parking lot situation.

This one was made during the period when Hooper was 'on fire' as a director. In 1981, there was a barrage of slasher/horror films saturating theaters everywhere. And, the vast majority of them were pure junk, ranging from *My Bloody Valentine* to *Terror Train*. Tobe Hooper, director of the first two *Texas Chainsaw Massacre* films, as well as *Invaders From Mars*, and the tv mini-series adaptation of Stephen King's *Salem's Lot* delivered one of the most original and terrifying films since Carpenter's *Halloween*. As a matter of fact, the film opens with a homage to *Halloween* and *Psycho* in a scene that shows from the outset of the film that terror lurks in this story, but you're not going to know where and/or when until Hooper is ready to unleash it on you.

Setting the film in a very realistic fairground that will have any fair going public from the good ole days of the fair having flashbacks (most fairs are really lame anymore). He captures the whole mood from the parking lot, the rides, the freak shows, the Adults-Only Show, to the actual funhouse of the title. What adult today doesn't look back on their very first visit to a carnival or fair and remember the seedy characters lurking about?

The plot involves two couples who decide to spend the night inside the funhouse, something any fair going teen has dreamed of at one point or another in their lifetime. The only witness to the couple going inside but not coming out of the funhouse is the little brother of one of the two females, Amy. Inside the funhouse, the couples witness something far more strange, more sinister than any of the funhouse's horrors. Sounds kind of silly and idiotic, but that is what makes this all the more realistic: Because teens are prone to do stupid and idiotic things for pleasure, and sometimes with horrible results.

But, the horror in this story is mainly Amy's horror. Played to perfection by Elizabeth Berridge (who looks a *lot* like a young Natalie Wood), Amy's character goes through ranges of terror that makes one wonder just what Hooper did to get her to react in such a horrified manner (right up there with Shelley Duvall in *The Shining*). But, anyone familiar with Hooper's work knows that his films tend to have a very realistic/documentary look about them (that is until Speilberg ruined his career with the horrible *Poltergeist*) that makes the viewer feel

as if they are in the story instead of just watching it.

Sylvia Miles was great, as well as the entire cast, but my pick was Elizabeth Berridge, for she gave such a realistic portrayal of a teenager in a state of mortal fear that it made me wonder what Hooper did to her to get her to reach such 'horrific' heights in her performance (like the girl in *Texas Chainsaw Massacre*). Everybody else was just as realistic as well, and that's something I loved about those early Tobe Hooper films.

Also to help set a tone of pure terror for Amy before she and her friends even enter the funhouse is having Kevin Conway cast as not one, but three different 'barkers'; and having each one stare intensely at Amy as she is passing by. Also making a great appearance is the (always) terrific William Finley as a magician.

The tagline on this film was "Pay to get in. Pray to get out". That is so appropriate! This is definitely one horror film that will haunt you long after viewing it. Definitely one of the very few slasher/horror genre films to stand the test of time, and still be just as relevant and scary today as the day it was released. Definitely one of my all-time favs from that era and/or genre.

Dean Koontz, writing as Owen West, did the novelization of the screenplay by the way.

I believe you'll really enjoy this rare little classic from a once great horror director. I have my ticket to a front row seat, it's time for me to enter the

Funhouse again. Thanks and Keep on slashing!

Jason's Nightmare...To be 'Re-Imagined'... This review is from: *Friday the 13th* (DVD)

I admit there have been some really good remakes in film, especially Carpenter's *The Thing*, Cronenberg's *The Fly*, and Phillip Kaufman's *Invasion of the Body Snatchers*. I hate to contradict that when I'm taking my 'stance' against remakes, but the thing is the principal for the remake to begin with: So a whole new generation can appreciate the story, and that, in my opinion, is wrong, because it robs the original art of filmmaking; and, thus, we see the vision of great film makers like Hitchcock, Welles, Wilder, Capra, DeMille, Polanski, De Palma, Kubrick, Lynch, et al, disappearing from the screen.

I would rather have a axe to the skull than to sit through garbage like this. May Jason Vorhees rise from the undead and stalk and kill Michael Bay for even releasing such a piece of crap on the public. If you want to see a great slasher/horror flick, then seek out the 1980 *Friday the 13th*, and/or the 1st two or three sequels (after "Part 5" they sucked), but forget this turd even exists.

The *Friday the 13th* films weren't classic cinema by no means, but they represented the era they were made in, and that to me is what counts.

Michael Bay is terrifying enough without ruining great horror films. And, remakes are a travesty! Could you imagine books being rewritten by new authors every new decade? Or albums being re-recorded by new groups?! No way! So why do we

allow films to be remade?!

Seriously, could you imagine a publisher hiring a new author to re-write, let's say Stephen King's *Carrie* and/or *The Shining* so a new generation could relate to how it reads in new text because they weren't taught to appreciate the art of literature to begin with? Doesn't someone own the rights to films like an author owns book rights?

Another reason I'm against remakes is I consider it to be thievery on a grand scale. How would all of these popcorn eating fans of these 're-imagined' films feel if they had made the original film themselves just to see some unknown filmmaker wanna-be come along and pilfer their work for their own gain? I don't think they would be too crazy about it then, huh!!
Just say NO!
Thank you!

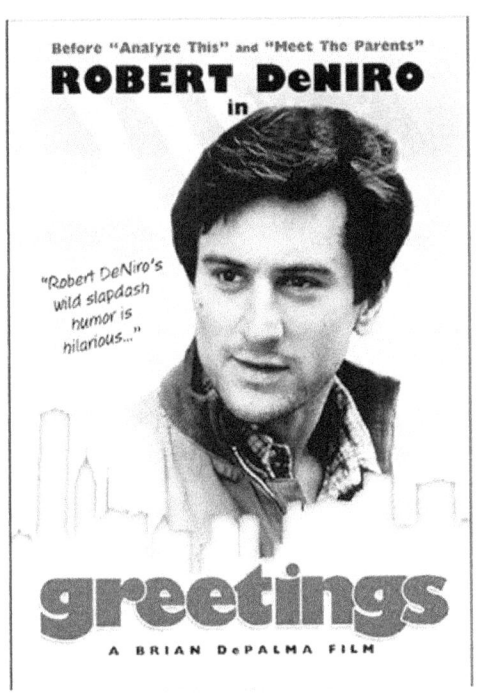

De Palma's Satiric Salutations...
This review is from: *Greetings* (DVD)

The early 1960's were a great era for films and filmmakers. Brian De Palma made a huge impression as a up-and-coming gonzo-guerilla-radical-rebellious-independent filmmaker. And, that was just with this one film, his 2nd feature.

Starring a very young, unknown Robert De Niro, De Palma created a satirical farce that skewered practically everything society was dealing with at the time: Vietnam, draft dodging, racism, paranoia, the JFK conspiracy, Antonioni's *Blow Up*, Hitchcock's *Rear Window,* teenage angst, rebelliousness, young love/lust, voyeurism, and entertainment.

Telling this in the style of short stories, well, postcards, pasted together to tell one story, this is a very interesting, complex (yet simple) piece of film that is still fun and relevant today. Join Jon Rubin and his merry band of friends (including Gerritt Graham in his film debut) as they experience some really cool and off-the-wall things, from unrequited love to trying to solve the JFK conspiracy. Funny as hell, and a blistering reflection of a more innocent time when America was in a uproarious upheaval state. Dizzying film styles and techniques, and with a very witty script help move this film along charged at a rate of very high velocity.

It's a stunning, beautiful piece of work. No conventional plot, just a wonderful anti-war parable.

If you have never seen Antonioni's 1966 classic *Blow Up,* then you really need to check that one out ASAP! It's a solid masterpiece of cinema, and this film parodies it in a lot of scenes.

My favorite scene(s) falls somewhere between the middle and the end, when Jon is following the mysterious blonde, and the breathtaking shots of the park, and the stunning music in the soundtrack, so bittersweet and innocent, so reflective of the 1960's, and *so* hard to describe in mere words. The title song sounds a lot like The Byrds. Oh, and the whole bookstore sequence is hilarious!

This film was made before *Hi, Mom!.* As a matter of fact, *Hi, Mom!* is a sequel of sorts, with De Niro again playing Jon Rubin, but in *Greetings,* it's before he goes to Vietnam, and *Hi, Mom!* is after his return.

I'm sure you'll love this if you're a fan of De Niro and/or De Palma. It's a super cool little film. This is very obscure but worth the hunt. Highly recommended!

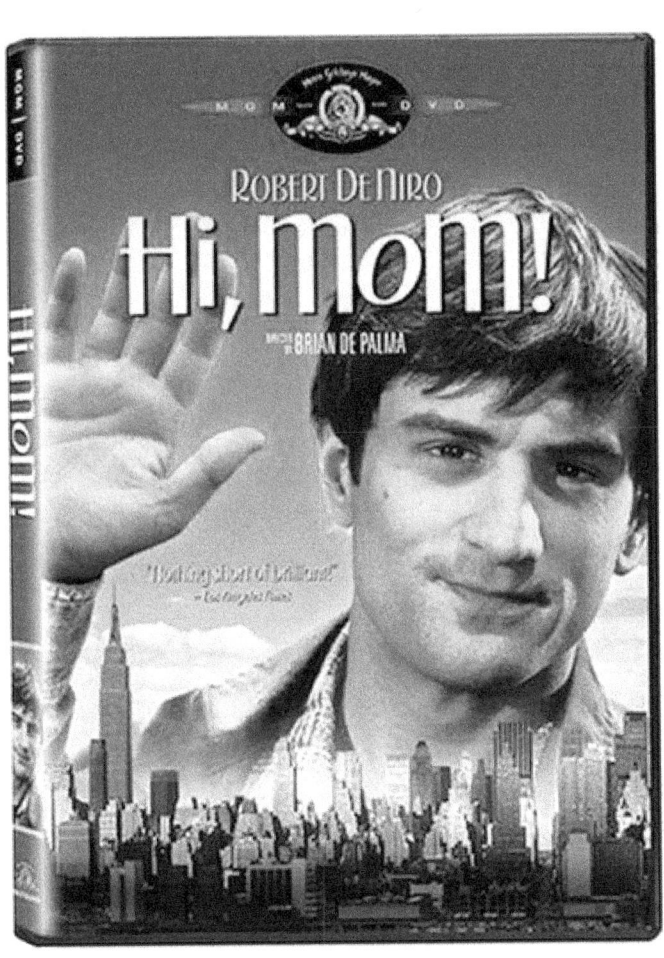

De Palma's 'Hello, Vietnam, I Don't Give A Damn!'
This review is from: *Hi, Mom!* (DVD)

Okay, so you know, there was a time that Brian De Palma made films that didn't resemble Hitchcock fare. Story-wise and style-wise. He was more of an avant-garde/guerrilla style filmmaker that made very daring, audacious films with very powerful statements (well, like his films still do to this day, but with more of that 'Hitchcock' flare). No, this leans more toward the Antonioni/Lelouch/Godard style of filmmaking. The 1960's were a great era for films! Especially the up-and-coming De Palma.

And, so people will know, it was De Palma that discovered Robert De Niro, *not* Martin Scorcese! De Palma cast a very young, unknown De Niro in three of his first films, *The Wedding Party*, *Greetings*, and this one (which is a sequel to *Greetings* in a way). Yeah, it was De Palma that discovered De Niro! This is a real gem too! Definitely a winner! Especially for fans of both talents involved. And especially for fans of independent films.

This also features Jennifer Salt (also in De Palma's *The Wedding Party, Greetings,* and *Sisters*), Charles Durning (also in De Palma's *Sisters* and *The Fury*), Rutanya Alda (also in De Palma's *The Fury*), and Gerritt Graham (also in De Palma's *Greetings, Phantom Of The Paradise,* and *Home Movies*).

This is a very powerful, hard-hitting revolutionary film that deals with some very tough issues of the

day that are still relevant today. Things like war, racism, obsession, paranoia, and equality among the Human race. And, yes, voyeurism! De Palma deals with voyeurism in the best possible sense than any other film director in the business. First, he makes us want to watch, then makes us almost afraid to turn away, but also afraid to keep watching, then he makes us feel disgusted for even wanting to watch. Yes, he so effectively exposes the deep sick desire that we as a people share in common: We love to be witnesses to any kind of event; spectators to the entertainment.

Whether it's television, film, and/or live events, we just can't help but watch. And, if asked to participate, well, that is just a crime! And, that, my friends, is the crime that De Palma commits so many times with his brilliant films! That is why he so effectively splits his audiences down the middle: He asks for participation from his audience. Don't just sit there like a imbecile, actually try to 'solve' something, try to find the solution to the problem, try to, well, quit just letting your life pass you by as you just sit there as a witness to your own drama. Participate in Life!

For anyone who hasn't had the pleasure of seeing this film, be prepared to be shocked out of your seats by some very hard-hitting subjects, mainly that of racism in this country. The "Be Black, Baby" sequence is possibly one of the most daring, straight-forward approaches to dealing with this subject ever committed to film. Disturbing, hilarious, jolting, and very dramatic, this film turns itself inside out, exposing and exploring the art of

filmmaking in and of itself. And, gives a whole new meaning to 'guerilla terrorism'!

Oh, this also pokes fun at the whole porn industry, something that Brian would continue to do many years later with his classic psychological erotic thriller *Body Double*.

This film is fantastic, and would make a good double bill with *Taxi Driver*, because in many ways it feels like a comic trial run for that movie. More so even than most of his later work, this movie and its predecessor *Greetings* put De Palma firmly among the influential first generation of film-school filmmakers like Scorsese and Coppola.

As for Scorcese and Coppola, well, they and De Palma (and Spielberg & Lucas)) all started around the same time and are referred to as The Brat Pack. Never seen *Taxi Driver* (I know, shame on me!), but I could believe that Marty 'borrowed' from this for his film (like he borrowed De Niro and took credit for discovering him when we all know it was Brian who discovered him).

The obvious rough edges in *Hi, Mom!* may be due to budgetary or creative constraints in a few cases, but I think they are more often intentional. It's as if in trying to catch lightning in a bottle with an almost "guerrilla" style of filming and acting, they had to concede that a strange edit here or a too-shaky camera there were unavoidable. I believe all the editing and 'shaky-film-look' was on purpose to create what is known as a "guerilla" style.

In the meantime, don't rent from slumlords, don't take a 'job' from someone you meet in a porn theater, don't fight in a senseless war, and, for God sakes, don't hate your neighbor just because their skin is a different color than yours! Then, maybe you can get on TV and say..."Hi, Mom!"....

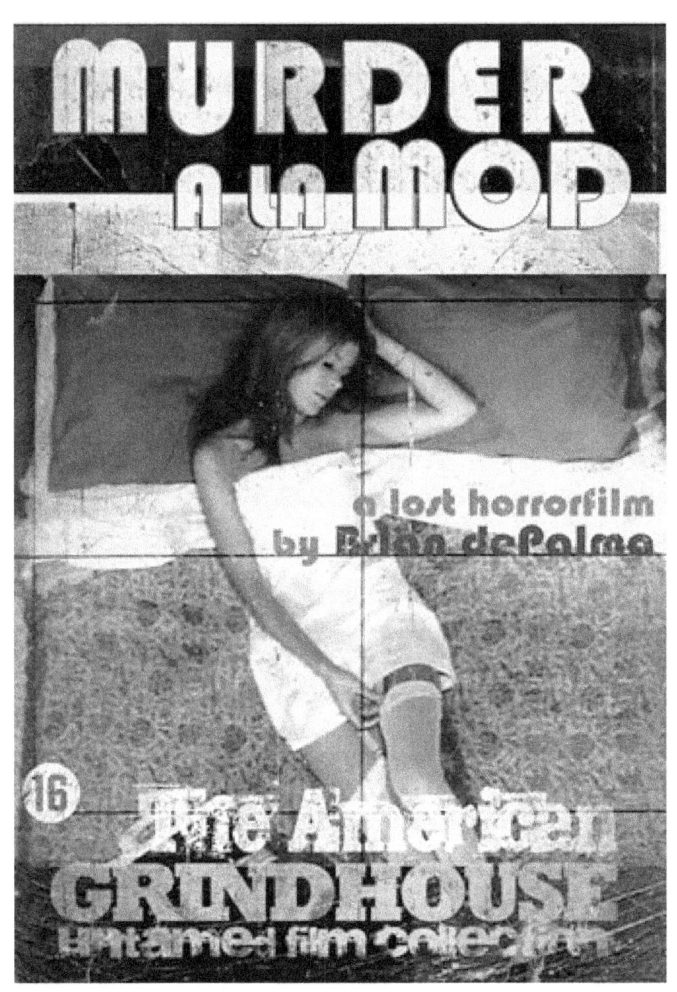

De Palma's DyNamic DeMented DeRanged DeBut...
This review is from: *Murder A La Mod* (DVD)

As most people who know me already know, I am hopelessly devoted to De Palma. And proud of it! Only Kubrick, Hitchcock. and the Coen Bothers are some other filmmakers that I love every film they made. But, Brian is special. Perverted and provocative and rebellious. And this little very rare gem has those traits in spades. This only got released on DVD about 4 years ago. It is a very rare treat, and something every De Palma fan should have. I just heard of it a couple of years ago, and I've been a fan of Brian's ever since the 70's.

Yes, this is director Brian De Palma's directorial debut, and wow, is it ever deranged, demented, delirious, and delicious! A perfect combo of Hitchcock's *Psycho* and Polanski's *Repulsion*, and a prelude to up-and-coming snuff films, this is an original film filled to the brim with stark originality and purpose. Told in a very non-linear, back and forth kind of way, this tells the story of Karen, a woman falling in love with Christopher, a porno photographer, stealing some cash to help finance him, and getting killed. This features the great William Finley in his screen debut as Otto, a very creepy, mysterious, silent character that is the prime suspect of the bloody crime.

But, as in all of De Palma's thrillers, you can never rely on what you see; so, all is a lie until the end of the film and you realize you were duped by a master filmmaker into believing an illusion. Marvelous

twists and turns abound, and such mysterious allusions aplenty. Just be sure to keep your eye on the ice pick!

This is a film that is still inspiring filmmakers to this day, including one Quentin Tarantino. His entire storyboarding and shooting style derives from this one film. As many that have tried to copy this rare original masterpiece, none have ever came close.
Breathtaking and intense and hilarious on every level, an ingenious young De Palma set the world on fire with this blazing, scathing, vicious, and hilarious tribute to horror cinema.

The young cast are phenomenal, and the plot is cooler than ice water. But, as with a lot of De Palma's work this isn't as much about plot as much as it is about being a social commentary on the generation of lost souls. So, in that sense, I guess that (as well as other reasons) makes this just as relevant today as it was back then.
HIGHLY recommended!

A De Palma Classic Mystery, Suspense, Noir! This review is from: *Obsession* (DVD)

Have you noticed the amount of so-called thrillers over the past 15 years that critics have hailed as a Hitchcock style thriller (like *Panic Room*, *Vacancy* and *Disturbia*), and they don't resemble anything Hitch anymore than Woody Allen resembles Kubrick? And, to make it worse, critics are throwing roses at these generic films, while heaving meat cleavers at Brian De Palma for his classy style. He dares to make genuine cinema art, relying a lot on the great technique of visual storytelling, with long scenes without any dialogue, making the viewer have to read movements of the characters (facial expressions, body language) as well as the camera.

And, for the whole Hitchcock connection, yes, his films do resemble Hitchcock's films a bit, but if you notice, they are *miles* apart in tone, style, character, mood, and technique. They happened to share a lot of the same fetishes, and the same type of story lines. De Palma's films can be violent at times, but a lot of it is implied, not shoved right in your face. His films have deep emotional feel, but not so syrupy you want to break out some pancakes.

A lot of people dislike De Palma because once they've seen his films, then go back for a second viewing, they realize just how well he fooled them, the whole time displaying any clues possible right before their very eyes; hence, making them feel stupid. That is one of the qualities I love about his films. For once you've seen it, then go back and

view it again with the knowledge you have of the overall film, letting all of the hints and *obvious* clues that are placed right before your very eyes the entire time; yet, when the movie was over, you felt like a rug just got pulled right out from beneath you.

And a *lot* of people point out the "Hitchcock" touch his films seem to have, which they do...to a degree. What a lot of people don't seem to realize is that De Palma was also a student of the French Cinema La Nouvelle, artists like Godard, Bergman, Fellini, Antonioni, and Lelouch. Yes, this film is admittedly (by De Palma - he said that he and friend, writer Paul Schrader had just seen *Vertigo* and loved the idea so much that it inspired this screenplay) inspired by Hitchcock's *Vertigo*, if anyone out there has ever seen Claude Lelouch's French 1966 masterpiece *A Man And A Woman* they will know what I'm talking about in reference to all of the *other* great artists of film that inspired De Palma's style, decision, precision, and delivery.

Not to give any kind of spoiler, but the climatic ending that swirls into a freeze frame is straight from the ending of Lelouch's brilliant film *A Man And A Woman*, and *so* appropriately so, seeing that this film has such a romantic tone throughout it, even during the most suspenseful of scenes, the style of filming it is so romantic (I don't mean a love story, but in tone). Opening the film in 1959 New Orleans, so beautifully recreated even though the budget wasn't too great for this film at that time; but, you couldn't tell that by looking at it. It is such a timeless masterpiece of cinema that definitely stands the test of time, looking even better now than

ever.

Cliff Robertson is awesome in his role as Michael Courtland. His facial expressions are dynamic in revealing his emotions during some breathtaking long scenes of visual story telling, without dialogue. And John Lithgow is great as Court's business partner/friend, "Uncle Bob" (possibly a homage to Uncle Charlie in Hitchcock's *Shadow Of A Doubt*?). But my hat's off to Genevieve Bujold for her brilliant performance, not just as one, not two, but three different characters (something common in De Palma's films, having one actor playing multiple roles or personalities or characters) in what I consider to be a tour-de-force for her. (She later did great work in Michael Chricton's *Coma* and David Cronenberg's *Dead Ringers*.) The fact that this was overshadowed by *Carrie* (another great De Palma classic that got released just a few months later the same year) is saddening. This film deserved to have a few nominations its way as well, especially for best actress. Again, not to be a "spoiler", but notice the range of expressions in her face during the climatic (or any) scene in the movie. Awesome.

The way the film is structured, it does homage a lot of Hitchcock, as well as some French directors, but this is the film that set De Palma on the map as for being considered the new Master Of Suspense (this was an excellent follow up to *Sisters*). Or, better yet, for another, more updated version of *Vertigo*, check out De Palma's 1984 classic *Body Double*. *Obsession* is a much more "cleaner", more "pure" film than *Body Double*; as a matter of fact, this is one the whole family can enjoy. Even with the

revelation at the end, thank God that De Palma changed a crucial scene into a wonderful, hypnotic dream sequence because it would have being so tasteless once the mystery is solved, but sense the change was made, it cleans up the film in several ways. In the screenplay, the scene would have had two characters making love in a "reality" scene, and trust me, it's great the change was made. And, thank God that De Palma listened to composer Bernard Hermann about ending the film where he did!

For those that don't know, the original screenplay was going to go even further into the future and the story. But, that was scrapped, and we now have (since 1976) a timeless masterpiece of cinema. A tale of love, obsession (before the word had a negative connotation to it), kidnapping, betrayal, murder, double identity, mistaken identity, character resemblance, double crossing, deja-vu, and mystery. In De Palma's world, everything is possible when sometimes nothing is impossible. Seeing is believing, but always look beneath the surfaces. Never take anything at face value, without knowing what's behind everyone's agenda.

And, if you want a great noirish story about any of the above done in a very stylish vision, then see *Obsession*. If you don't trust my review, read all the other 4 or 5 star reviews online, starting with Amazon's reviewer. They said a *lot* of things that I would have said had it not being said already. They've all done a great job praising this film in their own words, and I highly recommend all of their reviews, for they are very insightful and intelligent reviews of a timeless cinematic

masterpiece of suspense, romance, intrigue, and mystery.

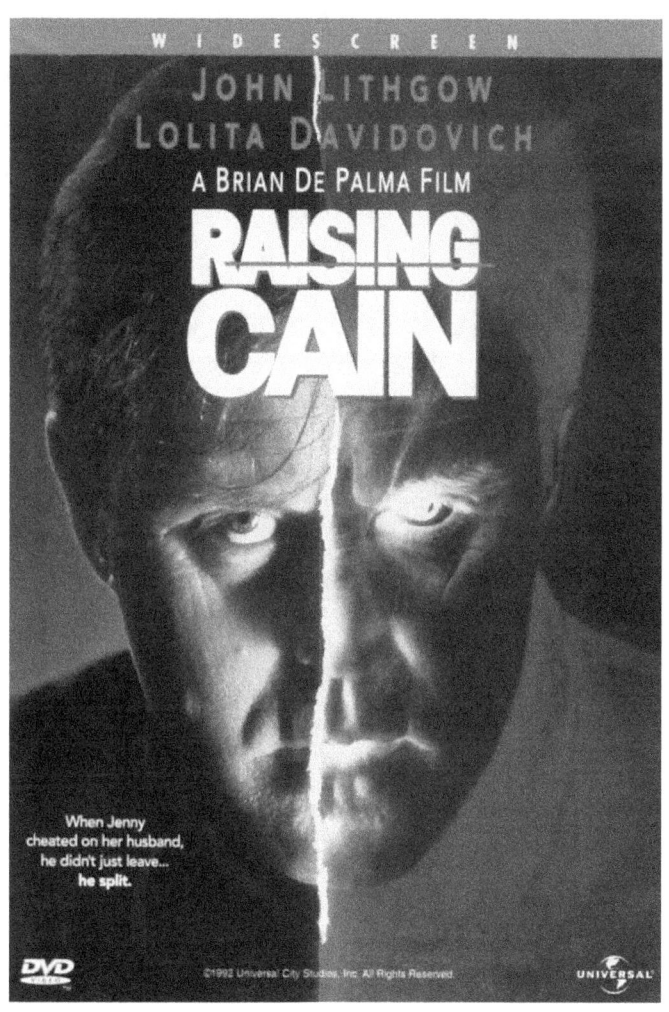

De Palma's Deceptive, Deranged, Demented Personality Disorder...
This review is from: *Raising Cain* (DVD)

I launched an online 'campaign' a while back to defend my favorite filmmaker, Brian De Palma (which I still need to finish sometime soon), starting with a review for the awesome *The Black Dahlia*. I started reviewing films of his that are practically either hated (for god alone knows what reason) or just flat out ignored by the general movie going populace.

This is a psychological thriller that couldn't have came at a better time than it did, but unfortunately it almost got ignored at the theaters. What a travesty! All that was coming out in those days were mindless, generic thrillers like *Sleeping With Julia Roberts*, *The Hand That Rocks Rebecca De Mornay*, and/or *Single White Stupid Movie*.

I still remember telling a friend right after seeing *The Bonfire Of The Vanities* that (even though I love all of the different genres of film that De Palma has made I think his thrillers are where he excels best) it was time for De Palma to return to the horror genre. And, it's as if he heard me, because this little treasure opened just a little over a year later.

Here it was to save the day! De Palma's most demented, deceptive, deranged piece of work in years. A psychological thriller that weaves back and forth, moving in and out, and in between dreams, thoughts, fantasies, flights of fancy, characters that

don't exist outside of the mind, a love story, a kidnapping story, a "mad doctor" scenario, murders, multiple personalities, framing the innocent for murder, a character that is either a "personality" or back from the dead, and reality.

Loaded with doses of extremely dark humor, this is a relatively simple story, just told in a difficult way (the basic rule of any great director), with not only references to Hitchcock (I especially loved the nod to *Frenzy*), but De Palma even riffed himself just to spite critics who had always bashed him for riffing Hitchcock and others. There is one scene in particular that is straight out of *Dressed To Kill*, as well as a few other references to that film. This is a very dark journey inside the mind of a very disturbed individual who was made that way by experimentation as a child.

Yes, John Lithgow plays Carter, Cain, Josh, and Margo Nix, as well as "their" father Dr. Nix, who is supposed to be dead; so is he too just another personality of Carter's? And he plays all five roles so brilliantly, that you believe every one of them. The way writer/director De Palma fleshes out and brings all the characters together is something to be praised for decades!

Excellent casting by Brian De Palma to pick John Lithgow as the evil Dr. Carter Nix. I really think most people view John Lithgow as a comedic actor only and they'd be so wrong to think that. John Lithgow is a natural at playing sinister and evil roles and he could have had a long career as a movie villain. I'm still in shock all these years later that

Lithgow's performance was all but ignored by Award giving/Fashion show drones. He was literally all over the place in this film!

Lolita Davidovich is great as Jenny Nix, Carter's confused, frustrated wife who has a few flights of fancy herself, again allowing the film to take us inside the minds of the characters in this film in such a stylish way that will stay in your mind for a long period after viewing. Steven Bauer is really good as Jenny's former lover, Jack, who lost his wife to cancer while Jenny was his wife's nurse, when they both fell in love with each other. But, Jenny married Carter, and now in her confused state of mind over her husband's behavior, up pops her ex to ignite a new passion in her; and Cain literally splits in two, three, four different ways.

Look for Gregg Henry in a great performance as one of the detectives, Mel Harris as Jenny's friend, Gabrielle Carteris as a doomed babysitter, and Frances Sternhagen in what could probably be the best role she's ever done, Dr. Waldheim, a psychiatrist who's surviving cancer, wearing a wig that she declares "I look like a transvestite in this!". A wig that is befitting for a real "Drag Queen" (the only other time Lithgow did this was in *The World According To Garp*, a great film in which this is openly paying homage to). Thus, leading the viewer to, what some reviewers have stated: The *best* ending in De Palma's film cannon, if not the best over any other film in this genre! After viewing this, and I watch *Body Double*, I now almost wished that De Palma would have scrapped the ending credits scene, and just faded to black after the final scene at

the reservoir; but, I now have come to re-appreciate that ending.

This is a film that could compare to Rob Reiner's *Misery* or Kubrick's *The Shining* as far as having a character that delivers lines so deviously sinister, yet hilarious in the same breath. This is definitely a thinking person's horror show! It dares to go where few films before it have dared to go...inside the Human mind and the horrors that lay dormant there, just waiting to awaken and come to life and be a character all their own. And, the coolest riddle of all to those that have seen it and loved it (which I know a lot of people that *love* this film, plus there are a lot of great 4 or 5 star reviews from some very insightful reviewers): If Margo is the protector of the children, then is her presence to be feared or comforting in a crucial scene?

Anyways, if you like films that play out like a cat and mouse game, then this is for you. It is not a very difficult film to follow, but like chess, it has continuous twists and turns, so just let yourself go for the ride and you'll love every minute of it! Something that's Deceptive, Deranged, Demented, Delirious, Devious, Delicious De Palma at his Disturbing best!

P.S.: I highly recommend looking online for the fan Re-Cut version of this, it is even better than the original release - and it has De Palma's blessing!

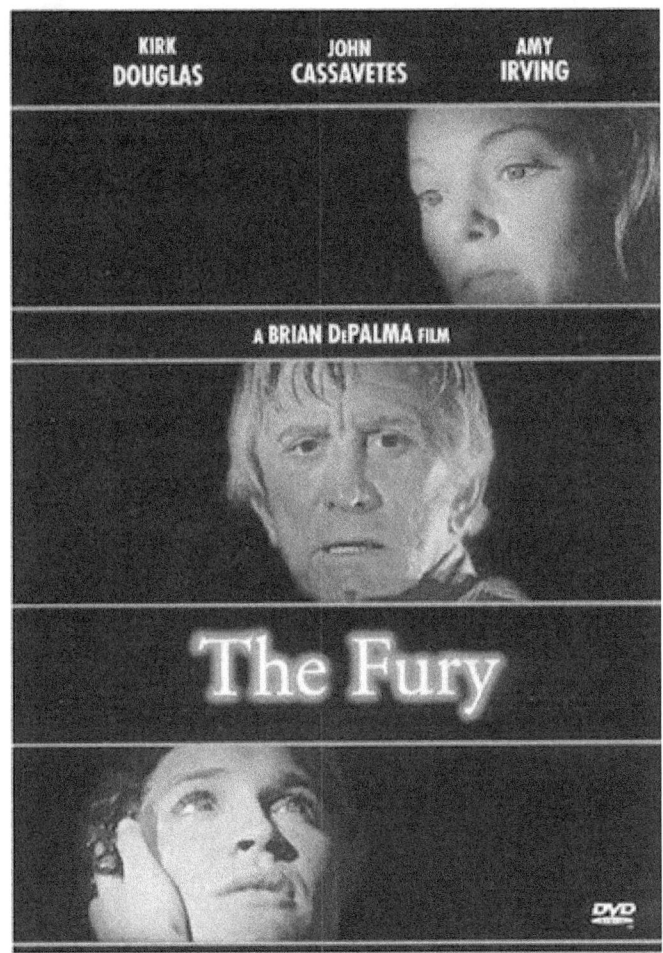

De Palma's Psychological, Telepathic, Paranormal, Mystery Thriller...
This review is from: *The Fury* (DVD)

In my opinion *The Fury* ranks right up there with the best of all time . Very few horror films made today take the time to tell the viewer a story like *The Fury*. It's sad because the formula used to scare us back in the 70's seems like it's been lost forever.

Two things that bother me whenever I hear and/or read in a review of this film are, 1) calling it an unabashed *Carrie* follow-up, and 2) critics citing it as a difficult story to follow. First of all, this film and *Carrie* are *miles* apart in style, tone, mood, character, story, and genre that it makes it sound retarded to compare the two. I don't remember people calling Stephen King's *Firestarter* "Carrie 2", and it was a lot more closer to *Carrie* than this film ever was; and, *Firestarter* also plagiarized this novel/film for its basic storyline.

The story is this: Peter Sandza (Kirk Douglas, who would later work with De Palma on Brian's independent comedy *Home Movies*) is retiring from a spy agency, making this from the beginning a more "espionage" thriller, rather than straight out horror. Peter has a son named Robin (Andrew Stevens), a seventeen year old that is very close to his father, and happens to have telepathic and telekinetic abilities. And, in keeping with the "espionage" thriller tone, a shootout occurs, Peter is seen by Robin in a boat as it explodes, thus leaving Robin to believe that his father was killed by terrorists. A year later, Peter, with the help of a

psychic named Raymond Dunwoody (William Finch), hears of a young girl -also 17 years old- named Gillian Bellevere (Amy Irving) who has psychic powers.

And, as De Palma turns the focus to Gillian, we learn that she has telepathy and the ability to cause people to bleed, something that mortifies her. Her mother wants her to see a psychiatrist, but Gillian requests to be taken to the Paragon Institute, a place that deals with "gifted" people like Gillian, as well as Robin Sandza. At first, Gillian is made to feel right at home, whether it be playing outdoor and video games with the doctor (Charles Durning, who had been in De Palma's *Sisters* as a baffling detective) and the rest of the staff, or with one of the nurses, Hester (Carrie Snodgrass), who may just be the most tragic character in this story. Notice the scene when she and Gillian are having lunch and then a sundae. It's apparent just how lonely, how romantic, and how imaginative (in a fantasy-world/dreamer kind of way) that reveals the true honesty of her character, as she describes her "boyfriend" to Gillian. And, then the irony about her fate, like a martyr that she was.

Peter hears through Hester that Gillian is at the Paragon Institute, and plots a way to have Hester help Gillian escape from a place that's a lot easier getting into than it is getting out; and, is also ran by Peter's ex-friend/business associate, Childress (John Cassavetes), who staged the whole shootout at the beginning of the film, and now has Robin hidden away from society to experiment on him, trying to turn him into a Human bomb. He almost succeeds.

Now, Peter and Gillian go in search of Robin (who is believed to be dead), who is shown to be self-destructing under the pressures of being drugged, and brainwashed by having to view films of his father's "death" over and over. Meanwhile, we have his nurse/lover, Dr. Charles (Fiona Lewis) trying to distract him from the fact that he is about to be killed and replaced by Gillian (by the Institute), Robin loses control and now, we, the viewer, have just stepped inside one of the greatest horror movies ever made! What follows from this point on leads to one hell of a (literally) explosive ending that will just blow your mind. See, simple story.

This film mixes a bunch of great genres together to create a horror movie from the 70's that is on a par with *The Exorcist*, *The Shining*, *Psycho*, *The Omen*, and *Rosemary's Baby*, as well as De Palma's *Carrie*. There are hints of *The French Connection*, as well as a lot of other genre pictures that this film uses to its advantage. And, that is to tell a simple story in a difficult way, every film student's golden rule, something employed by any great director. *The Exorcist* was a mixture of genres, but nobody raked William Freidkin over the coals for making the classic that he did, so why does De Palma keep getting bashed for the very same thing?!?!

If you want to see a stunning, stylish, bloody, almost gothic, psychological, telepathic, paranormal, mystery thriller, then this is a film for you. Look no further. This film has so many scenes of utter amazement, with De Palma putting his trademark touches throughout, that you can feel your jaw drop

every five minutes or so. It's very fast paced, and packaged nice and tight. And, as I stated in my review of *Raising Cain* that I felt that film had the best "De Palma" ending, well, I tend to forget this film's climax. This is the *best* "De Palma" ending ever! It is *awesome*! Even though it's something that may be considered somewhat gory, it's done in such a fashion (in rapid repetition, like the shower scene in *Psycho*) that will make you want to view it over and over. As one 5 star reviewer of this film stated, it totally gives the phrase "You go to Hell!" a whole new meaning!

Watch for some minor roles played by great talented actors, like Rutanya Alda (who was also in De Palma's *Greetings* and *Hi, Mom!*), Dennis Franz (in his first film) as a cop, Gordan Jump (of "WKRP In Cincinnati" fame), and a very young, unknown Daryl Hannah in possibly her first screen role, as well as Laura Innes, Melody Thomas Scott, and James Belushi.

Great film from De Palma in 1978, which helped concrete him as the new Master Of Suspense of cinema, which still stands as strong today as the day of its release.

De Palma's Smoldering Satire...
This review is from:
The Bonfire of the Vanities **(DVD)**

From the very outset of his career, De Palma has been a 'starspinner' ever since he started making films. Everyone from Robert De Niro, William Finley, Margo Kidder, Jennifer Salt, Dennis Franz, Nancy Allen, and Amy Irving to John C. Reilly, John Leguizamo, and Kirsten Dunst has him to thank for discovering them; and that's just to name a small few!

I just re-watched this again last night, and I must say it's even better now than it was last year when I last viewed it. It just keeps getting better, like a fine wine. Very well done, crafted, acted, written, directed. I highly recommend people give this another viewing! You will truly need to sit yourself back and glance at this cinema de 'misdisasterpiece' un classik again to *truly* find its funny bone, ha-ha! Seriously, there is a lot to be got from this, especially the 'ebony & ivory' theme.

Having read the novel by Tom Wolfe right before the movie came out, I tossed the damn thing across the room when I finished the last page, for the ending was horrendous! There was no ending! It just stopped, leaving loose ends dangling everywhere, and the reader in a mess of mass confusion with no resolution of any kind. Don't get me wrong, there were parts of the novel that I adored - it was definitely a masterpiece of modern literature, no doubt! Especially the old, Jewish judge who should have been played by Ray

Walston, or the guy that played the judge in the horrible *Presumed Innocent*. The character of the judge was the funniest character in the story. However, I have come to accept Morgan Freeman in that role, for his version of The Judge ranks among his best, like that of *The Shawshank Redemption* and *Driving Miss Daisy*. There are moments that he is extremely hilarious in a vicious way, to bringing the house down with his brilliantly acted "Be decent" speech scene at the film's climax.

As for the book of this, I read some really cool reviews the other night (mainly the 2 and 3 star one's), and a *lot* said basically the same thing I did about the book's horrible (non) ending. I have seen films from books come out a *lot* worse (*Flowers In The Attic* anyone???) and get treated a lot less aggressively; and, when you think about it, it was all for naught. Very little was changed. There was a *lot* to cover in that book, and I think the film did it just fine. The only three bestsellers turned into film that took such a beating and being so viciously ravished upon adaptation: Stanley Kubrick's classic version of Stephen King's *The Shining*, and Clint Eastwood's criminally bashed classic *Midnight In The Garden Of Good And Evil* based on the novel by John Berendt. All great films. *Gone With The Wind* and/or *The Wizard Of Oz* never caused such a stir, and we all know there were *major* things changed in those when translated from book to screen.

It's a good book, but the only reason I read it was because I read that De Palma was going to be filming it, so I read it real quick, and the film came

out about two weeks after I finished it. I need to read the book again whenever I get the chance. There were some great characters in it with names that were hilarious (I can't remember any off-hand) that didn't make it into the film, and I still struggle with the change made in the Judge's character (in the book he's an old Jewish man, and in the film he's Morgan Freeman), even though I have come to accept it over the years. And, as much as I like the "Be decent" speech, I do remember a *lot* of people start groaning and moaning (and I was one of them). It just seemed *so* corny and out of line with the rest of the film. But, after a couple of viewings, not only have I learned to accept it, I 'get' it, and actually like it now. The 'punch line' is after the Judge is done, and the crowd starts back into their 'mob mentality', letting us know they obviously missed the entire point of what he was trying to teach them. Very realistic, now that I think about it.

Now, about the film: This movie was killed by critics before it ever hit theaters. Things like "Bad casting", "Not faithful to the novel", etc, etc. kept popping up in article after article, and/or mentioned on talk shows before the film was even completed. So, you tell me who killed this film at the box office?! It sure as heck wasn't director Brian De Palma's fault! He served up a super satire that was very faithful to the book, except for the already mentioned judge character, and not detailing a lot of description about some of the character's backgrounds and/or motives, especially that of assistant DA Jed Krandall, perfectly played by comedic actor Saul Rubinek, and turning Peter Fallow from a Brit into an American, which I had

no problem with what-so-ever. As a matter of fact, if you'll notice, that works perfectly since there are so many other British characters in the story, like Fallow's publishing boss, and especially the brilliant Beth Broderick as a bitter socialite whose Italian lover has been stolen away from her by the devilishly femme fatale cunning bitch Maria Ruskin, who is obviously a socialite wannabe phony, sleeping her way among the idle rich, whose accent changes back and forth because she's such a phony person, who doesn't have any problem being a "black widow", or setting up Sherman for a crime he never committed, so wonderfully played by Melanie Griffith; her best work next to that of De Palma's 1984 classic thriller *Body Double* and Mike Nicholls' excellent 1987 film *Working Girl*. And, De Palma gave it a very nice ending that wrapped everything up. (Not that I feel that every story has to tie itself up all neat and tidy, but this is one of those stories that needed that kind of closure.)

And about the casting of Tom Hanks, well, I, too had my reservations about that since the only decent film he had made was Penny Marshall's *Big*, which was still somewhat of a juvenile film, but still one that I love. This is *the* film that started Tom Hanks onto the Award winning actor trail (and I'm so surprised, even all these years later, especially looking back on how his career evolved after this film that he didn't receive better accolades for his performance), because the next roles Tom got offered, which I'm sure was due in large part to his awesome job in this film, were films like Jonathan Demme's *Philadelphia*, Robert Zemeckis' *Forrest Gump*, Steven Speilberg's *Saving Private Ryan*, Ron

Howard's *Apollo 13*, and Frank Darabont's *The Green Mile*, all great films, roles that I don't think that he would have been offered had it not been for this film giving him the chance to showcase what a mature, talented actor that he really was and still is. His films before this were duds like *The 'Burbs, Bachelor Party, Volunteers, Turner & Hooch, Joe Versus The Volcano*, and the god-awful *Dragnet*.

And let's not forget Kim Catrall's performance of Sherman's socialite bitch of a wife, who until then was among the ranks of Tom Hanks' earlier work (except her great work in John Carpenter's comic classic *Big Trouble In Little China*), but went on from this to success in several great films and onto HBO's "Sex And The City". I loved Kim Cattrall in this. I thought this was one her best roles ever: Mizzzz Judy ("Sherman, we're at a dinner party, a married couple standing together talking to each other in the middle of the room, you just don't do that, now mingle!") McCoy. What an icy bitch!

And a seven year old Kirsten Dunst who comes off like a modern day Shirley Temple in her scenes as Sherman and Judy`s daughter Campbell, who went on to stealing the scenes in a lot of great movies, be it *Interview With The Vampire* or *Eternal Sunshine Of The Spotless Mind* . Even at such a young age she showed signs of her awesome talent for acting in this film.

And Rita Wilson (Tom Hanks' wife) had a great small part in the awesome tracking shop opening of the film, purposely playing a nerve-shattering socialite who comes across as meek and stuttery,

shy and jittery, naive and unnerving all in a 5 minute scene. Plus, the opening steadicam shot and the unnerving feeling that's created is on purpose because De Palma is bringing us into a world of chaos that's just smoldering away, just like today's eroding communities.

And the list of cameos by "top" name people is endless: George Plimpton, comedic genius Alan King as Maria Ruskin's *much* older husband, Arthur Ruskin, Geraldo Rivera (playing a fictional version of himself, which was dead on perfect since Rivera was the ultimate media slut - and I mean that in deep respect to Geraldo, for he in and of himself helped expose what trash the media can sink to - during the entire 1980's, as well as the '90's). As for Geraldo, well, I found that, even though he's not an actor, he was *perfect* for his role in this. A *true* media slut!

And for Bruce Willis, well, it's a shame that a lot of people can't except him unless he's in a *Die Hard* movie, but has shown such extreme degree's to acting. Whether it be on the TV or on The Big Screen, Willis has done some awesome acting, as in Terry Gilliam's brilliant *12 Monkeys*, Rob Reiner's criminally bashed *North*, and *The Sixth Sense*. His interpretation of Peter Fallow is pitch perfect, looking like a modern day Cary Grant.

As other reviewers who like this film and know the story, are so right, this film was killed by critics for political reasons. And, that's a damn shame, for this is one of the funniest satires to ever come out of Hollywood, and also because De Palma has sworn

that he'll never make another comedy because people don't get his sense of humor. And, for anyone who's seen *Greetings, Hi, Mom!, The Wedding Party, Get To Know Your Rabbit, Phantom Of The Paradise, Home Movies,* or *Wise Guys* will also agree that that's just flat out tragic, for his comedies are side-splitting hilarious! As for the rest of the cast, everyone did an awesome job bringing such loathsome characters to life in celluloid.

Everyone I knew back in 1990 agreed that this was an awesome movie, and they too had read the book. As for Tom Hanks' Sherman McCoy, I couldn't picture anyone else in this role. He offers the depth and pathos to make you feel for his plight as the man who's falsely accused, whose life is shattered by one simple little accident and will never be the same again, a common theme often used in Hitchcock films. Another ploy often used in Hitchcock classics was to use star power instead of unknown actors. And, I think this ploy serves to benefit both directors for the films that they choose to use it for.

This was definitely a film ahead of its time (remember the race riots in L.A. in 1995?), for it still stands out as a masterpiece of cinema even today. Even Kubrick's masterpiece *The Shining* didn't take such a beating for "not being faithful to the source novel", and I can't think of a better example of a film that stripped the source material down to the bare bones to be rebuilt into the classic it is today. And, *The Shining* was a far superior best selling novel than Tom Wolfe's one hit wonder ever

was!

So, again, it begs to question, why did critics, even before they even saw a single print of this movie, decide to trash it, calling it a bomb *before* it was even released?!?! Could it be because it was so daring? So `politically incorrect' at a time when half the world was crying for political correctness? Oh, did I forget to mention how politically incorrect this film is. *That's* what got a lot of critics in a panty-wad! When this came out, PC was overtaking this country like a new plague, and here this was just spitting it in the face. I mean what other film came out at that time, or since, where a white character says "We're in the jungle!" when seeing black characters? Or, "Natives!"? Or, the Park Avenue dinner/opera scenes where the latest fads are a man with AIDS and Sherman's arrest.?.?.

Could it be because of the way it so realistically portrayed the different social and racial classes in our society? The way it so effectively tackled the egos and vanities of people, laying them wide open, exposing the very jugular of modern society's ugly ass greed and selfishness? (I believe the answer is "Yes, Yes, Yes, and Yes".)

That has always puzzled me. Either way, it hurt the film's box office performance (which I was lucky enough to see it in the theater that it played, and I remember a huge audience roaring with laughter throughout the entire film). I was hoping that word of mouth would help people overcome the prejudices set by the critics, but that just never happened, at least during its theatrical run. Who

knows, it may have actually been a box office hit, but the media won't ever allow that to be known; because anyone I've ever known and/or encountered that has seen the film all agree that it was great.

But, either way, it's nice to see that it has gained a growing audience of viewers like myself over the years. Just think, Hitchcock's final film, the hilarious classic *Family Plot* flopped upon release, but is now considered one of his best films ever. Hopefully time will be as kind to De Palma's adaptation of Wolfe's novel, which was just as great as his adaptations of *Carrie*, *The Fury*, *Casualties Of War*, *Carlito's Way*, and *The Black Dahlia*.

Either way, I will continue to enjoy it every time I get the chance, for I feel it ranks up there with some of the best comic classics ever made, along with Hitchcock's best classic comedies, like *Mr. And Mrs. Smith*, *The Trouble With Harry*, and *Family Plot*; or as comparable to Robert Altman's *The Player*. And for those that do like the film, always think of Beth Broderick's character on that Xerox machine, saying to Peter Fallow "And when you find them, tell them this is from the twat that turned them in" whenever you need a laugh. If you haven't seen it, then it's worth viewing for that scene alone. Just remember this is a satire, not slapstick.

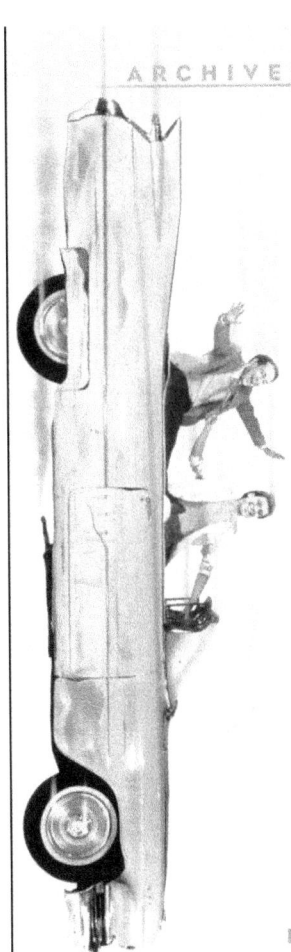

ARCHIVE COLLECTION

DANNY DeVITO
JOE PISCOPO
WISE GUYS

What kind of guys gamble with the boss' money, swipe a killer's Cadillac and party on the mob's credit card?

De Palma's Madcap Mob Movie...
This review is from: *Wise Guys* (DVD)

Although known primarily for his thrillers and crime dramas, director Brian De Palma started off as mostly a comedic director, but with the exception of 1979's *Home Movies*, *Wise Guys* would be the first pure comedic vehicle he has done since *Phantom Of The Paradise* in 1974.

After spending 2+ years making the epic gangster crime drama *Scarface*, De Palma immediately released another (great) typical satiric erotic psychological mystery thriller, *Body Double*; however, he felt the need to let off some steam and get a bit of comedic relief from all of the blood and violence. So, he made one of the funniest comedies ever made. I always thought the tagline on this film should have been "De Palma makes you scream...with laughter!"

Casting such talented people as Danny DeVito, Joe Piscopo, Dan Hedaya, Harvey Keitel, Captain Lou Albano, Patti LuPone, Ray Sharkey, working from a script by George Gallo, produced by Aaron Russo, De Palma put his trademark stamp on this film, and turned out something so funny that you will be screaming with laughter the entire time.

Harry (DeVito) and Moe (Piscopo) are two neighbors/best friends who happen to work for the local crime/mob boss (Hedaya), hoping and dreaming (and scheming) to one day be their own boss, and have their own 'crew'. In the meantime, they are very low on the totem pole, living in

Newark, being the 'go-getter' guys for their crime boss, they go get his dry cleaning, start his car, etc. One day at the tracks, Harry has a 'brainstorm' to bet their boss' money on the wrong horse, thinking it would win and he and Moe could make off with the cash, and no one would be none the wiser since their boss' bets usually were a bust anyways. Well, today is not their lucky day!

Separated and threatened, one is played against the other, trying to force them to rat one out; but, they are too loyal to each other, something that really bothers their boss. So, he tells them secretly, that to make things right with him, one must 'off' the other, and he gives each one a gun. In the meantime, bets start rolling in amongst the other 'employees' (mob thugs) as to who will 'bump' who first, Harry or Moe? They are warned that there is a hit out on them by the local bartender (Sharkey), so they steal The Fixer's (Albano) car, a pink Cadillac, and off to Atlantic City they go to see Harry's uncle Larry.

They are met with a very cold welcome by Harry's aunt, so they go to a long-time friend, Bobby's (Keitel), casino/hotel to stay. This is possibly the most hilarious section of the film, as it does keep the laughter coming as it moves along, with a brisk pace, and several twists and turns in the plot.

Yes, even though it is a comedy, De Palma throws in a terrific last minute twist that is utterly climatic and fantastic and hilarious.

Everyone in this is hilarious, especially Albano, DeVito, and Piscopo, who never did a funnier film

before *or* after this one. Not to be mistaken and/or confused with the weaker, less funny *Johnny Dangerously* (which came out the same year, something Hollywood has done to De Palma to this day, try to compete with his films by releasing a 'Hollywood' version that isn't as good).

DeVito is great in this, as is Piscopo, but the highlight is Captain Lou Albano as The Fixer, a mob hit man who has a lust for killing Harry and Moe with a vengeance (especially after they steal his car). Captain Lou 'killed' as The Fixer! This is a laugh riot!

Released in 1986 to mixed reviews (Siskel & Ebert gave it a huge thumbs up), this is the film that stupid comedies like "Dumb And Dumber" only wish they could be, and it's just as funny (if not funnier) today as it was 28 years ago when it was released.

Unlike the Farrelly Brothers (and that whole 'stupid/toilet humor/try-to-make-you-laugh-every-5 seconds') and other *bad* comedies (if they could be called such) that we have been force fed with since the late 80's (the 90's were *really* bad for these type of 'comedies'), this is "dumb comedy" done right, because it is intelligently made. I should have taken it as an 'omen' when De Palma's 1990 intelligent comedy *The Bonfire Of The Vanities* flopped, then the onslaught of 'Stupid Humor' took over for an entire decade, even still thriving a bit into this one.

Where as *Bonfire* is more 'satire', *Wise Guys* (while an intelligent comedy) is flat out comedy! This is

make-you-spit-your-food-out-'cause-you're-laughing-so-hard-type funny!

I believe this is a film that you will enjoy the more you watch it, because like all of De Palma's films, there are always a *lot* of hidden nuances that take repeat viewings to notice them all.

Heavily recommended!

Thank you. "No, thank you, Mr. Alcavado!" ;-)

Mind Rot @ Its Most Blatant!
This review is from: *Saw* (DVD)

I can understand when someone likes a film for reasons others may hate it, and sometimes acting, mood, lighting, sound, and direction all make a huge effect on someone's opinion of something. I believe anything could be better than this 'film', even cutting myself to pieces and filming it would be more fun than this crap!

Danny Glover stars in this. I had to check the main Amazon page to verify that sense I don't own this crap. Isn't that a shock in the rubber parts??!! To think at one time he was doing such *great* work in classics like *The Color Purple* to sink to doing this. Wow, what a downfall!! I think Glover needed the money. I was embarrassed for him! And, I thought he was embarrassing in *Gone Fishin'*, but this is the bottom of the barrel. This is unwatchable garbage.

Yes, this is simply nothing more than mind rot at its most blatant! There is no plot, no psychology, no suspense, just gore-gore-gore-and *more* gore just for the sake of showing gore. And to think this film not only is a 'hit', but it has spawned sequels. Now, that to me is psychologically frightening, a lot more scarier than this film (or its sequels) could ever dare to be. If I want to see someone being tortured, I'll visit youtube and watch some Iraq footage or something, but I really don't prefer to view someone being tortured just for shock value.

This isn't 'horror', nor is it a 'film', but disgusting pieces of footage combined together to whet a poor

filmmaker's egotistical fetishes and air them in public for all to see; and, what vile carnal garbage this is, at that. Bilge like this should be flushed down the toilet, along with the people who made it. I couldn't sit through more than 20 minutes of this crap. It isn't merely disgusting, it's PRETENTIOUS JUNK that's pretending to be "art", when in reality it has *nothing* to say or add to the world...except maybe provide viewing pleasure for people who get off on watching torture. And *that's* scary. We've sunk pretty low. These are some sorry individuals who made this!

The scariest thing is indeed the fact that so many people love this crap. Some are starting to call it "torture porn", meaning that it's pornography for people who love violence, not sex. I think that's an apt description.

These movies are inhuman. People, mostly kids and young adults, are paying good money to enjoy watching inhuman acts. Society is becoming like *Lord of the Flies*. And the people who are the sickest are the least likely to see it in themselves, apparently.

I advise anyone with any common sense of decency to stay as far away from these trash 'snuff-porn for dummies' films as possible. They are a plague on our country, and people are sitting in theaters eating them up as they are eating their popcorn and being told 'this is ok to watch', brainwashed like mindless sheep. Treat this crap like AIDS or Typhoid Mary, for it is liken to a very scary virus that's overtaking theaters in place of what used to be great cinema.

I read someone reviewing *Hostel Part II* saying that Hitchcock would love it. *Huh??? Really???!* What drugs are these people on to even remotely try to compare this garbage to anything Hitchcock???! He wouldn't even watch such crap, let alone applaud it. And the same goes for Jonathan Demme (the director of the classic *The Silence of the Lambs*, another film these 'fans' are comparing this crap to).

Don't get me wrong, for I believe everybody has the right to form their own opinion, but these type of films were hidden from sight and considered illegal just 20 years ago, and now they are being paraded from theater to theater with pride. What the hell happened to our society???

If I want to see someone digging in a toilet, I will watch a plumber working, that would be more entertaining than this trash any day.

And, since I prefer my horror films to be psychological, I will steer as far from this as humanly possible, and I advise the same for any other intelligent/intellectual filmgoer out there.

Yet Another Gory Snuff Film...
This review is from: *Hostel Part II* (DVD)

No offense, but I believe that anyone that would like this kind of trash cinema really needs psychiatric help! It's not natural for someone to want to see crap like that, and that's a scientific/psychological fact.

Many critics have dubbed *Hostel* and films of that ilk as "torture porn", and it definitely fits. The first *Hostel* was just ugly and pointless. And, to think this a "Part 2" to an awful 'snuff' film, like the *Saw* movies (and they have made now a total of 7 or 8 *Saw* films, oh, the horrors!!)

This type of garbage is a whole new, separate genre of film than the slasher/horror film genre, and for anyone to mistake the two should get a mental check up. For, whoever gets pleasure out of sitting and watching people being so graphically tortured (and enjoying watching it and giving it such high rating reviews) are pure sick perverted deviants who are in dire need of a mental evaluation.

Romero's *Dead* trilogy, Hooper's *Texas Chainsaw Massacre*, Cronenberg's *Scanners*, and/or Carpenter's *The Thing* are great examples of great horror films with gore in them to serve the story, as opposed to this kind of crap that shows just how lowbrow our society is sinking to, like Zero the Hero, where in the toilet, their mind floats there all day.

I believe that everyone has the freedom to have their own opinion, but when it comes to 'films' (if they

can be called such) like this, well, there was a time that these were considered 'snuff' films, and were considered the lowest form of filmmaking *ever*; and, still are by right minded thinking people. What's the next step, having people film other people being tortured and killed for real to get their jollies off on?!

I really wish that there was a minus 10 or more rating system for shit like this.

This is nothing more than smut at its most purest form, right there in the theater, and today's generation are eating it up like the popcorn they are eating while watching it. Now, *that's* scary!!

I *love* directors who make 'horror' movies, but this is *not* a horror film, but a smut/snuff film that anyone who likes needs a lobotomy!

I haven't ever seen the *Faces of Death* films, something that people are likening this new subgenre of films to, nor did I ever want to; and this (and *Saw*, *The Descent*, and *Hostel*) is just like those; and even just as plotless. Just gore, gore, and more gore just for the sake of showing gore.

As for Eli Roth, well, he's a trashy filmmaker who shouldn't be allowed behind a camera, let alone allowed to release his smut upon the unsuspecting public. What a grotesque hack of a filmmaker if there ever was one! How he ever got allowed to make his trashy 'films' is *so* beyond me. Especially when you take into account what a film is supposed to do, and that is to entertain, not repulse.

I'm sure filmmakers who pioneered the art, like Hitchcock, Kubrick, Bergman, Hawkes, Wilder, as well as filmmakers of slasher/horror films that have now passed on, are turning over in their graves, repulsed by how lowbrow our society has eroded to, and just how lowbrow they expect their 'entertainment' to be; especially if shit like *Saw*, *Hostel*, *The Descent* type 'films' are continuing to be made.

Films like those of the *Hostel* and *Saw* series are similar to what gonzo porn is to erotica: Stripped down scenes of physical overload, devoid of any context or plot. What is the thrill in watching close to two hours of nonstop blood and viscera pouring out of the tortured bodies of good-looking young women and men?

It may be true that *Hostel* and torture porn are thriving because our society is rather sick at the moment, devoid of spirituality and humanity, and indulging in its sadistic, ugly side. I don't know. Our society is devoid of a *lot* of humanity right now, but that's no reason for our entertainment to suffer and suck like it does these days. And, especially to be expected to like it. No way!

Even though there were some gory horror films I saw when I was growing up, they at least had a story, a 'plot', a word missing from today's garbage cinema; some I'll love forever in memory like Romero's *Dead* trilogy, Cronenberg's *Scanners* and *Videodrome*, Hooper's first two *Texas Chainsaw Massacre* films. But, stuff being made over the past

ten years is some of the most bizarre, twisted, sick, perverted garbage ever. And, as for crass crap cinema like this, it's nothing but snuff/torture porn/smut/gory garbage for the sake of being all of the above. That's all these kind of films thrive on, they are just a waste of celluloid.

There is not enough money in the world to get me to sit through a lot of films made today. I really don't get the draw of watching people die in graphic ways. I'd rather sit through Miike's *Ichy The Killer* any day over this type of snuff porno/smut/trash cinema any day, and from what I've read ITK would make me faint from all of the gore, but there's at least a story in it, and even depths of emotion, something missing from today's sloth of gore fest films like this.

Hollywood is a slut anymore, pandering out weak sequels, remakes, and just flat out gorefest snuff/smut film garbage that you couldn't pay me enough money in the world to sit through.

Check out Romero's *Dead* films (zombie films) for some awesome gore. Or, check out lesser known, independent horror films, like *Food Of The Gods Part 2, Hell Night, The Beast Within*, or view a lot of the Troma films like *Class Of Nuke 'Em High* or *Surf Nazis Must Die* for some good, cheesy entertaining gore fests.

Yes, I know the difference between a smut film and a snuff film, but this garbage is very akin to both. Just because the characters get up alive at the end of the day's shoot doesn't mean what they are shooting

isn't unforgivably ugly for the movie going public to have to sit through; and they are liken to the type of films that only sick perverted people would have very secret screenings of at secret parties because they used to be illegal. And, they ought to still be if you ask me.

I'm not talking about a gory horror film in general, but these torture/snuff/smut/porn for dummies films that people are getting off on while eating their popcorn and moaning like the mindless sheep they are while drooling over what they are viewing, being fed such repulsive eye candy, and being told that it's okay to enjoy it, that it's normal to want to view people being torn apart and tortured for their amusement. There is something *very* wrong with that.

I wouldn't call any fan of *great* horror films mentally ill, but those that soak this 'snuff' film type porn gonzo down like Pinto beans are. That's the problem today, too many people are 'sleeping' and spending money on crap like this and declaring it art.

There is a wide difference between the films of Capenter, Romero, Cronenberg, et al and Roth as big as the Grand Canyon. Sorry, but Roth is *not* an artist, but an egotistical hack who got lucky and got someone to finance this junk.

A *lot* of our younger generation is letting it further dehumanize them against humanity in general, and that's the target demographic in my review. Read some of the reviews, one declaring *Hostel* to be

something Hitchcock would be proud of...*Huh??? Really???* Scary!!!

And some of the reviews of older horror films, saying "who cares about them, they were slow, boring, and tedious, wasting so much time forcing us to get to know characters that are just gonna get killed off anyways, so why bother making us get to know them?" Now, how immoral is that? Where is the moral center, the moral core of statements and/or comments like that?! Plus the blatant ignorance to just how and what makes a horror film work in the first place. Let that sink in (and seek those reviews and/or comments out if you like), then rethink just *why* I feel the way I do about this trash and what it's doing to society as a whole.

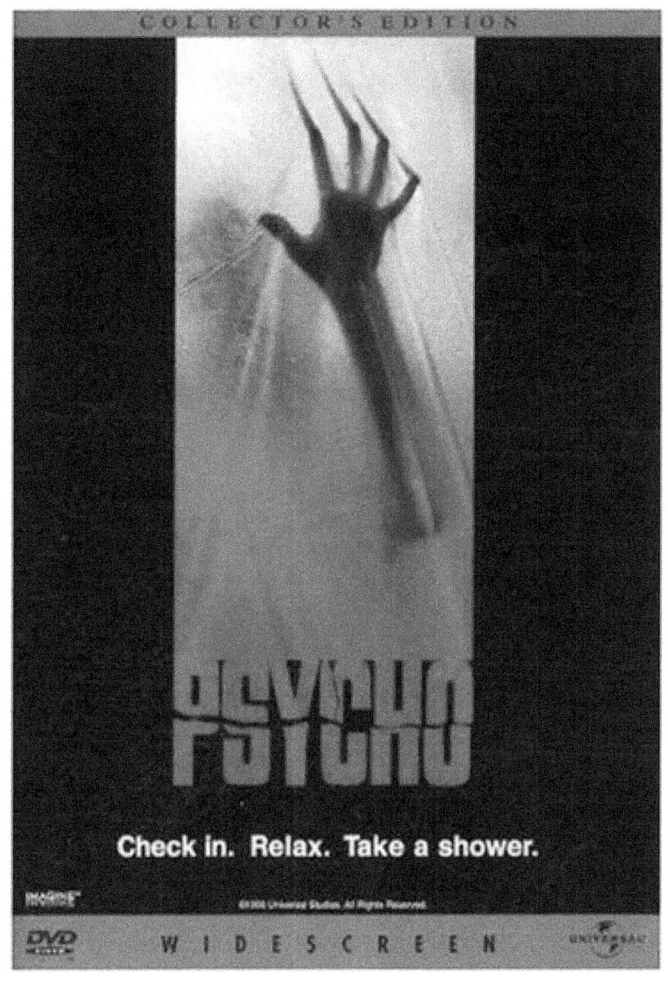

It Was Psychotic To Remake *Psycho*!
This review is from: *Psycho* (DVD)

It appears that all Hollywood can churn out anymore are god awful sequels and/or horrendous remakes of classics. It isn't that the original films are 'fixed', it is because they get 'stolen'. Why do films need to be remade for anyway? If someone doesn't like the way it looks originally, then move on to another film. How would you feel if you made a film, then 20 years down the road, some unknown filmmaker comes along trying to make a name for himself, decides to do it by remaking *your* film?!

I saw this one for free on Showtime a few years ago, and I still feel like I should get some kind of refund for even sitting through it. I definitely felt 'dirty', like I'd just seen a very bad porn.

I really hate to even give this one star. I really enjoyed some films by director Gus Van Sant, like *Drugstore Cowboy* and *To Die For*; but, after he remade Hitchcock's classic *Psycho*, I didn't care if he ever made another film again (but I have to kind of forgive him after he made *Milk*, don't judge me, ha-ha). First of all, this is a film that does not need to be remade. Especially a shot for shot *color* (?) remake. Hitchcock shot *Psycho* in B&W on purpose! He had a reason for not using color in the film. And, for Gus Van Sant not to get that just proves that he has no clue as to what made Hitchcock's masterpiece of cinema a classic to begin with, no idea of what made that film such a classic that it still is today.

Not only is the film as flat as a penny on a train track, but for some unknown reason, Van Sant felt the need to insert completely unnecessary shots, like storm clouds, and (what was he thinking?!?!) scenes of Norman masturbating while he's peeping. That was very offensive to any fan of the original, because the suspense is now replaced with repulsion! But, to me, the ultimate crime was at the end: Instead of freeze framing on the license plate of the car as it is being pulled from the marsh, Van Sant for God knows what reason allows his camera to keep rolling, letting the scene play out during the duration of credits. What a travesty to anything Hitchcock!!

People have slammed director Brian De Palma for borrowing from Hitchcock (one of the many reasons that I love De Palma!), and some have even declared his classic *Dressed To Kill* a *Psycho* rip off; but, at least it had a very new and fresh angle. Even De Palma wouldn't be as stupid as to try and remake a Hitchcock classic. There is no need when you can still watch the original films by the Master Of Suspense, available in most stores and Amazon on VHS and/or DVD.

Take Gus to the gallows for his crime of remaking Hitchcock's ultimate psychological mystery thriller. Van Sant should be hung in a public square for tampering with this timeless classic! He should be crucified for even touching a frame of Hitchcock's classic film. Whenever I think of this travesty against anything sacred, I wished that he would just fall off the planet. Do not, I repeat, DO NOT waste your time with this piece of garbage! If you haven't

seen *Psycho*, seek out the original version and see what everyone is talking about when it comes to one of the best psychological suspense mystery thrillers ever made.

In the meantime, check out some De Palma films if you want that Hitchcock 'flavor', but this film should be retrieved and the prints burned, for its sole existence is null and void, so it should be destroyed! Who would really miss it anyway?! Gus? I know I sure wouldn't! As far as I'm concerned, this film doesn't even exist... I meant to say that if you want that Hitchcock 'flavor', avoid this film like a very bad case of TB, and stick to watching Hitchcock's unique films. Even the oldest of his films still stand up as classic cinema today.

Film Noir At Its unUsual Best!
This review is from: *The Usual Suspects*
(DVD)

I've loved this film ever since it came out, I'm just now getting around to reviewing it. This is without a doubt the best film noir film released in the past two decades! Bryan Singer, working on a very low budget, delivers a high quality film that stands just as strong now as it did upon release in 1995.

The story unfolds at a very deliberate intoxicating pace, and the characters are all so believable, even though some of them may or may not be fictional to suit what may or may not be fictional accounts of certain events in the film.

Kevin Spacey, Gabrielle Byrne, Kevin Pollock, Stephen Baldwin, Benecio Del Torres, and Chaz Palminteri turn in tour-de-force performances in this stunning crime-caper film noir masterpiece from the director of the *X-Men* trilogy and *Apt Pupil*, a classic film based on the Stephen King novella.

The only other performance(s) from Spacey that I feel come anywhere as close to this is *Glengary Glenn Ross* and *American Beauty*. Another awesome performance by Kevin Spacey is in the Clint Eastwood film classic *Midnight In the Garden of Good and Evil*. Awesome film! But this is his *best* in my opinion.

And, the film is *so* unique! I really wished that director Bryan Singer would have stuck with this genre instead of wasting his talent with comic book

films. He could have been the *other* great director named Bryan alongside the likes of Brian De Palma, but with the small difference in name spelling. Too bad more films like this don't get made more often!

The story is so twisted and convoluted that at film's end, you're still left wondering *who is* Keyser Soze?. Even when you think you have a grasp on things and have everything figured out (even after the film's final twist), it still leaves the viewer reeling, not really sure if they have figured out just *who* the real Keyse Soze is or not, if there even is a Keyser Soze.

And, that is how great film noir is supposed to work. Think *The Big Sleep*, a story so twisted that allegedly the screenwriter didn't even know who 'done it' at the film's end. This is definitely a five star film (I would rate it higher if Amazon allowed such, giving it a ten or higher) that any film buff should add to their collection. I know that I am glad to own this modern day masterpiece. Comparable in some ways to John Carpenter's *In The Mouth of Madness* in that it spirals and twists into an ending that will leave you utterly breathless.

This film isn't for everyone, but it's definitely for me. My cup of tea. This is a film that will still be talked about in another ten years from now.

Confidentially...Not Noir!
This review is from: *L.A. Confidential* (DVD)

Not to `compare and despair', but Brian De Palma's film version of James Ellroy`s *The Black Dahlia* blows this out of the water as far as noir films go. And, didn't *anyone* notice that James Ellroy even praised that movie to the high heavens???! Now, about Curtis Hanson's *L.A. Confidential,* I don't recall Ellroy ever uttering a word about the film version of his work. Yes, it's set in the 50's, as opposed to the 40's like *Dahlia*, but this is a film that I've owned on VHS before, and had to watch it every so many months to remember what it was even about.

And, the dialogue is bad, for a period piece noir film, that is - except for a few words here or there - this dialogue could be in any modern film about any modern story. And the visual style just doesn't really go in the world of noir like Hanson would want it to. It is a great film. It's just that it didn't feel as 'noirish' as I feel it could have been. See Billy Wilder's *Sunset Boulevard* and then watch De Palma's adaptation of Ellroy's novel *The Black Dahlia*, and you may see what I mean about the whole 'noir' thing. Now, noir is not for everyone. Some people like it to feel more glossed over like Curtis did here. But, real noir is supposed to look sullen and dark and gloomy, and over-the-top performances.

I've just recently viewed this film, so it's fresh in my memory as I write this. The best part of noir in the film was in the movie being made in the film. Now,

that was *noir*! And, that's the kind of film De Palma modeled *The Black Dahlia* on. Hanson, on the other hand creates a terrific atmosphere, and directs a very stellar cast (but I do not see why Kim Basinger won the Academy award for her role in this, for she is good, but she drolls out the same kind of 'whisper-talk acting' that makes it very hard to hear her at times, plus it is extremely nerve-jarring, like she did in *Final Analysis*. And, to think that people are comparing Scarlett Johansson's great performance in *Dahlia* to hers is beyond me. Plus, where do people get that she's a femme fatale? That description does *not* fit her character!), and weaves a wonderful story, but it just never quite feels like noir. It looks too flashy, too modern, well, like a film *about* a film noir story would look like, instead of going for a flat out film noir approach, like Brian De Palma dared to do with *The Black Dahlia*.

I would give this film 4 stars for the great cast (except Danny DeVito, who did a great job, but was miscast in my opinion), and for the story line, but the look of the film gnawed at me several times. As a matter of fact, I would give it 5 stars for the story, but again I stress that this is *not* what film noir is supposed to look like! It is a movie that I would recommend, even highly so, but not if I were referring someone to take in a good film noir. For that, I would steer them toward *Double Indemnity, The Big Sleep*, De Palma's *Snake Eyes*, the Coen Brothers' *Blood Simple*, De Palma's *The Black Dahlia*, Ridley Scott's sci-fi noir *Blade Runner*, De Palma's *Obsession*, Bryan Singer's *The Usual Suspects*, the Wachowski Brothers' *Bound*, James Mangold's *Identity*, or back to earlier classics like

Dead Ringer (with Bette Davis and Karl Malden), *D.O.A.* (and I don't mean the horrendous Dennis Quaid/Meg Ryan remake), or Hitchcock's *Stagefright, Shadow Of A Doubt*, or *Saboteur*.

So, to recap, as a modern film, this is a great movie, but as film noir, I can only give it 3 stars at most. (Like *The Green Mile*, a movie I love, but have trouble with because it is a period piece, yet the dialogue could be out of any modern film.)

But, compared to any other film (especially most of the drek Hollywood keeps churning out), I would even give this film a 5 star rating. It's only because it looked too modern for a film noir set in the 50's, just sounded too modern in the dialogue and film tone. I just appreciate it more when a filmmaker is true to the era they are filming.

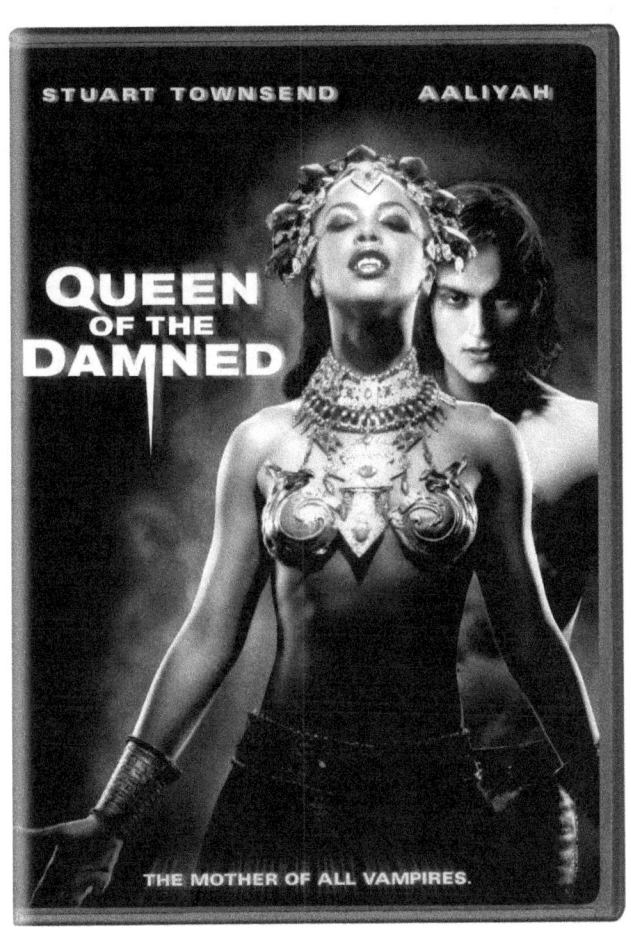

This Vampire Tale Rocks!
This review is from: *Queen of the Damned* (DVD)

I want to say that I refused to watch *Queen of the Damned* for the longest time because I was so afraid of how bad it was supposed to be. The trailer for this film does it no justice, and the amount of negative reviews, plus it seemed as if the whole 'Vampire Chronicles' was raped by these filmmakers, allegedly.

Now, after finally letting curiosity get the better of me, I finally relented and bought a copy of *Queen of the Damned* on widescreen DVD. I won't bother with going into plot and/or characters (except to correct reviewers who think the film made a mistake by opening with Lestat arising from a coffin, and not picking up where *Interview With The Vampire* left off. That's because *Interview* was Louis' story, and this is Lestat's story. Reread the novels if you need to, in case you don't believe me. Lestat even declared Louis a great liar about a *lot* of what was said in *Interview*), but I will state that this is the *best* modern vampire movie ever!! I would even rate this film higher than *Interview With The Vampire*, which kind of bores me after seeing this one. Plus, I could have done without having to see all the rat eating scenes in *Interview*!

Don't pay attention to other reviews, get this movie and make up your own mind. I'm sure you'll be glad that you did, especially if you're a fan of the first three novels by Anne Rice. Sure, some things get left out, but my god it would take a 3-part mini-

series just to tell *The Vampire Lestat*, and another 4 or 6 hours for *The Queen of the Damned*. And a large part that was cut was just repetitive stuff to begin with. And, plus, now there's the chance to make an entire film about "The Legend of the Twins". That story is not dead (as some reviewers on Amazon seem to think). Just because it wasn't in this film doesn't mean it can't be used in another!

The filmmakers of *Queen of the Damned* pieced together the most important aspects of the story that connected between two novels and ran with them and made an extraordinary masterpiece! Vive Lestat!! And, the soundtrack by Korn's Jonathan Davis and Marilyn Manson is *awesome*!! I have to admit, years ago after reading the books, I imagined a band like Queensryche or Judas Priest (someone with an operatic voice) doing the soundtrack, but I must admit that the 'Goth' music was *so* perfect for it in my opinion; and, that (along with the whole 'Fellini' look of the film) is why I love it so much. Yes, it's a bit hokey in spots, but overall, I don't know why so many people hate it as much as they do.

Reviews for this are split down the middle. If you like music and old-school style filmmaking then you may just like this. I'm not really that into vampire flicks. I *hate* the whole *Twilight*/tween fad that's overtaking the country. I didn't care for the vampire films of the 80's either. But I liked Stephen King's *Salem's Lot* and Anne Rice's first 4 or 5 (vampire) novels, and the films based on them.

And the DVD is *so* loaded with bonuses that definitely make this a very worthwhile investment!

PS: I hope that there are plans to film *Tale of the Body Thief* sometime in the near future!

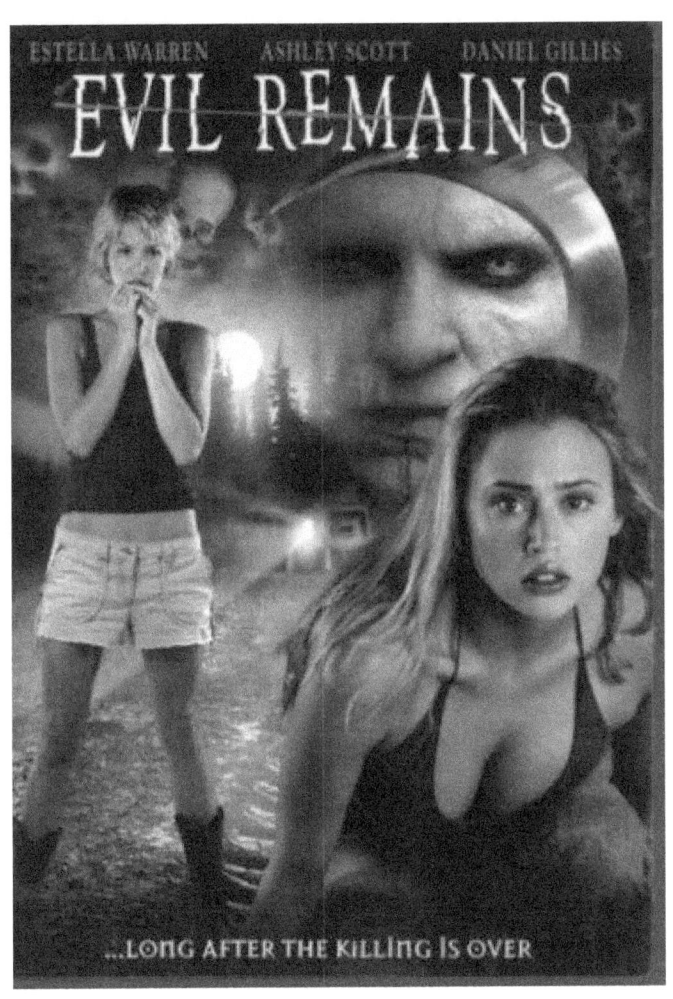

Creepy Psychological Slasher Horror At Its Finest!
This review is from: *Evil Remains* **(DVD)**

I caught this on late night TV a while back, and at first I thought that I was in for just yet another bad generic slasher/horror film, but after the film starts moving along, and even though there are some scenes early on that look very familiar to viewers that have seen the likes of *Halloween, Friday the 13th, The Amityville Horror, Texas Chainsaw Massacre,* and *The Blair Witch Project,* the plot and the acting and the story are so addicting that it is very hard to turn away...Then, wham, it turns into one of the most ingenious, original, refreshing horror films ever. Psychologically disturbing, supernaturally haunting, and bloody and violent and grotesque in the most brilliant way.

It is very hard to describe this film without giving away any of the plot, and some reviewers have done that (or have tried), and to do so would ruin the film for those who haven't seen it. For the whole point of the film is the mysterious aura placed all around and inside it. Three guys and two girls (I don't know *why* everyone online keep wanting to stress that the girls are lesbians...Who cares?!) go to an allegedly 'cursed' plantation house to investigate. From that point on, the way the story twists and turns, and the way characters turn on one another, lose trust in one another, misplace trust in one another, and question and/or argue about who and/or what they saw and/or seeing will have you on the verge of your seat the entire time until the end of the film.

About the females being lesbian, I thought they made a great couple, I think it saved them from having to have a 'forced' romance between one of the guys (now *that's* generic!). And it just seemed like *every* review I read before I wrote mine had that stated in there as if it was something of utter importance, or utter stupidity.

The spookiest part of this film relies on the brilliant use of sounds, like floorboards creaking, walls bleeding and thumping, steps sounding as if someone is coming or going. Loud attic noises. Loud basement noises. Just flat out creepy!

I can't believe I had never heard of this unknown masterpiece of modern slasher/horror, and for fans of good psychological supernatural slasher horror, I heavily recommend this, as I will definitely be buying a copy for myself *very* soon. Don't let the hokey DVD cover fool you (why they choose a cover like that baffles me!), this is along the lines of *Texas Chainsaw Massacre, The Funhouse, The Exorcist, The Shining, Psycho, Halloween*, and *Identity* as far as being a very top notch horror film. Very well made, and awesome casting and acting, and an awesome story (even though it may sound rehashed, it's *very* original once it gets going!).

I thought the movie was great, but still had its flaws. Despite the good acting, the movie does little to establish its characters, in particular the two brothers with a troubled past that's brought up but dropped just as quickly in favor of some bloody slasher action. As for the brothers, that was a last minute thing that I almost didn't catch because it

was so fast.

I do think a few of the characters could also show a little more common sense. One guy sees a freaky-looking image on a photo he just took, but neglects to show it to anyone else as incentive to leave. Another guy leaps off the roof of the house to escape but actually ends up backing himself towards the front door. And there's one lengthy scene that'll have you shouting "close the damn door!" And there was an exciting chase scene through the woods that makes an abrupt segue that temporarily kills the momentum. But, the chase scene, I think, gave way because the filmmaker wanted viewers to think that the guy the female heroine ran to for help was the killer.

And, after seeing this, you may want to re-think just how careful you have to be in the woods, what with the dangerous animal traps that could so easily kill someone, or at least keep someone trapped long enough for someone to kill them.

Hope this is helpful, and hope you enjoy it as much as I did. If not, then check out a few other 5 star ratings on this film, for they are all valid reviews. This is what great psychological slasher horror is supposed to be.

There is never a dull moment in this, and refreshingly, it's a film where the dialogue is very interesting throughout the film, for with every line of dialogue there is something learned about the characters and/or the plot, and/or both. Great mind fuck film!

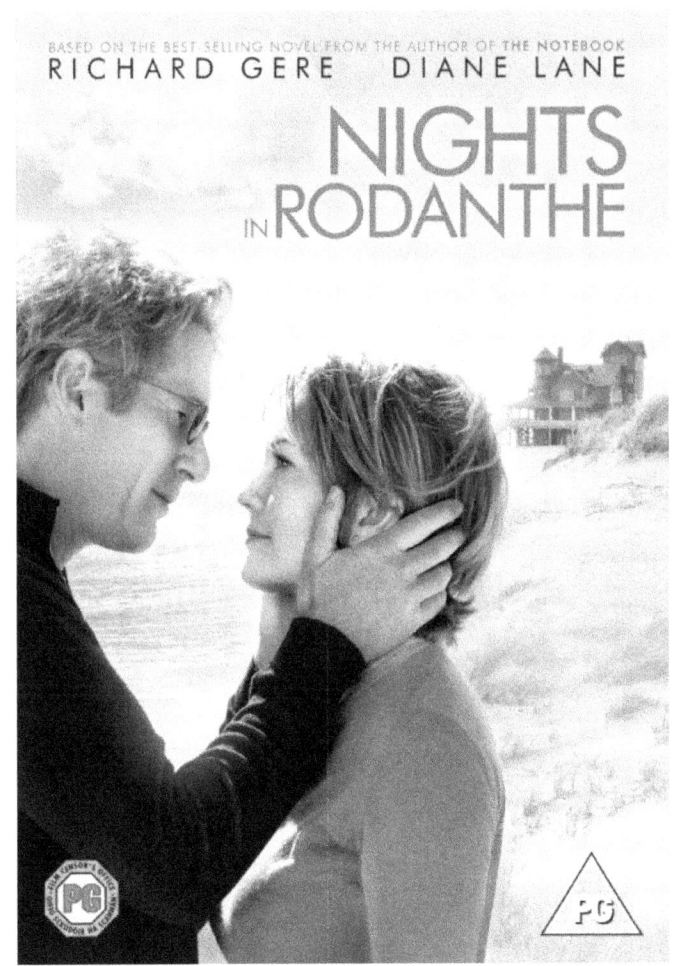

Oh, Those Summer Nights...
This review is from: *Nights In Rodanthe*
(DVD)

People are slamming this romantic drama for being too predictable and sappy. Well, they are right in one sense, but wrong in another. Yes, the film is predictable, but it isn't about the predictability but how characters deal with certain unpredictable things in life. Sappy? Yes, but, again, this deals with certain feelings, provoked and unprovoked, that lay dormant in all of us.

There was some unnecessary melodramatic acting about midway through that kind of put me off (hence the 4 stars), but the rest was good. I can see where people were put off by this melodrama, because I was a bit turned off by the over-dramatic acting about midway through, but I feel the story had a lot of depth.

There are a range of emotions in this film, from love to bitterness, from anger to forgiveness. There are things in life that will always take us by surprise, and none more so than falling in love with someone then they die before you really have the chance to get to know them. I know from my own experience in life. This film hit close to home with me. Yes, I have had something very similar to this happen to me, so it was something I could relate to on a personal level. I met someone one night at a party after work, and it was mutual that we liked each other, and planned on doing something the next evening. He died in a car wreck on the way home, and I was the last person to see him alive.

Something I never got closure on...

I, too, saw the outcome of this coming; but I didn't see the way a certain character was going to deal with the end result. Fabulous performances all across the board: Richard Gere, Diane Lane, Scott Glenn, and Pablo Schreiber all give top-notch performances in this, some roles larger than others; but all important to the overall story.

I wanted to see this when it came out because of Gere and Lane, but normally I don't fall for that 'hey they were in that and now they're in this' fad; but those two, well, that's an exception to the rule that I'll break gladly. Anyways, I was really impressed with this. Even if the story didn't hit close to home with everybody, I still feel it was a really good film.

Critics ravaged this upon release, but luckily I ignored them; and I am so glad I did!
Awesome direction, acting, and some breath taking scenery make this a very pleasant viewing experience. This is on the same par as the two previous films Gere and Lane did together, Francis Coppolla'a *The Cotton Club* (1984) and Adrian Lynne's *Unfaithful* (2002).

Basic plot: A divorced woman (Lane) meets a single doctor (Gere) while he is on vacation to deal with a grieving father (Glenn) and son (Schreiber). The two fall in love and the rest is, well, for you to see and find out for yourself. Highly recommended!

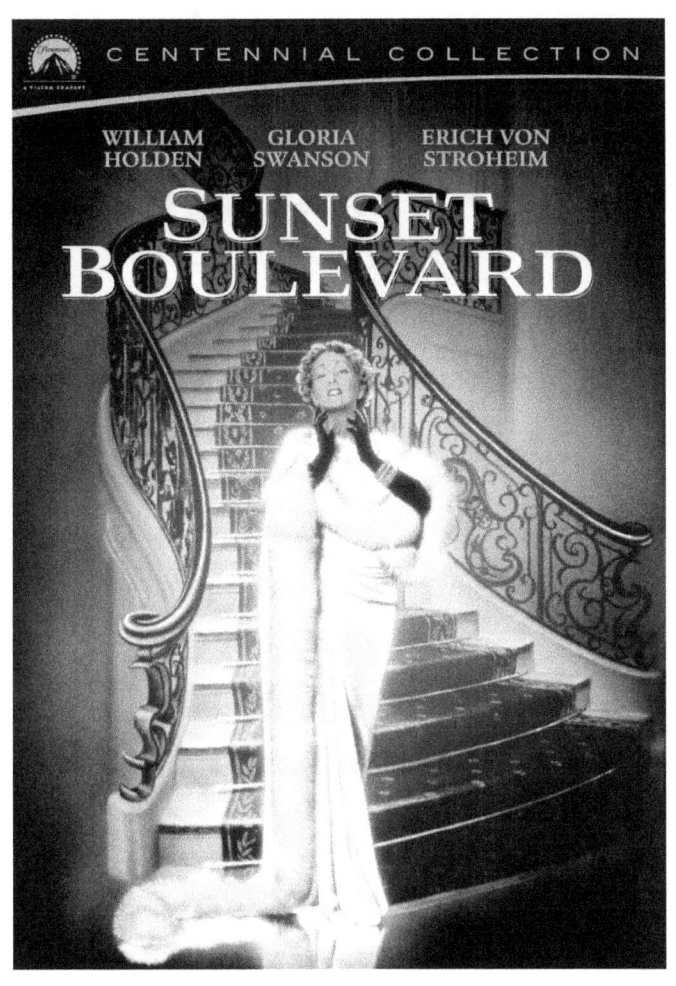

'Sunset Boo-la-vard'...
This review is from: *Sunset Boulevard* (DVD)

I am stunned that I hadn't seen this sooner over the years! I have sure more than made up for lost time though, because I have about worn this DVD out. This is one of the greatest films of all time.

Billy Wilder, one of the best filmmakers ever, crafted here one of the best film noirs ever made. Filled to the brim with scathing insight into Hollywood, biting satire, sweeping dramatic arcs, and uncanny resemblance to real life, this is one blistering depiction of a by-gone era that is still as relevant today as it was upon its release in 1950.

Gloria Swanson, a real life former silent film star, plays Nora Desmond, a former silent film star who is living solely on memories and faded dreams from the past. The industry has tossed her aside when films moved into the 'talking' era. William Holden, who in real life was a promising young actor who was on a down slope, plays a burned out promising screenwriter who is on bit of a down slope, broke, running from debt collectors, stumbling into Nora's 'world' literally. He becomes her 'writer' and lover and confidant, and eventual enemy.

Filled with real life film stars from the period, and film director Cecil B. De Mille playing himself, this is also a scathing look at the whole inside of the Hollywood industry and the mechanisms that are within it.

Hailed by many as a classic, and rightly so, this

timeless masterpiece is ripe for discovery for any film fan out there. Brian De Palma used a set piece, the luxurious hotel, in his noir film *The Black Dahlia*. Other films have paid homage to this over the years, but none can compare to this. Truly a classic for all to enjoy.

Billy Wilder was an awesome filmmaker. He was on fire with this masterpiece!

"Mr. De Mille, I'm ready for my close up"...

Highly recommended!

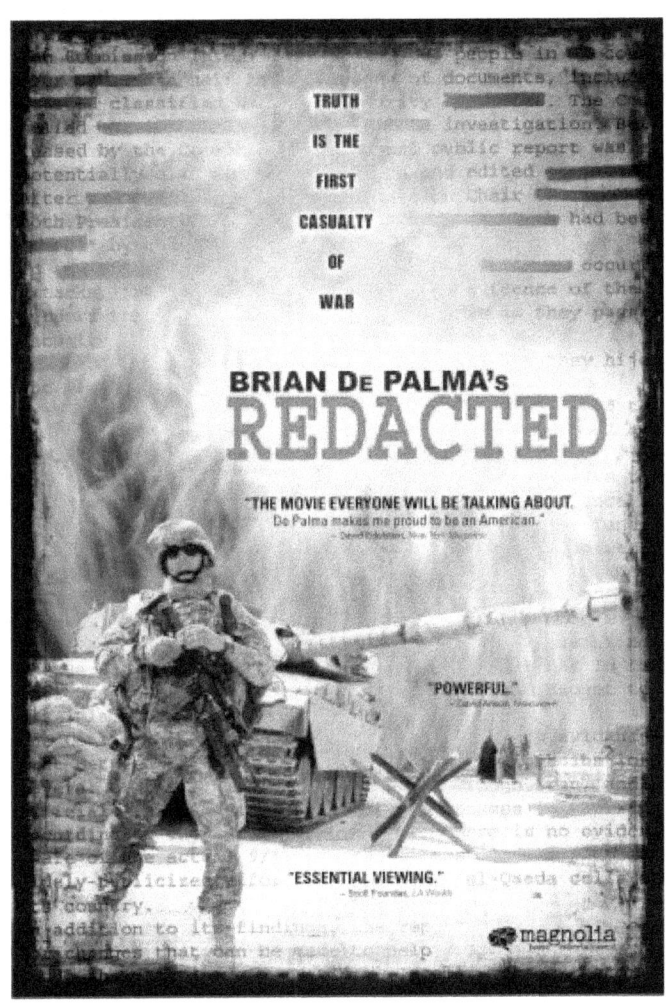

De Palma's Anti-War Masterpiece...
This review is from: *Redacted* (DVD)

This is hailed by a *lot* of critics as an utter masterpiece that leaves them breathless. I agree. If you have read any of my other reviews, you'll see that I am a very huge fan of Brian De Palma. I love every film he has ever made! But, don't let that distract from my opinion of this film. It's a film like this that makes me favor his work so much. Yes, there are some very scathing reviews of this film around (and all over the web), but there are some really glowing one's as well; and, rightly so!

First off, this is *not* a 'war film', but an 'anti-war' film. Yes, Brian had the balls to make a statement declaring how awful this whole war mess in Iraq really is. And, the results are magnificent. This is possibly the most powerful piece of anti-war propaganda since Kubrick's *Paths Of Glory*, and/or De Palma's own *Hi, Mom!*. Comparable in plot to his film , De Palma used the 'raped-girl-murdered-family' theme here to symbolize the whole brutality and senselessness that is war. And, the whole 'raping of a nation' that it encompasses.

This is not just a film to make you feel proud to be an American, but to make you feel glad to celebrate the fact that there is some Human decency still left in some of us. Yes, there are criticisms about the acting in this...Wow, some people just don't have a clue! The acting in this is spot on perfect! It is not a 'Hollywood-piece-of-crap' saturated with such generic quality that makes me want to barf. This is supposed to come across as reality, and it does! I am

still stumped by the fact that this film was considered so 'controversial'.

De Palma utilizes film techniques that he hasn't done since the radical days of the 1960's, when he was more of a guerrilla style filmmaker. Forget the 'Hitchcock borrower' style he so often utilizes. Yes, the film is glossy, beautiful to behold, and has magnificent cinematography, but the underlying theme is gritty and very ugly: The Truth!!! He incorporates so many techniques and styles in this, that it is pure dizzying, just like the chaotic world of the hell these guys are in. Using youtube videos, blogs, camcorders, documentary style footage, and straight out powerhouse filmmaking, De Palma has crafted possibly the best film in his entire career.

For all the 'Bill O'Reilley's' of the world, this is not a film for small minded people like you. No, this is a film for us that hate war, detest the violence and brutality and 'rape' that it induces on us, and desire to live in peace, harmony, and love between all of the nations; *not* just one. We are all under God, not just the U.S.. Yes, we do need to start a tsunami of Truth, and De Palma has tried to instigate just that with this brilliant film.

The final montage of photo's is so powerful, it would take a robot not to be moved by the very haunting images on the screen. And, don't even get me started on just how awesome the whole 'coming-home' scene at the bar is! This is an emotionally charged film that will leave some people weeping unabashedly, and rightfully so. No shame in that!

One of my favorite scenes is of a girl posting a youtube video, stating just how morose and barbaric war and machochism is. Don't let small-minded Bush-loving idiotic people cloud your judgement of this film (for most of them haven't even seen it, and if they did, they just don't understand its wonderful message), for this is such a awesome piece of filmmaking that it received a 15 minute standing ovation at its Venice premiere. The Cannes festival gave it top honors as well.

Too bad more anti-war films don't have the same kind of distinctive style and voice as *Redacted*. O'Reilley called De Palma "The Devil" (ha-ha-ha) for making this, some have even gone as far as to call him anti-American, but most intelligent critics are declaring (like I am) this to be one of the best anti-war statements in the history of film. O'Reilley and the whole Factor should be treated as an Enemy of the People.

This is not Hollywood, baby...This is a reflection of real life!

Hope this review is helpful to whoever reads it, and hope you enjoy the film! In the meantime, let's just hope that we don't all end up getting 'redacted' on what we want to voice as our opinion, especially when it comes to this atrocious war (Vietnam Part 2).

Thank you & Peace out!

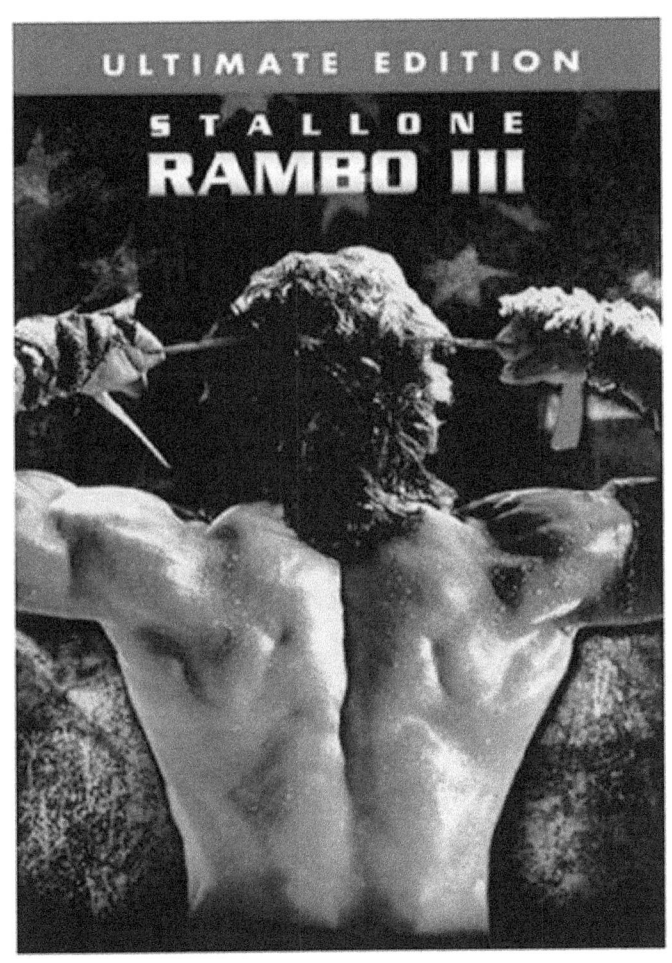

Brain Cells Died When This Came Out!
This review is from: *Rambo III* (DVD)

Ok, I hate this movie with a passion! A black passion at that. I hate the mere thought of its existence. And, it's not for reasons that many others may hate it, like bad plot (boy does it excel there!), bad acting (awards could be thrown like crazy at it for that one!), or the abysmally bad over-the-top machismo of it all (oh, yeah, Rambo a MAN, all MAN, and he no girly-man, get it!). Yeah! Right! What crap!

Of all the reasons to hate this film, and there are MANY, but I won't list them all here; just the one that has always bothered me the most, is the title. The first movie was called *First Blood*, then the sequel *Rambo: First Blood Part II*, so how did the people who made this garbage *ever* get away with the title *Rambo III*???!! There never was a movie called *Rambo* except for the subtitle of the sequel, so to me that would be as lame as calling the third sequel to *The Omen* (there were three films in that series: *The Omen, Damien: Omen II,* and *Omen III: The Final Conflict*) "Damien 3".

There never should have been a third film with the Rambo character, but if Hollywood really felt it necessary, then it should have been called by its rightful title: *First Blood Part III*, NOT *Rambo III*! That is a tremendous insult to moviegoers everywhere, highly displaying the dumbing down of our nation, making it extremely blatant that intelligence can take a back seat where this is concerned.

And, the scary thing is, well, look at all the "good" reviews on the Internet. *That's* scary!!! Why? You may ask. Well, in case I wasn't clear about what I was saying about the mistake in the title, let me remind you that there never was a *Rambo*, or a *Rambo II*. It was *First Blood* (which was an extremely good film, by the way), then the ill-conceived sequel, *Rambo: First Blood Part 2*.

This is an abysmally bad film, no matter what the title was. But, if the title had been *First Blood Part III*, then I feel like I could at least insult it on a more intellectual level instead of feeling like I am reviewing something a bunch of elementary school aged kids made. Almost. To give this piece of crap one star is too generous. Save some brain cells and skip this one!

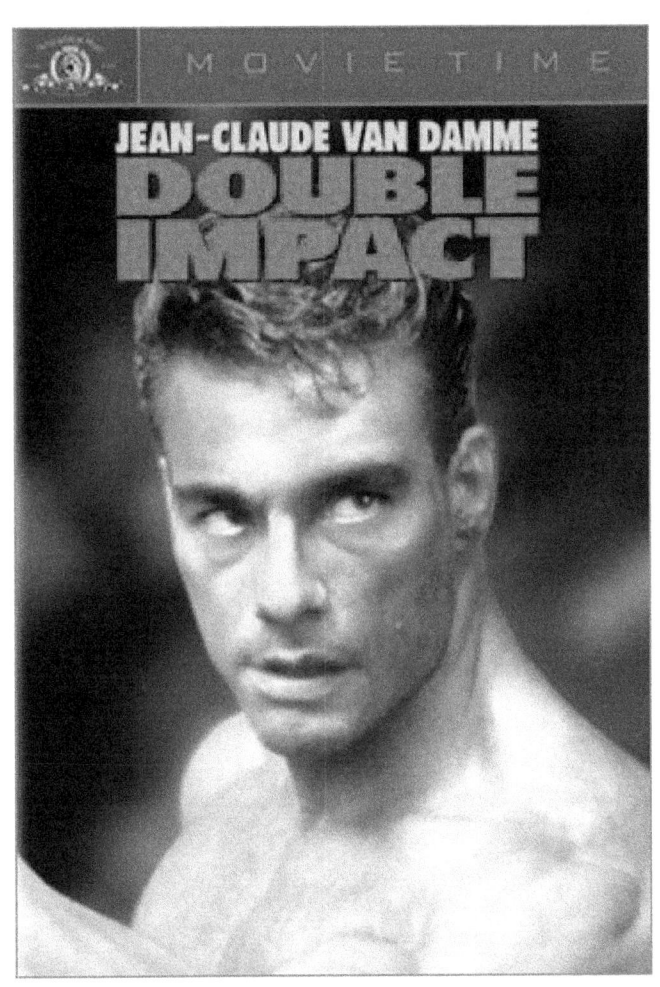

Dynamic Double Van Damme...
This review is from: *Double Impact* (DVD)

This is not necessarily my favorite genre of film, but I must say that it is a *very* impressive entertaining film. Jean-Claude Van Damme is *so* believable as twin brothers that it is so easy to think that Van Damme has a twin in real life starring in a movie with him.

The martial arts and action is great, as well as a very unique storyline. I especially enjoyed the (always) great Geoffrey Lewis in this. He is a perfect casting choice as the body guard of the twins' late parents, then years later as a friend/partner/protector of the adult twins.

I've never even been a big fan of Van Damme's, but he is great in this. And, as two completely different people! It's very well scripted and very well directed, and the acting is very well done by everyone in the film.

The story is that, as infants, the baby brothers are orphaned when their parents are murdered by a Chinese businessman and his American associate. Years later, the boys are now grown men, living completely separate lives, unaware that the other exists until Geoffrey Lewis' character brings them together to exact revenge on the people who murdered their parents, and to take back what is rightfully theirs.

This is a film I would highly recommend to anyone who is a fan of this genre of film, and/or anyone

who just wants to sit back, eat some popcorn and enjoy some great kick ass action and some awesome martial arts. This is definitely in the same league as any Bruce Lee flick, or any Jackie Chan film, if not better. It has all of the ingredients that this genre of film calls for: Action, adventure, martial arts fighting, murder, betrayal, double crossing, double dealing, revenge, and double Van Damme.

This was a surprisingly dynamic film. I say 'surprisingly' because I had never been a fan of Van Damme's before I saw this. I'm still not a 'fan', but I sure am open to seeing more of his films.

Not a movie that I would own, but one I would highly recommend. My only complaint was there were way too many head-butting scenes. Other than that, well, let's just say that this is a rare gem for the fans of martial arts/action films.

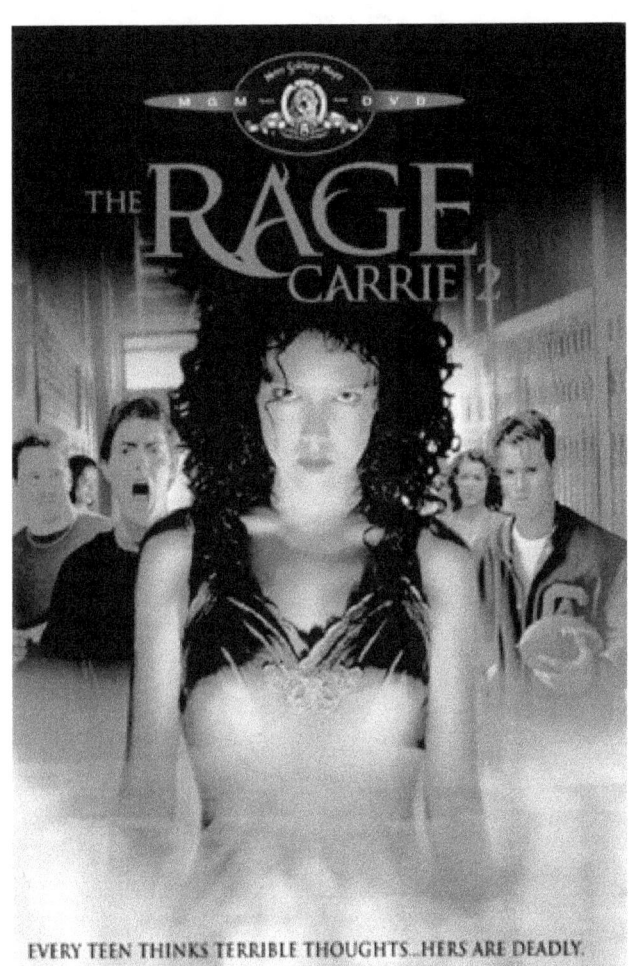

Calling A Film *Carrie* Without Carrie Is, Well…Scary!
This review is from: *The Rage: Carrie 2* **(DVD)**

I flat out refused to even view this tepid turkey for several years on principle alone. Carrie White *died* at the end of the film *Carrie*, so I have to wonder how in the hell can there be a sequel?!?! Anyways, I finally let my morbid curiosity get the better of me when I came across a copy of this on VHS a few years ago for only $3.

When someone goes to Hell in a burning house in the first film, that ought to be pretty sequel-proof, don't you think? And you'd think Amy Irving (whose character is the lone survivor in the first picture's slaughter finale) would run screaming from a follow-up. But no, we have to have Irving return, playing a school guidance counselor. Only reason to watch this: the grisly reward Irving receives for being in this picture.

Carrie was genius. This is trash! No Sissy Spacek. No Brian De Palma. No Piper Laurie. No "They're all gonna laugh at you!". No characters called Carrie. No soul. No pulse. No point. As generic in every aspect as Brian De Palma's original was inventive. This piece of garbage stars an unknown Emily Bergl as Rachel, a Different Kind of Girl with the ability to send coffee cups flying. Ho-hum.

How dare someone give this piece of garbage 5 stars???!! I believe that everyone has the right to their own opinions, but the prints to this film should have been burned by the studios before it got

released on the unsuspecting public. This is considered one of the all-time worst films ever. But, if people like it, more power to them, but don't ever question *my* taste in films just because I don't.

As for *The Rage* (I refuse to acknowledge this garbage as "Carrie 2"), even Stephen King hated this trash so bad that he remade his novel *Carrie* so people could have a modern day version of the Carrie story. However, *The Rage* had NOTHING whatsoever to do with De Palma's classic horror film *Carrie*! I know, they wrote that Rachel is Carrie's half sister, but how lame. That was also done in *Halloween II*, another useless sequel.

The current edition uses the original as a blueprint, but leaves out all the wit, sympathy and bravado. Though ideas and scenes are shamelessly recycled from *Carrie* and other horror movies - including gratuitous inserting of some 1976 clips - *The Rage* seems hellbent on diluting every exploitable aspect.

Maybe there's a real use for this film after all. Stand it up against the original, and you have a pretty good lesson in what's happened to the movies in the last couple of decades.

This simply repeats the story without extending it; it's little more than *Carrie* without any of the pizzazz, style, psychological cause and effect scares, graceful acting, and without the skill, intensity or excitement of the original. It's a prime example of the pointless remake, adding nothing substantial and only making its predecessor look even better.

Even among the misguided, unethical, numskull ranks of so many, many film producers, it's hard to believe anyone had the idea to revisit Brian De Palma's *Carrie*, which enjoyed a certain perverse perfection and narrative completion.

The Rage is the kind of film that gets unintentional laughs. They happen when Sue takes Rachel to the site of the burned-out old high school, where nobody has even cleaned up the rubble after 20 years, and every time there's a flashback to the original movie, mostly showing Sissy Spacek covered in blood. Yes, the central character visits the scorched wreckage of the old high school, which, for no discernible reason, has been allowed to stand for 20-odd years. Of the many clumsy sequences in *The Rage*, this one was one of the lamest.

The movie *Carrie* helped launch both Stephen King and Brian De Palma into their respective big leagues and kicked off the whole gutted teen genre. Unlike the truckload of horror flicks that followed it, *Carrie* didn't rely on knife-wielding bad boys in scary masks for its frights, but on a gawky little slip of a girl - which was, in lots of ways, much scarier.

What makes a movie like *The Rage* difficult to pull off is that its entirely lacking in suspense. The bad kids may pull their cruel stunts, but we all know that once they really piss her off, their puny spear guns will be no match for Rachel's Incredible Hulk anger-management style. Because the movie's all about bad coping skills, Rachel can't let her anger leak out a little at a time - she's got to grit her teeth until she

finally, cataclysmically, loses her cool. What this means is that most of the action takes place in the last few minutes, as bodies are impaled, castrated, decapitated, drowned and creatively dispatched via flying CDs in such rapid succession it's hard to tell what's going on in all the grisly mayhem. All that's certain is that it's really gross and it's over really fast. Before then, and for a huge chunk of the film, *Rage* actually bears no resemblance to *Carrie* whatsoever! Best to avoid this garbage!

Modern Day Gothic Film Noir...
This review is from: *The Number 23* (DVD)

As for *The Number 23*, I can't believe that so many people didn't like it! It is a solid masterpiece! But, I saw that it was hated by a *lot* of people and almost didn't buy it, but different opinions are a great thing in this old world we live in, and it's neat when we can so honestly be divided in half on some, like this film.

Jim Carrey is right at home in this role, especially as the detective. I will stand by my opinion, especially that it was one of Carey's best performances ever. I prefer him in more serious roles like that, unlike the godawful painful stupid comedies like *Dumb And Dumber* and (I actually wanted to swat myself in the crotch with a sledgehammer to end the suffering those films brought on!). *Liar Liar* and *Ace Ventura: Pet Detective* were 'cute' and funny.

No, this isn't one of Carey's dumbed down piece of crap "comedies"! If that was what most people were expecting, then no wonder they were disappointed. But for people who were expecting a more intense, intellectual film with Carey in it, then this was a real treat!

And, Virginia Madsen as his wife *and* Fabrizia...Wow! Just simply WOW!!

As for director Joel Schumacher, he's only directed 2 or 3 (ooh, 23, ooh!) films that I truly love: and this one. Sorry, I hated *The Lost Boys*. There, I said it, now get over it and move on. I didn't like *Flatliners*

either. As a matter of fact, during the 80's and 90's, I was very leery of even seeing his name attached to a film. But he sure struck gold here, in my humble opinion!

By the way, I thought parts of this looked a lot like what Tarantino ought to be doing (instead some of his recent trainwrecks), especially the ultra hip scenes with Detective Fingerling (especially when Fabrizia is introduced...Wow!!!). Again, I am baffled that so many people didn't like this. It was *so* hip, so *noir*, and a really cool mystery.

Even though I had read every low-star rating of the film and knew the 'mystery' before I watched it (you know how these reviewers are great at giving away too many spoilers), I still found myself suspecting other characters, like the psychiatrist, the wife, et al.

And for those who felt like there were maybe some "loose ends", the reason the film doesn't explore Carey's fascination with 23 is explained in the end (when it's revealed the book was written by...), and I never felt like anything made anything else in the film a 'joke'.

People really should give it a second chance! I'm realizing that there were a *lot* of films over the past recent years that I didn't like on a 1st viewing. *The Ring* comes to mind. But, after a second viewing, I loved it. Usually it's the other way around with me: If I don't like it on a 1st viewing, then I'm not going to ever like it; or if I love it the 1st time, then, well, you get the picture.

Oh, the scenes with the dog all through the film made me think of Spike Lee's *Summer of Sam*, so that made me like it even more. What a *great* film noir film! I am *so* glad I bought it, because not only is the film awesome, but it has some great bonus material about numerology on it that I found real intriguing. Highly recommended!

**Little Orphan Esther...
This review is from: *Orphan* (DVD)**

Sometimes a film will impress the heck out of me upon a first viewing, but then when I view it again later, it seems to fall flat and I find myself questioning what ever made me like it in the first place.

I just re-watched this last night, and I must say that I am so surprised that I ever liked it. Ok, sure, it is well acted, well lit, and well shot, but the story is so preposterous it isn't even funny. Plus, it's edited very poorly, and has an entirely wrong feel for the story that is being told here.

Yes, everything good about it, like the good lighting, color schemes, acting, etc etc, all work against the mere simplistic evil child storyline here. And nothing is ever really established as to any of the main character's motives. Yes, it shows that the mother suffered a miscarriage (in the over-the-top gory opening scene), but that doesn't really explain to me why they would want to adopt a child (who is almost fully grown, mind you), when they already have children. ?

I could understand if they were childless, but they already have two children. Plus, if they really wanted another child, why not adopt a newborn baby? ? Anyways, enough about that lapse in logic.

And, as for things not ever been really clearly established, well, that also goes for a lot of other scenes in the film. Namely, it is never explained (or

fully explored) why the children react the way they do around Esther at school. Plus, the early scenes of little orphan Esther at school had me rooting for her, because it was the other children that came across as the bad seeds, and she was just some innocent outsider. And the whole scene in the playground, I found myself way too distracted wondering why the little girl was so afraid of the orphan girl, that it robbed the film of any form of suspense that it was trying to build in the moment.

And the entire "bad seed" plot is kind of well forgotten by the third act, because the tone of the entire picture has shifted so dramatically that it in no way no longer really resembles what it was when it started. Plus, this was such a confused story. I don't mean confusing, but confused, in that it didn't really know what it wanted to be: Was it a thriller, or a horror movie, or was it an erotic thriller that happened to have the "good child is really evil" subplot? (Oh, yes, did I mention that this had way too many over-the-top erotic scenes in it that served absolutely no purpose what-so-ever.)

And the entire thing was so way way way over the top it isn't even funny. Ok, well, maybe it is, but not in the way the filmmaker would want it to be. I found myself laughing at the movie so many times I lost count. And I was laughing at them, not with them!

Everything is handled in such a heavy handed way, it robs the film of any genuine thrills it should have. There were some scenes that were shot so well, and so well lit, I could watch them over and over, if they

were in another film. This may have been better serviced if maybe shot on a lower budget. ? But, as it is, there are way too many well crafted shots wasted on this kind of story.

And don't even get me started on the father in this. He is possibly the most irritatingly stupidest character in all horror film history. And especially when he actually broke down and cried in front of the orphan girl, how pathetic was that! I wanted to kill him myself!

And that leads me to yet another problem I have with this movie (matter of fact, I had this problem the first time I saw it): The extremely over-the-top, gory, gruesome murder of his character. The way it was filmed made me feel like I was inside a snuff film, because it was just too gritty, and again, completely out of tone with the rest of the film.

Plus, I almost felt like by that time in the movie, no more characters really needed to be killed off. It was such a blatantly bad decision in plotting in my opinion. And, then, this leads me to the extremely bad, over-the-top (notice a theme here) ending. Wow, could *Halloween*'s ending be ripped off anymore??? You know, the thing that would not die, no matter what you do to it, you know, like, stab it, set it on fire, stab it some more, shoot it, drown it, stab it some more, and IT STILL KEEPS COMING BACK FOR MORE!

This is definitely a "shut your brain off at the start" kind of movie, and even kind of good for a first time viewing, if all you're out for is some kind of

cheap, dumbed down quick thrill, but if you're like me, and like your movies to be a little bit more cerebral and challenging, then you may want to skip this one. I sure wish I did!

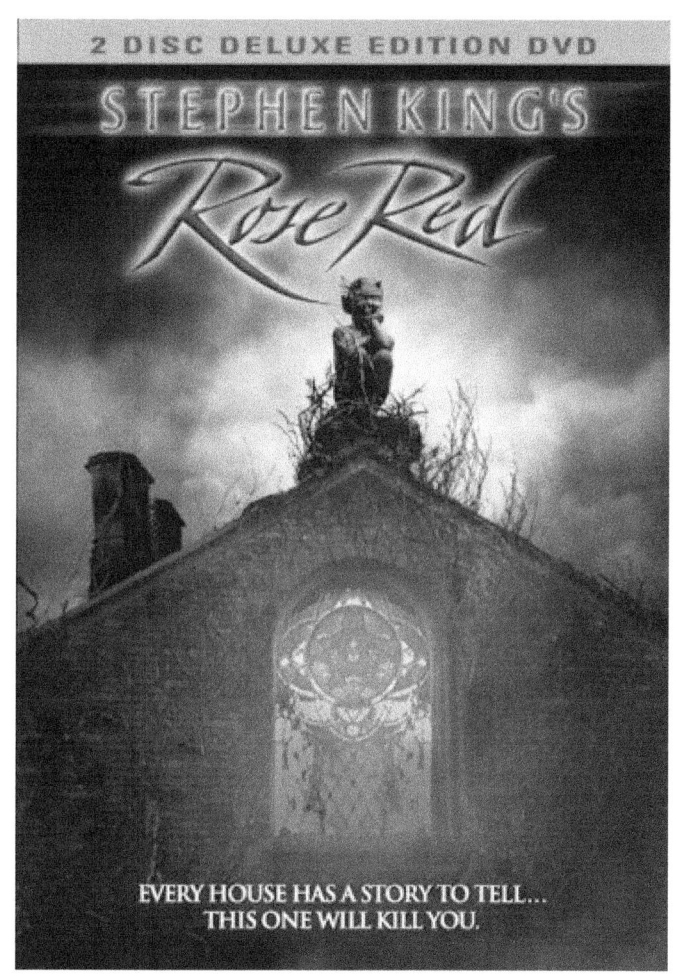

**Horrible Piece of Excrement...
This review is from: *Rose Red* (DVD)**

Sorry, but for anyone to give this horrible excuse for a TV mini-series anything over 2 stars is beyond my comprehension. This had to be the worst piece of garbage I've ever sat through. Derivative doesn't even begin to describe this trash. Bad acting, bad writing, bad everything makes this an extremely bad movie.

Stephen King should be ashamed of himself for ever releasing this piece of shit on the unsuspecting public. I've seen better TV ads for dog food than this piece of excrement. What a waste of time to even think about it a minute longer. Enough said, you've been warned. You're welcome!

Clint's Million Dollar Mess...
This review is from: *Million Dollar Baby*
(Two-Disc Widescreen Edition) (DVD)

I can see why so many viewers are split on this movie. It's very well made, extremely well acted, beautifully filmed, masterfully directed, and brilliantly crafted with some very intense action. It also features some of the best boxing scenes ever committed to screen. And for the most part, has a magnificent story.

However, a little over half-way through, the story takes a very unexpected dramatic turn that has split audiences straight down the middle. And, like I said in my opening sentence, I can see why.

First, let me state that I heavily applaud Clint Eastwood for his immaculate direction, and I am astounded by the breathtaking acting by everyone in the cast. I honestly don't think Hilary Swank has ever been better. And she has done some fine work in her career.

But, what I (and I'm sure others) feel hurts this film is the unexpected way it turns from being a story about an underdog who fights (no pun intended) her way to the top, to a very depressing second half that deals with the issue of euthanasia.

Like some other reviewers have stated, it is a very schizophrenic screenplay. Not to say that it is a badly written script, it's just that is seems a little unfocused on where it was initially headed from the beginning.

Plus, there are some things that do beg to question why they were even in the film to begin with. One being the character of Danger. Now, don't get me wrong, I love Jay Baruchel, and especially in that role. I felt he brought a very sympathetic character to life, and made the audience want to reach out and give him a hug. But, what was the point of his character to begin with? He doesn't advance the plot at all.

There were some moments in this film that I loved, and could watch over and over, but there are also some scenes (especially in the second half) that I wish I had never seen, and hope to never see again.

I rate this four stars solely because it is so well made, and so well acted. But for story, I would probably rate it about only two. I would raise it to five if it had ended after the last fight, and on a higher, more positive note. But, that wasn't the story that they were trying to tell, so I have to lower my rating a little to reflect how I feel about the story that was told.

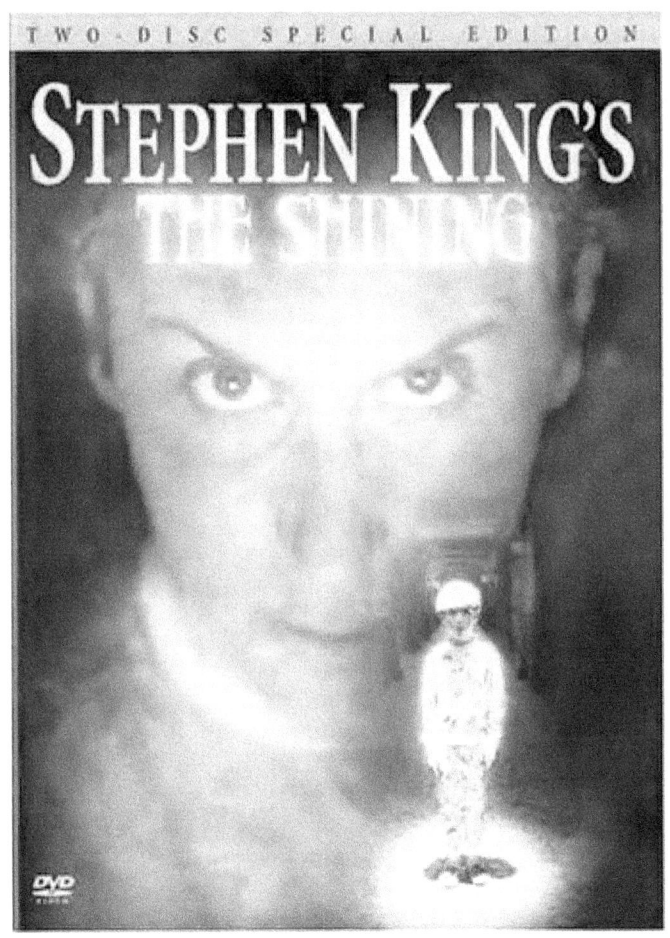

The Simpsons' "The Shinning" Was Better Than Stephen King's *The Shining*!
This review is from: Stephen King's
The Shining (Two Disc Special Edition) (DVD)

What in the world was Stephen King thinking when he made this 5 hour travesty? Or better yet, what wasn't he thinking? He threw everything and the kitchen sink in this, yet sadly nothing stuck. I know he openly detested Stanley Kubrick's 1980 masterpiece, a stunning classic of cerebral horror on a grand scale that has yet to ever be equaled. But, was that a reason to defile your own work, Stephen, and try to readapt it - and for television at that? The answer is a resounding no!

From the start, King and director Mick Garris do everything wrong, from the opening shot of Jack Torrance in the boiler room with Watson, to the horrendous outdoor scene of people still at the hotel playing croquet. What the fuck? So much for creating any sense of isolation. Yes, you can forget any kind of feeling of anyone being isolated, killing any further buildup of feelings of claustrophobia and doom.

Oh, and also let me mention how pretty much from the get-go, King butchers his own novel. Yes, he made changes that would even stump Stanley Kubrick, who performed plastic surgery on the novel in his awesome adaptation; and rightly so. Number one, it is mentioned that Grady was at the Overlook *alone* when he killed himself. That's right. By himself. No wife. No twin girls. No family at all. Just him. Not the way I remember it from the book.

And I've read the book so many times over the years, I've lost count. And King wanted to badmouth Kubrick for the changes *he* made when adapting the novel. Ok, makes sense...NOT.

Then, if all that isn't bad enough, director Garrison keeps throwing in these senseless flashbacks that do nothing but dumb the story down to the umpteenth degree. You know, like they do on the "CSI" shows, you know, because they feel people are too stupid to follow what's been said, so they have to show you as well as tell you. And it robs the movie of any kind of suspense right off the bat.

One of the things I really liked in the novel, and oddly enough never thought about being changed in the Kubrick film was the way Danny talked to Tony. In the novel, he talked to an older version of himself, who hovered nearby and showed him visions of things to come. Neat idea. In the Kubrick film, Danny simply talked to his finger, his imaginary friend, the little boy who lives in his mouth. A great idea visually. Well, in this version, Danny talks to a floating teenager. And it looks hokey as hell. Dreadful.

And, again, as if other things that dumbed down this version wasn't enough, they feel the need to remind you that Jack Torrance is/was an alcoholic, and he had a "problem", and he hurt Danny, and he lost his teaching job because of his drinking problem every chance they get. Which is like every five minutes. Telling the audience one time isn't enough. Oh no. They obviously felt the audience was too dumb to get that, so they felt the need to throw it in as many

times as possible so you would, you know, get it. Dreadful.

And, speaking of that reminds me of something I had never questioned before until now: I've seen so many reviewers talk about how they didn't like Jack Nicholson in the Kubrick version because it was obvious from the beginning that he was insane. Well, I noticed in this that because of the way it keeps reminding the viewer that Jack Torrance is an alcoholic, and that he once hurt Danny, and has a history of violence, well, right there tells you that he is going to eventually lose it when he gets to the hotel and gets snowed in during the winter, killing any and all suspense. You know, now that I think about, the novel even did that. Heck, if King wanted his readers (and viewers in the film here) to be totally surprised when Jack gets possessed and starts to go after his family with a croquet mallet, well then why not make him a saintly person with a very good background in the beginning. Heck, make him a preacher or something with a pristine background. Someone who would never dream of going off on a mad binge and hurting someone. Now, that would be a surprise!

Anyways.

And, I will slightly mention since I'm talking about certain characters/cast members, another heavy criticism I've heard over the years against the Kubrick film I've never understood was against the great Shelley Duvall as Wendy Torrance, a role I feel she was simply brilliant in. Well, over the years, I've read negative reviews talk about how she

was so wrong for the role, how she was too whiny and too weak, blah blah blah.

Well, here's the deal. Sure, Rebecca DeMornay is more like the novel Wendy, however, visually on film, I just don't buy that a woman that strong would be with a man like Jack. Nope. Never. Not in a million years. She would beat the hell out of him, set him on fire, cuss him until he cried, and make him her little bitch. True story.

Thus, making her all wrong for the role film-wise. But she's the best actor in the whole thing. Yeah, I said it, and I meant it. And, as for Wendy, I really don't get where people get that Shelley Duvall's Wendy was a weak woman. Sure, she was meek, and a little timid around Jack, but pay attention next time you see it, and notice that any time when it comes to Danny, and Wendy thinks Jack may have (or possibly will) hurt him, she turns into a ferocious protective mother, standing her ground, not afraid of Jack in the least.

I really liked Courtland Mead's small part in the movie *Go*, but he is completely wasted here. I blame it on bad direction. And that goes for the performance of everyone else in this. Awful. Atrocious. And I blame it on bad direction from Garris. Watch anyone of them in something else. Heck, watch something else than this altogether, and you will be better off.

Anyways, even though King made some other questionable changes from his novel in this, I will give it two stars for at least being somewhat as close as it can be. I still prefer the Kubrick version.

Always have. Always will. Especially after seeing this stinker.

Oh, has anyone else ever notice the similarities between *The Shining* and *The Amityville Horror*:
The Amityville Horror: Family moves into haunted house with a history of violence where man went beserk/was possessed and killed entire family, and now current family living there has a father/husband who goes beserk/gets possessed and tries to kill family before family flees in horror.
The Shining: Read above ^ but add psychic kid, ha-ha.

**Lovecraft Dun Right...
This review is from:** *The Dunwich Horror*
(Midnite Movies) (DVD)

I have been wanting to see this movie all the way through for the longest time - well, ever since the late 70's/early 80's when I caught it on TV a couple of times late at night, and fell asleep every time it was on.

I have not read the book this is based (nor have I read any Lovecraft for that matter, unfortunately), but from what I gather, this is a very good adaptation of his work. And it is a very interesting film! Even if uneven in a few spots. But that's almost understandable due to its low budget, and the era it was made in.

But, even though made on a low budget, it does manage to throw in some really nifty special effects from time to time; but I could have almost done without all the jerky/flash edited hallucinatory segments that were more confusing that interesting. But the overall mood and tone of the picture is very well crafted, and the pacing is perfect for the story that is told.

Both Dean Stockwell and Sandra Dee were very good, and offered very realistic performances, making the viewer believe in and care for their characters. I have read that Peter Fonda was the first choice for this, but thank goodness that he declined, because I feel it would have given the movie a completely different tone with him in it. Well, picture something like *Race With The Devil* and you

probably get the idea. Dean was effectively creepy, yet almost naive and innocent at the same time, and Sandra Dee was very relaxed and a very mature actress by this time in her career, and showed no signs of her *Gidget* days, which is a very good thing.

Very suspenseful, and even lightly comedic in some spots, I feel this is a very timeless tale that was captured on celluloid successfully. However, as much as I usually detest remakes, this is one that I would love to see someone like John Carpenter get a hold of and remake. He came close with his own Lovecraft inspired *In The Mouth Of Madness* a few years back, and I think a remake of this would be right up his alley, so to speak.

I highly recommend this!

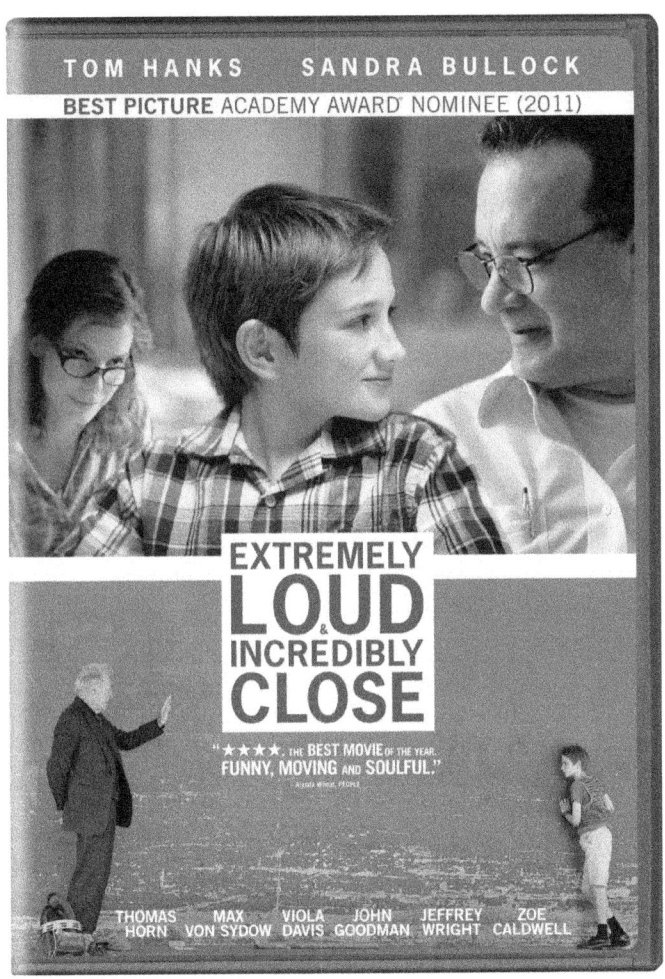

Amazingly Close To Home...
This review is from:
Extremely Loud & Incredibly Close **(DVD)**

Without a doubt, this is one of the most amazing films I've seen this decade, if not ever! In all my years, I don't think I've ever seen something that deals with the loss of a parent in such an honest way. Yes, even though the bulk of the story kind of comes across like a fairy tale, the themes it deals with and how they are handled are some of the most realistic I've ever seen committed to film.

I remember being excited to see this when it came out, and the wait was well worthwhile. Unlike another kind of similar tale about a youth's search for meaning in the midst of life's turmoils that I was excited to see when it came out, but ended up being disappointed with, *Where The Wild Things Are*, I felt there was never a moment in this that wasn't just extremely brilliant and beautiful and moving.

Being someone who lost my father a few years ago (he died unexpectedly of a heart attack), I relate to everything Oskar went through emotionally in this film, as I'm sure anyone else who's lost a parent will do. I felt this movie captured all the raw emotions and feelings that a person experiences after such a great loss, ranging from grief, anger, confusion, anger, feelings of euphoria from lack of sleep, anger, to even assessing blame on the surviving parent.

I was also very moved by the way the film dealt with generational themes, depicted beautifully

between Oskar and the tenant in his grandmother's house (Max Von Sydow). The endurance of learning self respect and love and respect for others passed on from one generation to the next was so wonderfully depicted.

Sorry, but I'm not going to go into plot scenarios here. If you want that, read someone else's review. I feel the plot has been discussed enough in so many other well written reviews. What I'm trying to share here is my experience and emotions while watching the film. This is something that made me weep unabashedly, and I'm not ashamed to admit that. Yes, this is a deeply moving film, and even has some very depressing moments, but it is not an overall depressing film; and it also has some very magnificent enlightening moments, capturing the beautiful bonds of family relationships that will just take your breath away.

And let me just say that the acting from the cast in this is some of the best I've ever seen from any of them. I honestly don't think I've ever seen better work from any of them before. Why the Academy didn't recognize their work in this is beyond me.

As you can already probably guess, I *highly* recommend this movie!

Quentin's Quintessential Classic Homage To Drive-In Grindhouse!
This review is from: Grindhouse Presents *Death Proof* **(DVD)**

I was honestly dead set against seeing this for the past few years because for one it being attached to Robert Rodriguez's *Planet Terror* (which may be a good movie, but it looked like a gore-fest, and I was taking a stance against those back when *Grindhouse* came out), and also because of all the negative reviews I've read over the past couple of years.

However, I finally relented and let curiosity get the better of me and ordered a copy and watched it yesterday. And let me just say: WOW! WOW!! WOW!!! I fucking LOVE it! Did I say WOW?! Best movie I've seen in ages. True story!

From the opening animated credit sequence to the final frame of closing credits, this is such a breathtaking, riveting masterpiece! And there are so many iconic images from everything 1970's drive-in cinema, and includes one of the greatest soundtracks ever committed to film. Tarantino even made use of Pino Donaggio's awesome score from Brian De Palma's *Blow Out* (the small piano piece that plays while one of the female characters reads a text message early in the film).

Since pretty much every reviewer has mentioned the plot in pretty much every review since the movie came out, I am not going to bore you with repeating that here. I will, however, say that I have never seen some of these actors in a better film. Ever! This is

the best work from Kurt Russell since his glorious work in John Carpenter's classics, like *Escape From New York*.

And every single female in the cast is riveting! (Excuse me if I've used that word already.) Especially Zoe Bell, playing herself. You may recognize Zoe from her stunt work being Uma Thurman's stunt double in Tarantino's *Kill Bill*. She is simply electrifying as an actress!

Anyways, really don't know what else to say except that if you haven't already seen this movie, don't wait another minute: See. It. NOW! And I am going to go now and watch it again (for the third time since yesterday afternoon).

HIGHLY RECOMMENDED! Thanks for reading!

The End

De Palma Puts Passion Back Into Filmmaking!
This review is from: *Passion* (DVD)

After I got through watching Brian De Palma's latest film, *Passion*, I have to say it's possibly the best film he's made in his entire career! Amazing how a man in his 70's can still put out such awesome movies!

Now, I've been a long-time fan of De Palma's, going all the way back to when I first saw *Carrie* when it came out in 1977. And, honestly, when I first started seeing previews of *Passion*, and reading some of the negative reviews, I wasn't all that excited as I've been over all of De Palma's other releases to see it.

It just kind of looked like it would be a little too bland for want of better word, and from what I was reading, the plot was going to be over-the-top convoluted to the point of being incomprehensible.

Something that I really hate is when I see so many people stating how they've recently seen a movie, and they didn't "get" it, or didn't understand it, thus the movie was bad in their opinion. No, of course it couldn't be because they just don't have the intelligence or the intellect to grasp what the filmmaker was trying to convey, no, it is because the film is bad and that's that.

Well, that is not always the case, matter of fact, probably not the case in any one of the movies those people reviewed. There are lots of great movies out these days that have complicated, intriguing, mysterious hard-to-understand plots, but those of us

who follow along and pay attention (and have higher IQ's, obviously) don't consider them "bad films" unless they are badly made.

And, unfortunately, over the entire past decade, Brian De Palma has been blasted so many times for making "bad films" by people who just don't understand his films (because we live in such a dumbed down world these days) it isn't even funny.

(Oh, and just because something is described as an "erotic thriller", doesn't mean that every scene in the film is going to be some kind of titillating erotic soft-porn film for people wanting porno. So, for people complaining about this not being erotic/sexy enough, please buy a clue.)

And, sure, the first half of the film is made with a whole new style than what De Palma fans are probably used to, but honestly, I found that most refreshing, and thought it was a brilliant choice on his behalf to film it that particular way. But, on the other hand, the entire second (and especially the third) half of the film is deliciously, deviously, dementedly De Palma in all his delectable glory.

I'll tell you this, I'm glad I was watching it alone, because the entire last 10 minutes of the film I was shouting out, "Wow! Hell yeah! Wow! Hell yeah! Wow! Hell Yeah! Wow!" over and over, and I would have hated to have interrupted someone else's enjoyment of it.

Plot-wise, I'm not going to divulge anything at all, because to say anything about any particular

moment in the film would ruin it for anyone reading this, for every moment in the film leads from one glorious surprise to another, giving the viewer twists and turns like riding a roller coaster.

I will say, though, that the film gives De Palma the chance to work in lots of his given themes from older films, ranging from betrayal to the evil doppleganger.

Style-wise, the film is a cornucopia of styles reflecting not only other great films of the same genre from decades past (I even caught whiffs of nods to *All About Eve*), but also from De Palma's own catalogue, ranging from split diopter to a breath-taking split-screen scene that rates up there with the likes of *Carrie* and *Dressed To Kill*.

Anyone who hasn't seen it needs to see it NOW! You'll thank me later.

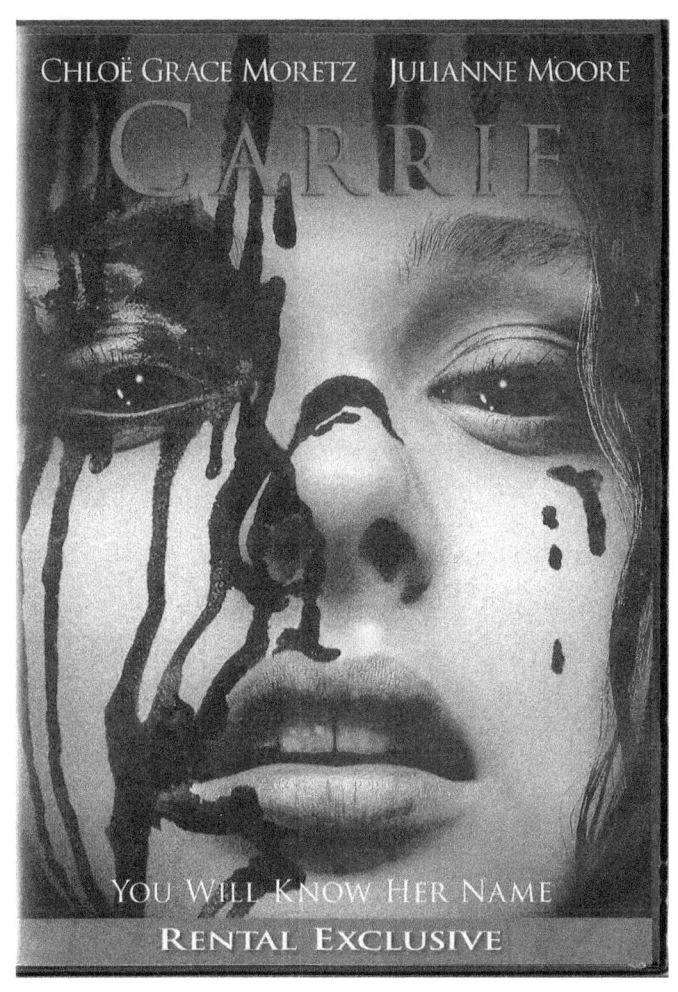

Carrie Ruined For A New Generation... This review is from *Carrie* (DVD)

You know, even as much as I am opposed to most remakes, I was actually excited about and looking forward to a new adaptation of this particular Stephen King novel. This story was not only my introduction to my favorite author, Stephen King, but also my favorite director Brian De Palma. And, the love affair I've had with both artists' work over the years has been very rewarding to say the least.

As I said, I am typically against film remakes, and for several reasons, but I won't go into that here. But, in this case, I don't really consider this necessarily a "remake" as much as a new adaptation of the source novel. And, I honestly enjoyed the previous updated version of this that was done for television a few years back. Sure, there were some hokey moments, and some over-the-top CGI effects, but overall it was closer to King's novel, and it was enjoyable in its own right.

But, when I first started seeing trailers for this one, I started getting a little concerned, and my interest starting to wane a bit, because it not only looked like a direct retread of the Brian De Palma classic, it looked like it was loaded with very bad CGI to the point of looking unrealistic.

Well, I relented and gave it a try anyway, and sorry to say, but I felt like this was pure torture to sit through, and not for the reasons the filmmaker probably wanted. First off, the acting is atrocious. Very cut-rate, generic, dumbed-down so the

audience won't feel left out, obvious script-reading at its worst. In other words, the kind of acting you might see on some lame television series that only lasts a couple weeks before cancellation. Yeah, it's that bad!

And as for the story, well, it is nothing but a direct lift from Lawrence D. Cohen's script for the 1976 De Palma classic. Oh, sure, there are some modern technology updates, but nothing really effective to the overall story. This is pretty much the same kind of "remake" as Gus Van Zant's misguided remake of *Psycho* a few years back - nothing more than a frame for frame re-imagining at its worst.

And, don't even get me started on the whole prom sequence fiasco! What was the high point and crescendo of the original film (and even the television remake) falls very flat here, and makes the viewer cringe for all the wrong reasons. Dialogue is added where it's not needed (you know, the whole dumbing-down so the audience will "get it", ugh), and the acting is nothing more than some retread of something from the *Twilight* movies.

Matter of fact, this entire project seems to be directed at that whole *Twilight* tween crowd, and not at any serious lover of film art.

I seriously recommend you stay as far away from this turkey as possible. If you want to see a filmed version of this story, stick with the classic De Palma film (it was nominated for two Academy awards for best actress and best supporting actress, something unheard of for a horror movie back then), or even

try the 2002 television remake; but avoid this one like the plague.

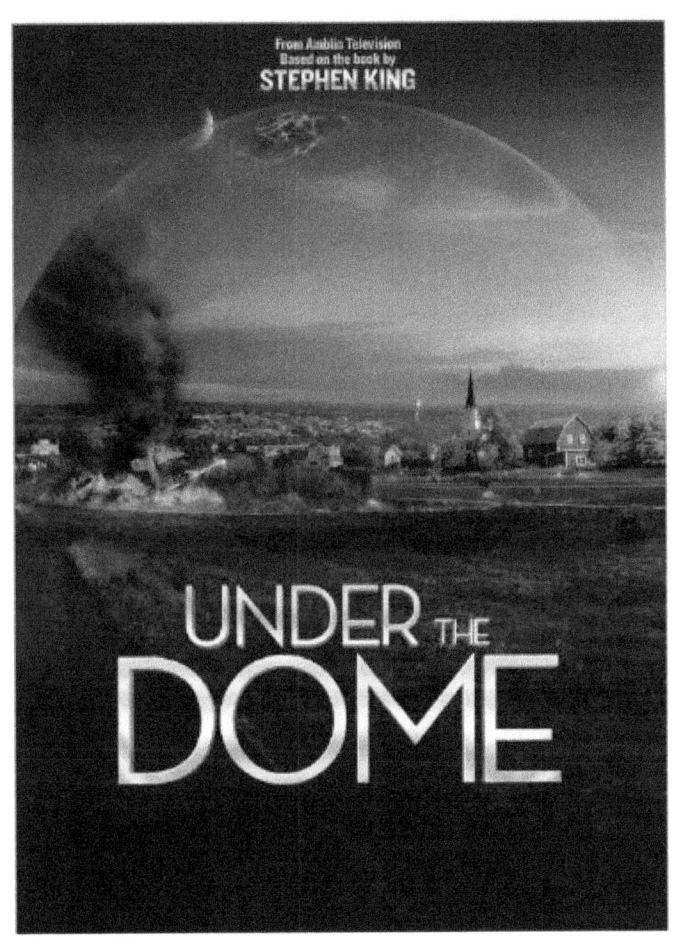

Garbage In...Garbage Out...
Under The Dome: Season 1 (DVD)

What the fuck is the writers of this show smoking, ha-ha. Seriously, where in the world did they come up with some of this crap, like mini-domes, monarchs, and mysterious people showing up from out of nowhere? I understand some changes being made when adapting a novel to the screen (heck, Stanley Kubrick's *The Shining* is not only one of my all-time favorite films, but one of my favorite adaptations of a Stephen King novel), but the writers of this show have completely abandoned the original story, and ruined what could have been a good mini-series.

They have changed the plot into something unrecognizable, adding crap that is not even necessary to the basic storyline, and made radical changes to all the characters, even adding characters, or cutting characters out.

Honestly, this is not only an insult to Stephen King, but also to anyone who has read the novel. It's as if the writers (if you can call them that) hated the book, and have decided to throw everything from it out and just write whatever comes to mind. It's a huge slap in King's face, and if he supports this like some people are alleging, then there has to be some monetary motivation involved.

It's abysmal. It's television at its worst, lowering itself to the lowest common denominator of viewers' intelligence. And, don't even get me started on the atrocious homogenized, generic, dumbed-

down-for-TV "acting" that is so bad it's laughable.

If something like this was done to something *I* had written, I would be filing a major lawsuit, trust me. And yeah, it's something that only someone with the mentality of a 10 year old could enjoy.

People who enjoy this garbage, more power to you. But for anyone who is looking for something of quality, avoid this like the plague! Read the book, or simply watch something else instead.

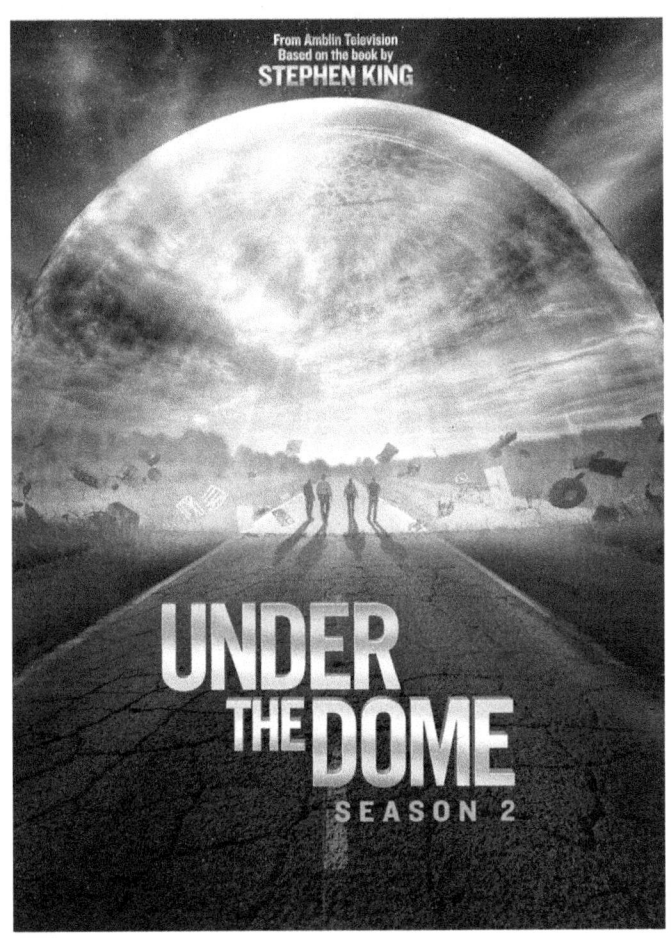

King's Great Novel Bastardized For Television...
Under The Dome: Season 2 (DVD)

As bad as this show was last season, after a long break before it returned, I had kind of forgotten just how awful it was, so when it did return, I thought I would tune in and give it a chance. Oh, my bad.

Now, let me say off the bat that I am a huge fan of Stephen King's writing. Matter of fact, I own every single novel of his in original hard back, which I've been collecting since the late 1970's. And the novel this dreck is (LOOSELY) based on is one of his strongest in my opinion. So, with that in mind, when it was announced last year that a mini-series was going to be made based on the novel, I was excited (I would have been even more excited if it had been a feature theatrical film, but I could live with a television mini-series).

But, right off the bat, things started going down hill, and they never picked back up. Horrible acting, atrocious dialogue, stilted acting, horrible writing, generic dumbed-down-for-TV acting (yes, I know I keep mentioning the acting, if you can call it such), and an almost non-recognizable plot.

I think the last one was the most unforgiving thing, that the plot was changed so dramatically that about the only thing this garbage has in common with King's novel is the title, and the fact that a dome fell over some town in Somewhere USA. Ugh.

I am actually embarrassed and ashamed to hear that not only is King alright with all of this, but he is also "involved" and has given it his blessings, and even worse, he wrote the script for the second season premiere.

Whoa, nelly, what a travesty! I haven't seen something this bad written for TV by King since *Rose Red* (don't even get me started on how bad that crap was!). It was as if they were making stuff up as they went along, and the actors simply reading from the script as it was handed to them, no major emoting or acting involved, and some of the new cast brought in were some of the most bland people I've seen on television in my entire life.

There were moments that were so bad that I didn't know whether to laugh or cry. Laugh because it was so silly and over-the-top bad, and cry because I was witnessing one of my favorite later-day King novels be completely bastardized for national TV. And, Stephen King is alright with it! Heck he even made a cameo! (And don't get me started on how lame that was!)

I seriously don't feel like I can voice my hate for this loud enough to steer potential viewers as far away from it as possible!
You've been warned.
You're welcome!

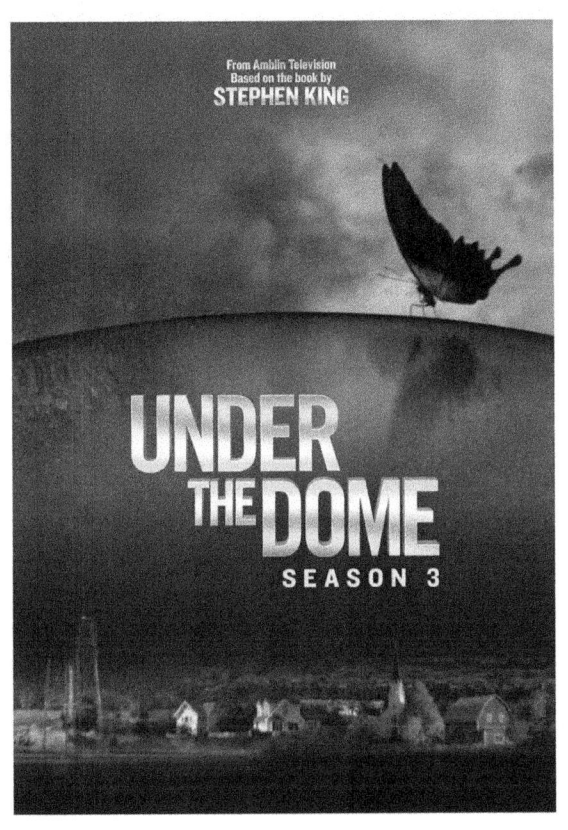

Dumbed Down Trash Claiming To Be Based On A Stephen King Novel...
Under The Dome: Season Three (DVD)

While *Under The Dome* was a pretty awful TV series, and I had been guilty of watching it, I just realized something while watching the last season, and that is that turning it into a weekly television series missed the entire point of the novel. The novel was simply a parable, an allegory of how the crazy right wing nuts rose up and tried to take over after a castastrophic event (in reality, it was 9/11, in the book it was the dome). And people like Big Jim Renny mirrored people like Dick Cheney. The series may as well have been called something else because, even though it's got a similar plot, and the characters have the same names, it's still a completely different thing now that it's adapted for television. Just saying.

And I don't know why people think Stephen King had anything to do with this show. King didn't make this show, he wrote the book the show claimed to be based on (but in reality was *nothing* like). Sure, he was one of many executive producers (in other words, he helped raise money to finance it, nothing else), and it claims to be based on his novel (but in fact is so far removed from the book they should change the name of the show).
But, other than that, he was not involved with this abysmal train wreck of a show in any way, shape, form or fashion.

And as far as him being on board with all the changes, well, first of all, he is more than likely

under contract and can't say anything publicly against the show, and also if you noticed in the one episode he wrote (the season premiere for the second season), he killed off two characters - one was a character that was killed in his novel before the story started and was kept alive in the show, and the other was a character solely created by the writers of the show for the show. Does that kind of help anyone see a possible pattern of how he may really feel about this?

And, I am also well aware of how novels get altered when adapted to the screen. Heck, one of my all-time favorite films is Stanley Kubrick's adaptation of *The Shining*- something that Stephen King openly detested (do you really think if he was so upset by the minor changes Kubrick made with that novel that he is fine with the blatant butchery they are doing with this novel?).

This is so much more than making some simple changes adapting something to the screen, no, this has veered so far from the source novel, it is as if the writers hate King, hate his novel, and hate his fans, and are going miles out of their way to rub it in King's (and our) face.
I truly can't believe any fan of King's (or fans of good programming, for that matter) enjoy this rubbish.

I have heard all about how King allegedly likes this trash. But, see, I am old enough to remember how he ranted and raved and threw a hissy fit because director Stanley Kubrick made some changes when adapting his novel *The Shining* to the screen; so I

hardly believe that what he is saying about this is nothing but a publicity stunt and poor PR drivel. Sorry.

There is a huge difference between making some minor changes when adapting something to the screen as opposed to altering it to the point that it is *nothing* like the source material it is based on. The only things this show has in common with King's novel at this point is the name of the show, some names of some of the characters, and the fact that a dome dropped over some town.

Hell, this show has *never* made sense, but at least this season it's a lot easier (and more fun) to follow, as hard as that might be to believe or comprehend (I even find myself wondering why I felt that way while watching, ha-ha).

And just because an author sells something to be adapted doesn't mean they always have a say in how it goes. And as for his cameo in a season two episode, well, I am sorry to say how much I am ashamed of him being associated with this garbage.

I tell you, some of these *Under the Dome* viewers are not some of the brightest people I've ever came across. Example: Simply state how you're not enjoying the show, and they will offer such helpful words of wisdom like, "You can change the channel."
Now, who would have thunk such a thing if they weren't around to tell you that?

I find it funny that most of the people who were

defending it to the death the past two seasons, attacking anyone who voiced a negative opinion of the show are now the ones saying "it's too difficult to understand, it doesn't make sense, blah blah blah" during its third (and thank god final) season, ha-ha.

Has it ever crossed their mind that some people can criticize something and enjoy it at the same time? Plus, a lot of people, including myself, tuned in to see STEPHEN KING'S NOVEL adapted to television, not this crap the writers of *Lost* concocted.

If you enjoyed it, more power to you. No one is trying to take that away from you, or saying anything to you about that.

What gets me is that all of the people who have been declaring their undying love for this mess don't know what an even *better* show they could have been watching (and defending) if it had only stuck more close to the novel.

A lot of times when people are moaning that a movie wasn't just like the book they read can be irritating, but in this case, this show is nothing, I repeat, *nothing*, like the book it alleges to be based on. Other than the title, the dome, and some of the character's names, there is NO similarity between the two whatsoever

Yes it was *very* different! This wasn't just a case of changing some things so it can be adapted to the screen (because we all know no book can be translated to the screen verbatim since movies and

books are two completely different art mediums), this was as if they never read the book, ignored everything about it except the title, the names of some of the characters, and the actual dome and just made shit up as they went along.

Honestly, I think it should have stuck to only being one season and not stretched out like it was. Because not only did it run too long, but it became such a convoluted mess that could never be explained. It wouldn't matter if there were 10 more seasons, there are a lot of things that will never be answered because most things the writers just made up on the fly and never intended on coming back to and explaining.

And notice I didn't even bother wasting time criticizing the horrible acting from the cast (especially newly-added cast member Marg Helgenbeger, who should have definitely known better to get involved with this garbage, because it was nothing but career suicide), the wretched directing, mind-boggling bad special effects, and atrocious storylines. I just don't feel the need when everything else was so off about this misguided production.

Thank god this was cancelled so there won't be a fourth season! Now if someone will maybe adapt it into a proper movie in a few years so we can all forget this travesty ever happened, and actually have some kind of film version of King's novel to enjoy. One can only hope!

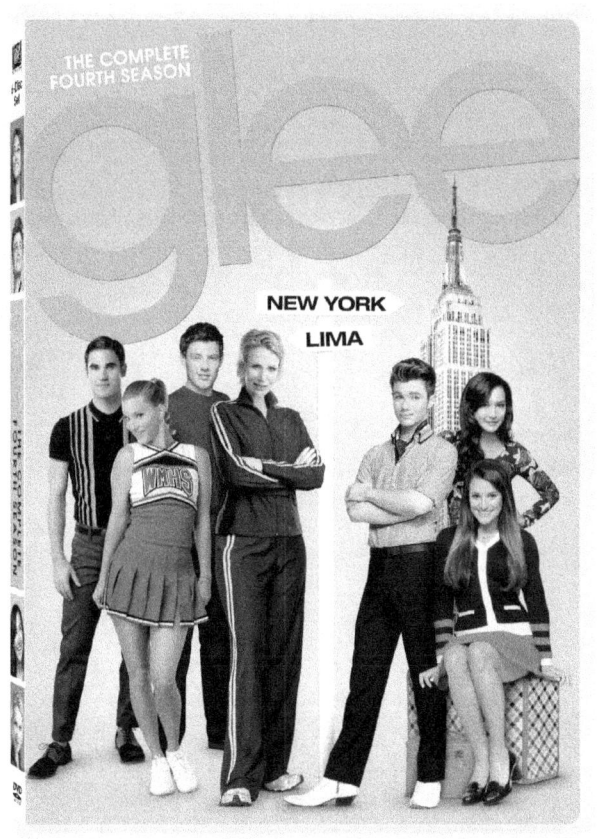

Feels Like A Weak Sequel...
This review is from: *Glee*: Season 4 (DVD)

When *Glee* first emerged on television during its first season, I was so excited about it, and wouldn't miss an episode, and have continued to watch it every season ever since. Even though there have been a few hits and misses along the lines over the subsequent seasons, mostly though I felt it was a very strong show, and enjoyed it immensely.

But that's not the case this season. And, here's why:

First off, this show isn't -nor was it ever- just about Rachel Berry becoming a star. Go back and watch season one if you need to, which sounds like some people may. The show was supposed to be about a high school glee club, its teachers, and its students - *not* any particular set of people or one particular person. Which, is what I feel is this season's main downfall: Is following characters who graduated last season and should no longer be on the show.

Honestly, I was so ready for a few of them to be gone at the end of season two, and was a little frustrated when I saw them return in season three. But, I feel it is irreprehensible to *still* have them on the show this season! If they felt so strongly about carrying on with storylines that involved characters like Rachel, Kurt, Finn, etc etc, then they should have done a spin-off series about them, just devoted to them. But they should *not* be carrying them on in this show! They graduated! Time to move on! True story.

And, as for the new cast members, well, sadly most of them are bland, and the show kind of comes across like a poor sequel to the show it was; kind of like, well, something like *Grease 2*.

And, I've noticed that as the season progresses, the show continues a downward spiral that I really don't foresee it surviving. Such a shame. Even the show *Fame* (which this show is heavily inspired by) knew when to let characters move on, and how to refreshen and revive itself and stay fresh for several seasons before it finally ended. Sad that I can't say the same for *Glee*.

As I previously stated, this show was not ever about any particular set of students, but about a high school glee club. If the producers and/or writers want to make a show that follows all the former students into a new life, then they need to change the name of the show. Period. Simple.
But since the show is called *Glee*, then it is easily understandable that the viewers are going to expect the show to be about, you guessed it, a high school glee club. Not college students in New York.

And, frankly, just because the people at Fox Television (and some fanboys of the show) think it best to concentrate on former students doesn't mean it is the right direction to go in. I for one know quite a lot of people who happen to share my opinion of this show, and if anyone has been paying attention, the show was down in the ratings this past season, and most complaints were focused on how the show, you guessed it again, focused too much on people who graduated the previous season and

should be moving on already.

As painful as it's becoming, I will finish watching this season since I've been watching for so long, but after this season, if it returns next season, I won't. Thanks for reading.

Updated edit:
After seeing last night's powerful episode, I have to make a change in my review, and that is to say that the new cast members aren't as bland as I thought. Matter of fact, if the show would do like it did in that episode, and forget the damn New York subplot (and all the previous cast members who graduated last season), and focus on the high school, then the new cast members could shine. They really are a good bunch, but are sadly overshadowed weekly by all the former cast members continuously showing up.

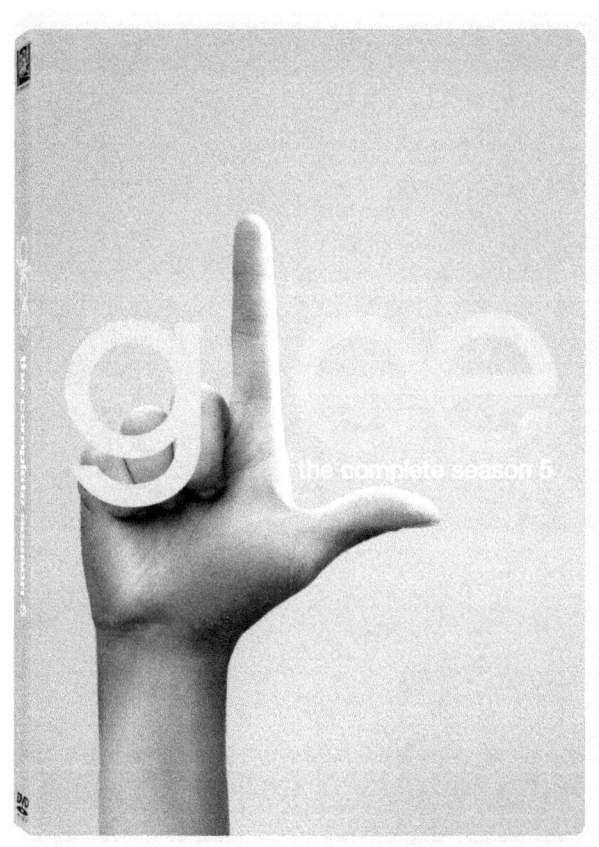

**No Longer Gleeful...
This review is from: *Glee*: Season 5 (DVD)**

While I still watch and (somewhat) enjoy *Glee*, I can't help but want to point out that it's not the show that I and others fell in love with back when it premiered - and the subsequent 2nd and 3rd seasons. It's not because older cast members graduated and moved to New York (even though I felt still having them on the show was a huge misstep), and it's not because near the end of this season they decided to dump the high school plotlines and move the show to New York entirely to focus on a small few number of the cast, no, it's because the entire tone of the show is radically different. Let me explain...

I can still remember when this show started and how exciting it was because it not only featured some blistering renditions of some awesome songs incorporated into the plot, but it was also a very edgy dark comedy that had some dramatic moments intertwining to help establish mood and character.

But, this season all of that has changed! The show is no longer a "comedy", but a flat out drama. Pretty much every scene of every episode is now filled with so much dramatic moments, and there is no longer any humorous relief to help balance things out. And, when a show makes that kind of dramatic turn around then I feel it is time to call the show something else entirely, because it is a completely different show entirely now.

Oh, sure, it still has most of the same cast it has had

since its incarnation, and it is still a musical at heart, but when you strip away the craftly infused dark humor that sparkled throughout previous seasons and helped moved the show along and instead fill the void with neverending treacle that tries to pull at viewer's heartstrings in scene after scene, then it kind of ruins the show as far as I'm concerned.

This was not the show that we tuned in to watch back when it started by a long shot. So, drop the name and call it something else and then I can judge it on different merits. But, as of this writing after reviewing some reruns of this season I am saddened to say that the show called *Glee* that I fell in love with about 4 or 5 years ago is dead and gone.

PS: Take the show back to its high school roots because that is what most viewers (including myself) tuned into a show called *Glee* to begin with - and not to see former high school students after they graduated and moved to another state entirely.

Glee Is Officially Dead!
This review is from: *Glee:* Season 6 (DVD)

Tuned in to catch an episode of *Glee* last night, and oh my god, what kind of train wreck the show has turned into this season! It's like the writers not only hate the show, but hate the fans who've tuned in all these years and made it famous, and are doing everything in their power to sabotage everything that made it a once great show!

I honestly don't know where to begin, other than pointing out the travesty of turning Coach Beiste into a transgender character after taking so much time and effort to emphasize in previous episodes that she was not a lesbian and was actually a very feminine woman inside who never felt pretty - something I thought made her one of the most poignant characters on TV in years.

I'm sad to say that the show that I once knew and loved called *Glee* is now officially dead! It's as if the writers hate the show and the fans, and are making up random stuff as they go along just to see how far they can take it. And don't get me started on how ridiculous it is that former high school students are *still* hanging around the high school, ugh! You know how many times I visited my high school after graduating? ONCE! And, I am someone who *loved* high school and really didn't want my senior year to end (but at the same time couldn't wait to leave), but after I graduated I returned one time the following year for five or ten minutes to see a good friend, and to say hello to a few teachers and then LEAVE.

And I had to go to the main office and acknowledge my presence before I could even do that! Unlike the people in *Glee* who drop in at er whim and stay throughout the entire day, some even teaching or sitting in on classes. Oh, and don't even get me started on how wrong and insulting to the viewer's intelligence that Sam is now teaching a class in his former high school after only being away for one year! That's not how it works, people, grrrr. For one, it takes several years of college to get a teaching degree, and then the odds of getting a teaching gig at the high school of your preference (let alone the same high school you graduated from -which most people do NOT do) is astronomically high!

After being somewhat disappointed with the show for not letting go of certain characters upon graduating at the end of the third season and focusing on a new cast of high school students (you know, since the show is supposed to be about a group of high school students in the high school glee club and not about former students running off to New York after graduation) and focusing on former students who graduated the previous season and following them to New York (and back and forth between the high school and New York City).

Then midway through the 5th season, the show's creators randomly decided to ditch the entire high school glee club storyline (as well as the entire new cast of high school warblers) in favor of moving the show to New York and focus on the path of Rachel, Kurt, Blaine and all the rest as they struggled (well,

not really struggled since they lived like they had an endless supply of money) to get work and career opportunities, and just roam the streets of New York and randomly break into song at any (predictable) given minute.

And, honestly, as much as I thought I would hate that decision since I felt a show called "Glee" about high school students in a high school glee club should continue to focus on high school students in a high school glee club, I found myself pleasantly and surprisingly enjoying the new direction the show was taking.

But, lo and behold, the 6th season starts and everyone is now back at the high school as if they never left (you know, because all former high school students love hanging around their old high school and not moving on in life…not!) and the entire New York storyline is now dead and gone as if it never happened. Oh, and the entire new cast of high school students introduced in seasons four and five are now gone and replaced with generic no-name people who just stand around and linger in the background while people who should have left the show at the end of season three prance around and sing song after song after song after song (seriously, it seems as if there is a song every five or six seconds now and the plot only serves as a way to introduce yet another song).

I've said several times after being disappointed with the show from season four on out that I was going to stop watching, but I kept coming back to see if it would get better, but this time I say it and mean it - I

am done with it forever! And any true fan of the show should be as well. Unless that is you enjoy being heavily insulted and being yanked around and being the blunt of the show creators' joke. Because that is how it feels now: the writers don't care about the show or the fans, and are in on some kind of sick joke to see how bad they can make the show - and people still watch.

Either Ryan Murphy has stopped caring about the baby he created or he is no longer involved and is only in it in name only. But either way, I don't care anymore and will no longer be watching this travesty.

And such a shame, because this show had such promise when it first started, and continued to shine brightly off and on for the next two or three seasons. But now it is officially dead - or at least it is in my opinion.

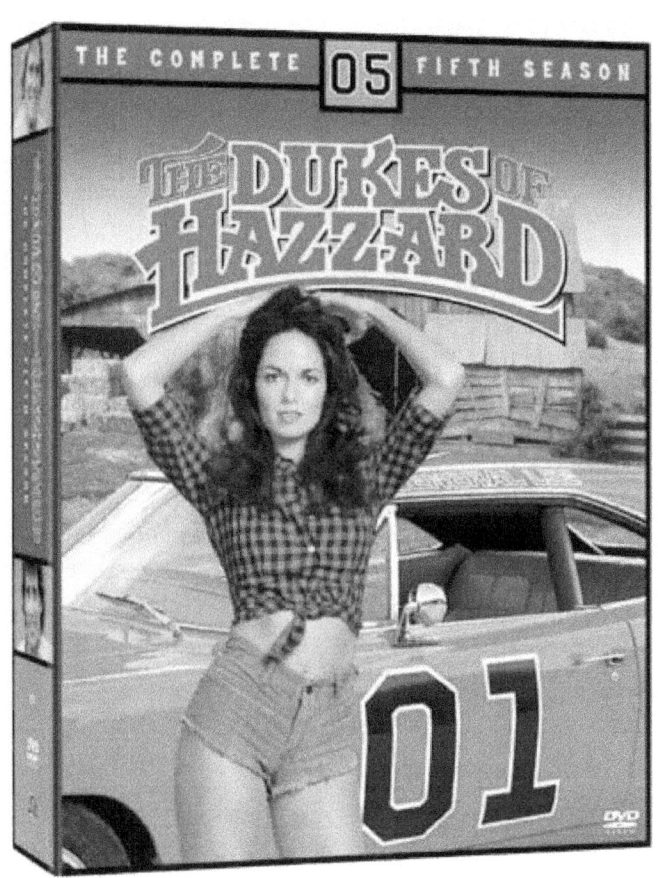

General Lee Jumps The Shark...
This review is from: *The Dukes of Hazzard*:
The Complete Fifth Season (DVD)

Ok, it's been several years since I last saw this show, so most of my review is straight from memory; but I feel my memory is correct in its opinion. I was such a huge fan of this show in its initial run back when I was a teenager. Watched it pretty faithfully every week, and even caught reruns in the summer.

However, I found my liking of this show come to a dead halt during this, the 5th season. Why? you may ask. Well, I'll tell you:

It's simple. Luke and Bo Duke were no longer on the show. Yep, Tom Wopat and John Schneider left due to contract disputes, or something like that. Anyways, that really wasn't the part that bothered me. No, what bothered me to no end, and rightly so, and something that should bother anyone with half a brain, was that not only had Bo and Luke left the farm, but they were replaced with very generic carbon copies that were excruciatingly bad to look at.

And, what a *huge* insult to the viewer's intelligence here! Wow! Talk about jumping the shark! This mistake was like Jaws jumping Snake River Canyon.

Yes, the producers, writers, directors, whoever was in charge, expected viewers to buy into that not only did Uncle Jesse have yet 2 more nephews to conveniently step into the family household once

Luke and Bo flew the coop, but they were also cousins, one dark haired, one blonde, and close as brothers just like Luke and Bo.

Huh? What? Wait! Yeah! That's right! So, all in all, Daisy, Luke, Bo, and the two new generic guys were all cousins, meaning that every one of them had different parents. Made me wonder just how many siblings poor old Uncle Jesse had!

To think I was only about 14 when this season first aired, and I still remember then realizing what a huge insult to the viewing public's intelligence this all was! Yes, I know it was never really a very intellectual show to begin with, and that was part of its charm; but to dumb it down to the lowest denominator was unforgivable in my opinion.

The only reason I give this season two starts (instead of one) is because Enos returned. Loved Enos! And, even with the return of Bo and Luke (who I had the fiercest crush on, and could just sit and stare stupidly at him week after week), I still gave up on this show after this season, because it was never the same again.

Stanley Kubrick: The King Of Cinema! A Listmania! List…

When Stanley Kubrick exploded on the world of cinema, he immediately showed people that he was a pioneer, a visionary of the true art of filmmaking. He was a genius, no doubt about it. Every film he directed is a solid masterpiece, a timeless classic that could be kept in a vault, and still look as fresh and as important and as innovative whenever they are unlocked as they do now. Take any Kubrick film and freeze-frame on any scene and you've got a piece of art. *Any* and *every* scene was solely crafted to evolve artistically as well as solid plot development. His films were not just mere movies, but huge events whenever they were released; each one pioneering a new frontier in the genre Kubrick elected to tackle at the time. And, that, as well as numerous other reasons, is why Kubrick is considered by *so many* people to be the ultimate King Of Cinema.

Killer's Kiss
Stanley Kubrick wrote the story and produced, edited, shot, and directed his second feature like a one-man studio, and his developing cinematic intelligence turns an otherwise unremarkable story into a memorable if slight film, a hint at masterpieces to come. 1955.

The Killing
Stanley Kubrick's third feature, and first screen classic, is one of the great crime films of the 1950s, is a perfect introduction to the art and joys of film noir, and its bizarre narrative structure has been copied many times since. 1956.

Paths of Glory
After two great crime-noir films, Kubrick released this blistering indictment of military politics and an unforgettable movie experience! One of the greatest anti-war films ever made! B&W, 1957.

Spartacus
Teaming once again with Kirk Douglas (*Paths of Glory*), Kubrick chose to redefine the 'gladiator' genre, and no film in that genre before or after can hold a candle to this epic masterpiece! 1960.

Lolita
After *Spartacus*, Kubrick chose Vladimir Nabokov's darkly comic, erotic, tragi-drama that totally redefined "erotic drama". B&W, 1961.

Dr. Strangelove - Or: How I Learned To Stop Worrying And Love The Bomb
Stanley Kubrick's timeless black comedy satire classic about an "accidental" nuclear attack. A great anti-war film! B&W, 1963.

2001: A Space Odyssey
Collaborating with sci-fi novelist Arthur C. Clarke, Kubrick totally redefined and revolutionized the whole way sci-fi is viewed today! Dazzling and brilliant! 1968.

A Clockwork Orange
From the pages of Anthony Burgess' classic novel, Kubrick revolutionized the whole way of telling a dark comic satire about crime and punishment. Awesome! 1971.

Barry Lyndon
From the classic novel by William Makepeace Thackeray, Kubrick completely reinvented the period drama genre with this sweeping epic masterpiece. 1975.

The Shining
From Stephen King's bestselling novel of horror, Kubrick reinvented and revolutionized the whole horror genre with this epic masterpiece that will make you forget to breathe for 10 minutes at a time! 1980.

Full Metal Jacket
From The novel *The Short-Timers* by Gustav Hasford, Kubrick created the best anti-war movie *ever* made!! This time in Vietnam, a stunning odyssey into Hell! 1987

Eyes Wide Shut
Kubrick's haunting epic final masterpiece. Vivid, vibrant, brilliant, unforgettable, totally redefines "erotic thriller"! A major milestone of cinema! 1999.

Brian De Palma: De Palma: Dynamic, InDependent Director ~ A Listmania! List...

Murder A La Mod
De Palma's very first film, a horror cult-classic that's DeMented, DeRanged, DeLirious, bloody De Palma at his sizzling best. 1966.

The Wedding Party
De Palma's second film, a very satiric send-up of all things wedding themed and more. Hilarious! 1967.

Greetings
De Palma does satire with a bite, riffing on *Blow Up*, the JFK conspiracy, *Rear Window* and pop art. Classic! 1968.

Hi, Mom!
De Palma's 1969 follow up to *Greetings*, but a lot darker and a lot deeper, but still very humorous. One of the best anti-war films ever! The "Be Black Baby" sequence is *so* ahead of filmmakers like Tarantino and Stone. Classic!

Get To Know Your Rabbit
Filmed in 1970 after De Palma's previous indie-films, this countercultural comedy is fueled by the same irreverent, anti-establishment attitude that made *Easy Rider* so phenomenally popular.

Sisters
Dark, complex, mysterious, scary, humorous, hypnotic and compelling, this is De Palma's first psychological mystery thriller. 1973. The new Master Of Suspense had emerged!

Phantom Of The Paradise
De Palma collaborated with songwriter, producer, star Paul Williams for this Faustian take on *Phantom of the Opera*. Humorous, tragic, and thrilling 1974

Obsession
De Palma's classic noirish psychological mystery thriller that helped concrete him as the new Master Of Suspense of cinema. 1975.

Carrie
De Palma takes Prom Night to Hell in this horrifying satire based on Stephen King's first novel. A definite classic paranormal, psychological horror film from 1976!

The Fury
De Palma's 1978 horrifying espionage, suspense, paranormal, psychological mystery thriller that will blow your mind with its (literally) explosive ending.

Home Movies
Casting big names in an independent comedy filmed by Sarah Lawrence College students under De Palma's direction. Hilarious! 1979.

Dressed To Kill
This erotic, psychological mystery thriller gets its basic premise from *Psycho*, but in such an original spin, that it makes this film equal to Hitchcock's classic. 1980.

Blow Out
De Palma takes *The Conversation*, *Blow Up*, *Vertigo*, The Chappaquidick Incident, The Watergate Scandal and creates a thrilling psychological conspiracy thriller! 1981.

Scarface
De Palma collaborates with Oliver Stone's script for the bloodiest, most stylish, breathtaking gangster genre films ever! 1983.

Body Double
De Palma shows what an "erotic thriller" should look like. Sinister, suspenseful, and mysterious, this psychological thriller "drills" into your psyche and won't let go! 1984.

Wise Guys
De Palma's criminally under-rated comedy classic from 1986. Danny DeVito and Joe Piscopo never did a funnier film! It will make you scream…with laughter.

The Untouchables
De Palma recreates 1920's Chicago and Al Capone in this 1987 noirish tour-de-force. A classic!!

Casualties of War
De Palma's vision of the effects of the Hell known as Vietnam, and the possibility for redemption. Awesome!! 1989.

The Bonfire Of The Vanities
De Palma's satire is on fire! This "Bonfire" burns eternal! Released in 1990, but just as blistering today!

Raising Cain
De Palma's most DeMented, DeLicious, DeLirious, DeRanged, DeCeptive suspenseful psychological mystery thriller ever! 1992.

Carlito's Way
De Palma's best crime noir genre film ever! Stylish, tragic, and very compelling! 1993.

Mission: Impossible
De Palma's 1996 psychological espionage action thriller that will blow you out of your seat! De Palma gets in lots of classic touches.

Snake Eyes
De Palma's psychological, sinister conspiracy thriller from 1998. Watch until the words "The End" or you'll miss just how sinister this film really is.

Mission To Mars
De Palma has his own *2001: A Space Odyssey*! Stunning sci-fi done very stylishly, with a great Human story: A lonely widower who only wants to go "Home". 1999.

Femme Fatale
De Palma returns to true form with this erotic, psychological, noirish mystery thriller. It plays like a beautiful dream within a dream. 2002.

The Black Dahlia
De Palma's best work in years! Definitely the best film of 2006! Film noir has never looked so great. And, a very stunning cast and story. Sinister, romantic, dark, psychological!

Redacted
De Palma utilizes film techniques that he hasn't done since the radical days of the 1960's, when he was more of a guerrilla style filmmaker to tell this awesome anti-war story. 2007.

Passion
De Palma remakes the French film *Love Crime* and turns it into one of the best films in his entire catalogue. Mesmerizing and intense! 2012.

THE END

For anyone who's interested in checking out (or reviewing) any of my books, here's the link to my author page on Amazon.com, where you can find everything I've got listed on there in one place.
http://www.amazon.com/Randall-Brooks/e/B005PBWWFK/ref=ntt_athr_dp_pel_1
Thanks for reading!

Randall Brooks is the author of the novels *The Two Worlds of the Mind* and *Von Wyck: The Complete Story By Victor Holocaust*, and three short story collections, *Conversations At The Party*, *Perfect Strangers*, and *The Maze*, as well as his extensive collections of lyrics, *Von Wyck Songbook Volume 1: 1986 - 1988*, *Von Wyck Songbook Volume 2: 1988 - 1991*, *Von Wyck Songbook Volume 3: 1991 - 1997*, and *Von Wyck Songbook Volume 4: 1998 - 2011*. Brooks has also recently published two collections of his reviews, and a non-fiction book on religion and politics in today's world, *Ranting & Raving*.

He has been writing short stories, lyrical poems, and reviews for several years. His field of choice is psychological erotic satiric mystery suspense.

Even though he has been inspired by a lot of writers over the years (namely Stephen King, Peter Straub, Mary Higgins Clark, and Jackie Collins), he would have to say the biggest inspiration and influence on his writing has been some awesome filmmakers, like Alfred Hitchcock, Brian De Palma, and Stanley Kubrick.

www.ingramcontent.com/pod-product-compliance
Lightning Source LLC
Chambersburg PA
CBHW071356170526
45165CB00001B/68